ORIENTAL STUDIES

edited by

S. M. Stern and R. Walzer

vol. IV

PAINTINGS

from

ISLAMIC LANDS

For

BASIL GRAY

ORIENTAL STUDIES IV

PAINTINGS
from
ISLAMIC LANDS

Editor
R. Pinder-Wilson

University of South Carolina Press
Columbia, S.C.

©

1969

Bruno Cassirer (Publishers) Ltd.

Published 1969 in Great Britain by

BRUNO CASSIRER (PUBLISHERS) LTD

31 Portland Road, Oxford

and in the United States of America by

THE UNIVERSITY OF SOUTH CAROLINA PRESS

Columbia, S.C.

Standard Book Number: 87249-138-2

Library of Congress Catalog Card Number: 69-17154

Printed in Great Britain

TABLE OF CONTENTS

A MANUSCRIPT FROM THE LIBRARY OF THE GHAZNAWID AMĪR ʿABD AL-RASHĪD

by

S. M. Stern

I. ABŪ BAKR MUḤAMMAD B. ʿABD ALLĀH'S BOOK ON THE PHYSICAL AND MORAL CHARACTERISTICS OF THE PROPHET

The University Library in Leiden possesses an Arabic MS. containing a book on the Physical and Moral Characteristics of the Prophet[1]—a subject which belongs to the sphere of the science of Tradition and one to which a number of books has been devoted. There were handed down many traditions describing the Prophet's physical appearance and his moral character, and the books in question presented anthologies of these traditions. The classical representative of the genre is the monograph by one of the great authorities of the science of Tradition, al-Tirmidhī, which was highly venerated by later generations.[2] The author of our book was merely an epigone compared with a " father " of the literature of Tradition such as al-Tirmidhī, whose book was in fact among his sources. Nor does he count among the great and famous such as abounded also among the epigone authors of secondary compilations. His name: Abū Bakr Muḥammad b. ʿAbd Allāh b. ʿAbd al-ʿAzīz, seems totally forgotten and the Leiden copy of his book seems to be the only one extant. Not that the book is devoid of all interest. The traditions discussed in it are of course also known from other sources, but the notes appended to them—mainly of textual and philological character—refer to many early authorities of the science of Tradition and Arabic philology. Indeed,

[1] *Kitāb Khalq al-Nabī wa-Khulqih*, MS. no. 437, described in P. de Jong and M. J. de Goeje, *Catalogus Codicum Orientalium Bibliothecae Academiae Lugduno-Batavae*, iv (1866), pp. 60–1. (The book is not registered in Brockelmann's History of Arabic Literature.) I am most grateful to Dr. J. Parsons for taking the excellent photographs from this MS. which is rather difficult to photograph, and for the authorities of the Leiden University Library for their permission.

[2] *Kitāb al-Shamā'il*; see Brockelmann, i, 169–70, Supplement, i, 268–9.

the author vaunts the comprehensiveness of his lexicographical notes.[3]

I found no information whatsoever about the author. It is possible that I have not looked at all the right places and something will yet turn up; but it is evident that he was not an eminent scholar whose name would recur in the usual biographical sources. We can establish his background by examining the names of his teachers.

The teacher who is quoted most often as the authority for the traditions included in the book is Abū Saʿīd ʿUthmān son of Abū ʿUmar Muḥammad b. Aḥmad b. Muḥammad b. Sulaymān al-Sijistānī. He is not quite unknown, but it is rather his father, Abū ʿUmar, who was a scholar of some importance. He came from Nūqāt, also called Nūhā, a suburb of Zaranj in Sijistān, and studied, according to the historians, in Harāt, Marw, Balkh and Transoxania. The exact date of his death is not given, but there is evidence that he was alive in 382/992-3. He had two sons ʿUmar and ʿUthmān, who transmitted his teaching—ʿUthmān being the teacher of our author.[4] All the traditions quoted by our author in the name of Abū Saʿīd ʿUthmān, were transmitted by the latter from his father—as we shall see, our author probably read with Abū Saʿīd a book by Abū Saʿīd's father. In the *isnāds* a great number of Abū ʿUmar's authorities are named; I cannot enumerate them all, but choose a few names of particular interest. Abū ʿUmar heard from Abū Naṣr Muḥammad b. Khīw b. Ḥāmid b. Dillūya al-Tirmidhī the traditions about the Prophet's description related by Abū Naṣr's great compatriot, al-Tirmidhī, i.e., it seems, al-Tirmidhī's *Kitāb al-Shamāʾil*.[5] In a footnote I give the

[3] P. 82: " These are the rare expressions in the tradition related by ʿAlī. Abū ʿUbayd [al-Qāsim b. Sallām, third/ninth century rather than al-Harawī, of the fourth/tenth century, cf. below, p. 11] and others have begun to explain it, but have not assembled all the rare information (*al-nukat waʾl-ghurar*) assembled by me in this book . . . The sheikh Abū Sulaymān al-Khaṭṭābi says rightly in the preface of his book [probably the book on the rare expressions in traditions, cf. below, p. 11]: ' There remains a number of traditions which I was unable to explain and which I left so that God may disclose their secrets to those of His servants as He wills: every time has its own people and every generation its own knowledge '."

[4] A biography of Abū ʿUmar is found in Yāqūt's *Irshād al-Arīb*, vi, 324-5, a short note in his Geographical Dictionary, s.v. " Nūqāt " (iv, 824). The *Taʾrīkh Sīstān* (ed. Bahār, p. 20) includes among the famous men of Sijistān Abū Saʿīd b. Abī ʿUmar al-Nūqātī, Abū ʿUmar al-Nūqātī, and Abuʾl-Ḥasan ʿUmar b. Abī ʿUmar al-Nūqātī. (The editor's note, who wrongly takes Yāqūt's note in the Geographical Dictionary to mean that ʿUmar was the brother, not the son, of Abū ʿUmar, should be disregarded.) Yāqūt includes among the teachers of Abū ʿUmar also Abū Sulaymān al-Khaṭṭābī, whom we shall meet repeatedly. For ʿUmar, son of Abū ʿUmar, see also below, p. 12 note 22.

[5] Abū Naṣr gave the lecture attended by Abū ʿUmar al-Sijistānī " in his house in Tirmidh " (p. 22). I found no information about Abū Naṣr. Since his father and great

names of those masters of Abu 'Umar of whom it is stated where he met them;[6] the towns are Balkh, Tirmidh and Nasaf, and this confirms and completes Yāqūt's statement about Abū 'Umar's journeys in Khurāsān and Transoxania in search of knowledge.

Another teacher of our author was Abū Ṭālib 'Abd al-'Azīz b. Muḥammad, whose name occurs almost as frequently as that of Abū Sa'īd 'Uthmān al-Sijistānī. His fame, however, did not reach beyond his immediate circle, since his name seems to have escaped the attention of the compilers of biographical repertories. Our author heard from him traditions related by the famous scholar Abū Sulaymān al-Khaṭṭābī (died 386/996 or 388/998), who taught in Sijistān and other parts of Eastern Iran.[7]

Other teachers of the author, less often mentioned by him, were Abū Sa'īd al-Khalīl b. 'Abd al-Azīz al-Sijistānī, about whom I found no information, and Abu'l-Ḥasan 'Alī b. al-Ḥasan b. Yaḥyā, about whom I found only that he was from Sijistān and related traditions from al-Khaṭṭābī in that country.[8] Abū 'Abd al-Raḥmān Ḥanbal b. Aḥmad b. Ḥanbal al-Fārisī (I have no information about him) is only quoted twice (pp. 83–4 and 145).

Most of the author's teachers were, then, from Sijistān, and he himself was obviously also a native of either Sijistān or a neighbouring region, and possible a resident of Ghazna. It is not surprising that the library of the amīr of Ghazna—for which, as we shall see, the MS. was written— should have included a volume by a local author, though that author's fame did not spread beyond his own country. The eulogy at the beginning of the book: " Thus says Abū Bakr Muḥammad the son of 'Abd Allāh the son of 'Abd al-'Azīz, may God be pleased with him and his parents "

grandfather bear rare Iranian names I consulted F. Justi's *Iranisches Namenbuch*, where I did indeed find him under " Xīv " and " Dilūyeh " (pp. 172, 84). This bears eloquent witness of Justi's learning and comprehensive use of the sources—but does not help us, since Justi's authority was the catalogue of the Leiden library, where in the description of our MS. this scholar's name is quoted.

[6] Abū Ḥāmid al-Būsanjī, from whom Abū 'Umar heard a tradition " in Būsanj, a village belonging to Tirmidh " [see Yāqūt, i, 758] (p. 261); 'Abd al-Raḥmān b. Muḥammad b. 'Allūya al-Abharī, whom he heard in Tirmidh (p. 328); Abū Bakr Aḥmad b. Muḥammad b. 'Abd Allāh al-Khuwāshī, whom he heard in Balkh (pp. 340, 382); Abū Bakr Muḥammad b. Ḥāmid al-Warrāq, whom he also heard in Balkh (p. 384); 'Abd al-Mu'min b. Khalaf, whom he heard in Nasaf (p. 358).

[7] For al-Khaṭṭābī see Brockelmann, i, 174, Supplement, i, 275. On p. 332 the author quotes an observation of al-Khaṭṭābī about a luminous stone which he had seen in Ukishūtha in the province of Ushrūsana.

[8] Yāqūt, *Irshād al-Arīb*, ii, 83 (in biography of al-Khaṭṭābī).

suggests that the MS. was copied after the author's death.[9]

With the help of my old notes, taken in Leiden many years ago, I can give a brief description of the work. It is ordered according to the primary authorities to which the various traditions are ascribed. After an introduction, the traditions ascribed to 'Alī are given (pp. 21 ff.). Then follow the traditions ascribed to 'Ā'isha (pp. 83 ff.), Hind bint Abī Hāla (pp. 144 ff.), Umm Ma'bad (pp. 197 ff.), Anas b. Mālik (pp. 255 ff.) On p. 258 there begins a series of paragraphs discussing the traditions concerning the Prophet's use of various kinds of perfume. Then there follow additional traditions from Anas (pp. 289 ff.), traditions from al-Barā' b. 'Āzib (p. 302), Jābir b. Samura (pp. 303 ff.), Abū Hurayra (pp. 341 ff.), al-'Adā' b. Khālid (pp. 346 ff.), Abū Ṭufayl (pp. 350 ff.), Rubayya' (pp. 352 ff.), Abū Sa'īd al-Khudrī (pp. 353 ff.), 'Abd Allāh b. Ḥārith (pp. 356 ff.), Qurṭ b. Rabī'a (pp. 364 ff.), Jābir b. 'Abd Allāh (pp. 366 ff.), Hind bint Jawn (pp. 369 ff.). At the end (pp. 380 ff.) there are some traditions about the miraculous quality of the Prophet's sweat etc. and (pp. 385 f.) his luminosity in the dark.

A few indications about the written sources used by the author may complete this summary description of his book. We have seen that his chief oral authority was Abū Sa'īd 'Uthmān b. Abī 'Umar Muḥammad al-Sijistānī, who transmitted to our author traditions from his father Abū 'Umar. From some references[10] it results that these traditions were contained in a book compiled by Abū 'Umar, the subject of which was perhaps the same as that of our author: the traditions containing the description of the Prophet. The traditions from al-Tirmidhī's *al-Shamā'il*, which as we have seen our author derived from Abū 'Umar, were probably included in that book.[11] We have seen that two of the teachers of our

[9] It is true that the formula *raḍiya'llāh 'anhu* can also be used after the name of a living person (I. Goldziher, " Über die Eulogien der Muhammedaner ", *Zeitschrift der deutschen morgenländischen Gesellschaft*, 1896, p. 122, note 1), but this usage is very rare and is here excluded by the addition of the reference to the parents.

[10] " That is what Abū 'Umar says in his book ", p. 272; " In the book of Abū 'Umar it is spelt just as I have written ", p. 379. The books by Abū 'Umar enumerated by Yāqūt seem to belong—to judge from their titles—to belles-lettres, so that the book referred to by our author can be identified by none of them.

[11] Since the author also refers to particular spellings in al-Tirmidhī's book (e.g. p. 327: " I found it written thus in Abū 'Īsā's book ") it is obvious that he also read it directly, no doubt with his master Abū Sa'īd, who handed it down from his father Abū 'Umar. (Abū 'Umar derived the traditions of al-Tirmidhī, as we have seen, from Abū Naṣr Muḥammad.) There is nothing strange in Abū 'Umar including traditions from al-Tirmidhī in his own compilation which he read with his son, but also reading with his son al-Tirmidhī's book.

author were disciples of al-Khaṭṭābī, so that it is natural that he used the writings of that famous traditionist.[12] Many traditions are said to be extracted from " the book " of an older authority, Ibn Abī Khaythama.[13]

In his comments the author uses a number of special works on *gharīb al-ḥadīth*, rare words in Tradition. He says that he took the commentary on the tradition of Hind bint Abī Hāla from " Ibn Qutayba's book " (Ibn Qutayba's famous book on rare words is obviously meant), making, however, additions of his own (p. 197). The commentary on Umm Maʿbad's tradition is taken " from Ibn Qutayba and other scholars " (p. 205). As we have seen, the author used al-Khaṭṭābī's book on the subject; he also quotes the famous *Gharīb al-Ḥadīth* by Abū ʿUbayd al-Harawī, who was a disciple of al-Khaṭṭābī and was thus an older contemporary of the author.[14] Of other philological works we may mention some book by Abū Mūsā al-Ḥāmid and another by al-Azharī, both perused in the autograph.[15] Ibn Jinnī is also quoted.[16] Of lesser authors an autograph by the sheikh Abū Bakr,[17] or Abū Bakr al-Ḥanbalī,[18] is often quoted; its title is sometimes specified as *al-Shawāhid*,[19] and on one occasion the information is vouchsafed that its author died before the final revision of the book.[20] I think this author is identical with Abū

[12] See above, p. 8 note 3, for a quotation from the preface of al-Khaṭṭābī to a book of his, probably his famous work on *Gharīb al-Ḥadīth*. The traditions are always quoted from al-Khaṭṭābī through the intermediary of Abū Ṭālib ʿAbd al-ʿAzīz b. Muḥammad. Many are accompanied by comments due to al-Khaṭṭābī; it is likely that the traditions and the comments are derived from the *Gharīb al-Ḥadīth*, which our author would have studied with Abū Ṭālib, al-Khaṭṭābī's pupil. (I have no access to al-Khaṭṭābī's book and cannot check directly whether the traditions in question are discussed in it.)

[13] Died 279/892; see Brockelmann, Supplement, i, 272 (add: al-Khaṭīb al-Baghdādī, *Taʾrīkh Baghdād*, iv, 162; Ibn al-ʿImād, *Shadharāt al-Dhahab*, ii, 174). He is the author of a great biographical work on traditionists (still extant in MS.); the traditions quoted by our author may come from it.

[14] P. 62. Abū ʿUbayd al-Harawī was a disciple of al-Khaṭṭābī and al-Azharī, and died in 401/1011: Brockelmann, i, 137, Supplement, i, 200.

[15] Abū Mūsā (d. 305/918, Brockelmann, Supplement, i, 170, 184) is quoted on pp. 61, 104, 123, 168–9; al-Azharī (d. 370/980; Brockelmann, i, 134–5, Supplement, i, 197) on p. 62.

[16] Ibn Jinnī died in 392/1002 (Brockelmann, i, 137, Supplement, i, 191–2). He is quoted on p. 18.

[17] Pp. 12, 63, 179, 225, 230, 265, 301, 323, 331.

[18] Pp. 16–17, 30, 42–3, 72, 109.

[19] P. 80: *bi-khaṭṭ Abī Bakr fī Shawāhidih*.

[20] Pp. 217–18.

Bakr ʿAbd Allāh b. Ibrāhīm al-Ḥanbalī, who composed a dirge on al-
Khaṭṭābī[21] and was thus a contemporary of the author's teachers. There
are mentioned the " Baghdādī Notes " by a certain Abu'l-Ḥasan ʿUmar
b. Abī ʿUmar,[22] whom I cannot identify.

II. THE MANUSCRIPT

So much for the text. As for the splendid MS. which contains the
text, it has a colophon from which we learn the identity of the scribe
who wrote—and presumably also illuminated—it: Abū Bakr Muḥammad
b. Rāfiʿ the *warrāq*, " in Ghazna, may God preserve it ". The *warrāq*
was a professional copyist and bookseller—the shopkeepers in the market
of stationers (*sūq al-warrāqīn*) naturally enough themselves produced
their own wares.[23] There was good reason why in this case our bookseller
of Ghazna made an effort to produce a book as beautiful as he could make
it: his customer was not a scholar who would not care too much about
the look of his textbook and who would not usually be able to afford a
luxury copy, but the amīr of Ghazna himself, the ruler of a great empire,
in fact the son of Maḥmūd of Ghazna. To tell the truth, the Ghaznawid
empire had sadly declined from its mighty state under Maḥmūd by the
time of ʿAbd al-Rashīd, his son and third successor—but even so its ruler
would expect a copy worthy of a library which must have included many
books owned by his father, that great patron of literature.

We learn of the provenance of the book from the library of the amīr
of Ghazna from his ex-libris on the title-page. In fact the title-page is
taken up by two ex-libris: one of the amīr ʿAbd al-Rashīd in six lines, the
other of a certain rich merchant, written between the first and second
lines of the other ex-libris. In order to explain this anomaly I assume
that the ruler's ex-libris originally contained two more lines which were
later erased to give way to the ex-libris of a subsequent owner; we shall
see that an examination of the titles of the rulers as they appear in the

[21] Yāqūt, *Irshād al-Arīb*, ii, 87. On p. 108 in our book it is related that Abū Bakr
" asked Abū Muḥammad al-Sīrāfi " (whom I cannot, however, identify).

[22] P. 16 (his autograph *fī baʿd taʿlīqātihi'l-Baghdādiyya*), p. 194. [While reading the
proofs I realize that Abu'l-Ḥasan ʿUmar is probably the brother of Abū Saʿīd ʿUthmān
al-Sijistānī, see p. 8 note 4.] A poem " by one of the moderns " is quoted on the authority
of a certain sheikh Muḥammad b. Abī Yūsuf (p. 301), and on p. 276 a verse " by one of the
moderns " with a *tajnīs* on the word *ʿūd* is quoted from Abu'l-Fatḥ, who is probably none
other than Abu'l-Fatḥ al-Bustī, the court poet of the Ghaznawids, and himself one of the
chief representatives of *tajnīs* poetry.

[23] The alternative that Muḥammad b. Rāfiʿ was a craftsman permanently employed
at the amīr's court cannot, of course, be ruled out.

ex-libris confirms this assumption.[24]

The ex-libris of ʻAbd al-Rashīd as it stands now reads:

لخزانة كتب الأمير السيّد الملك

معزّ دين الله ومظاهر خليفة الله

[Two lines containing the ex-libris of the merchant Muḥammad b. Shibl]

ابى منصور عبد الرشيد بن يمين الدولة

أمين الملّة ابى القسم محمود

بن ناصر الدين نصير أمير المؤمنين

أطال الله بقاءه و[أعزّ] أنصاره

For the library of the amīr, the king, who glorifies God's religion, and aids God's caliph [. . . two lines containing the ex-libris of the merchant . . .] Abū Manṣūr ʻAbd al-Rashīd, the son of the Right-Hand of the Empire, Trusty Keeper of the Islamic Religion, Abu'l-Qāsim Maḥmūd, the son of the Helper of Religion— Assistant of the Commander of the Faithful; may God prolong his life and give glory to his victories.

It is not at all easy to read this text, which is written in gold against the background of a scrolling: the colour is badly damaged and it took several sessions during my stay in Leiden in 1951 to make out the script, by catching the reflection of the faded gold near a window. It was only after having done the work that I noticed that I had a predecessor nearly a century ago. Whereas in the catalogue of the Arabic MSS. of the Leiden Library (dated 1866) it was stated that the MS. was written for " some prince ", in an appendix (dated 1877) it was added[25] that during a visit J. von Karabacek had made an attempt to decipher the ex-libris and read part of it, establishing the identity of the prince as the Ghaznawid ʻAbd al-Rashīd. Since, however, he was unable to read some words, and others he read incorrectly, I do not regret the efforts spent upon the ex-libris, of which I can now offer a fairly certain text.

[24] The alternative would be to assume that the book was made for the merchant and was then acquired by the amīr, whose ex-libris was then written above and below that of the merchant. This is rather unlikely in itself, and the fact that some elements, which should figure in the title of the amīr, are absent, seems to clinch the argument in favour of the explanation offerred in the text.

[25] At the end of vol. vi/1 of the catalogue (published by M. Th. Houtsma in 1877); see p. 229.

'Abd al-Rashīd's reign only lasted for three years. He had been imprisoned by Mawdūd, his brother, when the latter assumed power. On Mawdūd's death in 440/1049, however, 'Abd al-Rashīd was proclaimed ruler by some troops who happened to be near his place of prison. They marched on Ghazna, causing 'Alī, son of Sultan Mas'ūd I, to flee from the capital, which was occupied by 'Abd al-Rashīd. In 442/1051 he in his turn was murdered by the usurper Ṭughril, a former *ghulām* of Sultan Maḥmūd.[26]

III. THE TITLES IN THE EX-LIBRIS

The ex-libris is not only valuable as a monument of Islamic art in itself and as evidence for the date and provenance of the MS., but also provides information about the titles born by 'Abd al-Rashīd and his grandfather Sabuktakīn (Sebüktigin). In a thorough article entitled " The Titulature of the Early Ghaznavids "[27] C. E. Bosworth reviewed the evidence available on the subject. Some uncertainty remained about Sabuktakīn's title, and I do not think that Bosworth has drawn the right conclusion. In 384/994 Sabuktakīn and his son Maḥmūd helped the Sāmānid amīr Nūḥ b. Manṣūr defeat the rebellious generals Abū 'Alī and Fā'iq, and as a reward, Sabuktakīn was given a new title. There is, however, some doubt about what the title exactly was: there is no question but that it was composed with " Nāṣir ", " the Helper of . . .", but there is a conflict of evidence about the second part. According to Bosworth " *Nāṣir ad-Daula* is probably the original form, and the *dīn* component [making it Nāṣir al-Dīn wa'l-Dawla] may have been added to it in popular usage soon after his death or even during his lifetime ". The evidence seems to me to impose quite different conclusions. The title Nāṣir al-Dīn wa'l-Dawla is attested by weighty authorities. Abu'l-Fatḥ al-Bustī, Sabuktakīn's intimate court poet calls him by this title in his dirge,[28] and the same form is given by al-Bīrūnī and Gardīzī, both writers who lived under the early Ghaznawids.[29] It is true that this full title was

[26] See Bosworth's article (referred to presently), pp. 230–1, and D. Sourdel, " Un trésor de dinars ġaznawides et salğūqides ", *Bulletin d'études orientales*, xviii (Damascus 1964), pp. 197 ff. (see pp. 198–9 for the chronology of 'Abd al-Rashīd's reign).

[27] *Oriens*, 1962, pp. 210 ff. The discussion of Sabuktakīn's title is on p. 216.

[28] Quoted by al-'Utbī, *al-Ta'rīkh al-Yamīnī*, Cairo 1896, i, 263 and Ibn Khallikān, in his article on Maḥmūd of Ghazna (ed. Wüstenfeld, no. 723).

[29] Al-Bīrūnī wrote his Chronology in 390/1000, during Maḥmūd's reign, but before

often abbreviated—not, however, into Nāṣir al-Dawla, but into Nāṣir al-Dīn. Abu'l-Fatḥ, in a second dirge, employs the form Nāṣir Dīn al-Ilāh, which is merely a poetical variant of Nāṣir al-Dīn, as is the form Naṣīr al-Dīn, which occurs in an anonymous dirge.[30] These are contemporary passages. A few years after Sabuktakīn's death, Firdawsī, in the chapter of the *Shāh-nāma* containing the dedication to Maḥmūd of Ghazna refers to Maḥmūd's brother Naṣr as " the son of him who is called Nāṣir al-Dīn.[31] Similarly, al-'Utbī, speaking of the same prince, has Naṣr b. Nāṣir al-Dīn, and speaking of a third brother, Ismā'īl b. Nāṣir al-Dīn.[32] Farrukhī, court panegyrist of the Ghaznawids, calls Maḥmūd " son of Nāṣir al-Dīn " and Yūsuf " son of Nāṣir-i Dīn ", and also in the headings of numerous poems dedicated to these and other members of Sabuktakīn's dynasty he is always referred to as Nāṣir al-Dīn.[33] Our ex-libris confirms that in the court of Ghazna, in referring to the ancestor of the dynasty, the shortened form Nāṣir al-Dīn was used.

There is only one apparent exception. In describing the bestowal of the title upon Sabuktakīn, al-'Utbī according to the printed text gives it as Nāṣir al-Dawla.[34] This is strange, since it goes against all the other contemporary evidence, and also, as we have seen, against al-'Utbī's own usage in other passages of his book. Thus there is good reason to assume that the text is incorrect, and this is confirmed by the fact that the

coming to his court. Gardīzī wrote in Ghazna under the reign of 'Abd al-Rashīd. The passages are in al-Bīrūnī's Chronology (*al-Āthār al-Bāqiya*, ed. Sachau), p. 134, and in Gardīzī's History (*Zayn al-Akhbār*, ed. M. Nazim), p. 62. On pp. 59 and 63, however, Gardīzī writes Nāṣir al-Dīn.

[30] Abu'l-Fatḥ's second dirge and the one by the anonymous poet are quoted by al-'Utbī after Abu'l-Fatḥ's first dirge, i, 263.

[31] Ed. Vullers, i, 13, line 230.

[32] ii, 330. He also quotes (p. 332) a poem composed by himself in which he calls the prince Naṣr b. al-amīr Nāṣir Dīn Allāh using a " poetical " form similar to the one used by Abu'l-Fatḥ. When Juzjānī, *Ṭabaqāt-i Nāṣirī*, ed. W. Nassau Lees, p. 8 (transl. H. G. Raverty, p. 75) gives Sabuktakīn's title as Nāṣir Dīn Allāh, he probably had some such poem in mind. Niẓām al-Mulk (*Siyāsat-nāma*, p. 126) also gives Sabuktakīn the title Nāṣir al-Dīn (though his account of its bestowal is erroneous).

[33] See for example *Dīwān* (Teheran 1932), p. 85 l. 3 (Maḥmūd); p. 140 l. 15, p. 142 l. 5, p. 201 l. 14, p. 220 l. 5 (Yūsuf). There is no need to give references for the very numerous headings. Also the Ziyārid Kay Kā'ūs in his *Qābūs-nāma* calls his father-in-law " Maḥmūd son of Nāṣir al-Dīn " (ed. Levy, p. 6).

[34] i, 193.

reading Nāṣir al-Dīn is also attested for this passage.[35] By accepting this as the true reading[36] the anomaly is eliminated: all the contemporary sources have either the full Nāṣir al-Dīn wa'l-Dawla or the shortened Nāṣir al-Dīn. Only later sources of no authority have Nāṣir al-Dawla,[37] all to be rejected.

The shortened form Nāṣir al-Dīn was preferred for ordinary use. It is not likely that the more pompous Nāṣir al-Dīn wa'l-Dawla is a " popular usage ", and it seems to me obvious that it was the official form assumed by Sabuktakīn in 384/994. It is true that the *dawla* titles are first in chronological appearance; it is only with the Saljūqs that the *dīn* ones become preponderant, although the Ghaznawids continued, on the whole, to favour the older, *dawla* ones.[38] Yet the evidence shows that the title bestowed upon Sabuktakīn was Nāṣir al-Dīn wa'l-Dawla which was currently abbreviated into Nāṣir al-Dīn. These facts are of great importance for the history of titles in Islam, and it is satisfactory that they can be firmly established as facts.

Let us come to the owner of the MS., 'Abd al-Rashīd.[39] That his *kunya* was Abū Manṣūr, is also attested by Gardīzī.[40] Of his titles, line 1 of the ex-libris gives some preliminary ones: " The amīr, the lord, the king ". Line 2 has in the first instance Mu'izz Dīn Allāh, " One who glorifies God's religion ": this title is also attested by Gardīzī. The second title: Muẓāhir Khalīfat Allāh, " Who aids God's caliph ", is not otherwise known. These two complex titles, similar to those invented by the later Buwayhids, can, however, by no means be the only ones given to the amīr in the ex-libris, but must have been preceded by titles of the

[35] There is no critical edition of the text. The old Manchester MS. (John Rylands Library, no. 288, dated 595/1198), and the fairly old MS. Oxford 811 (7th/13th century ?) have, as the printed text:

ولقب الأمير الرضى ؐ الأمير سبكتكين (this word om. Oxford) بناصر الدولة

The more recent Oxford 675 (Jumādā I 1042), reads, however:

ولقب الامير الرضى ؐ سبكتكين بناصر الدين.

(The reading of the Manchester MS. was kindly ascertained for me by Dr. J. D. Latham.)

[36] One can explain how the original Nāṣir al-Dīn was changed into Nāṣir al-Dawla: al-'Utbī relates in the same passage that Maḥmūd was given the title of Sayf al-Dawla, and I suggest that this caused some copyist to write Nāṣir al-Dawla by a sort of attraction.

[37] Ibn al-Athīr, ix, 72, and Ibn Khallikān in the title of the article on Maḥmūd of Ghazna (see above, p. 14 note 28).

[38] This is a quotation from Bosworth, who thus motivates his conclusion that the form with *dawla* was the original title of Sabuktakīn.

[39] Bosworth discusses 'Abd al-Rashīd's titles on pp. 230–1.

[40] P. 63.

simpler (and older) type, since they regularly precede in the complete series the more complex ones. Gardīzī gives as 'Abd al-Rashīd's title Sulṭān-i Mu'aẓẓam 'Izz al-Dawla wa-Zayn al-Milla Sayf Allāh Mu'izz Dīn Allāh. The coins only show the simple titles: 'Izz al-Dawla wa-Zayn al-Milla Sayf Allāh. It seems obvious to me that the titles 'Izz al-Dawla wa-Zayn al-Milla Sayf Allāh did in fact figure in the two lines (between the present lines 1 and 2) which were subsequently erased in order to make place for the ex-libris of the merchant Zayn al-Dīn. Since they would not have filled the two lines, we may assume that there were a few more words, more preliminary epithets for instance, such as " the great, the victorious " etc. The title Naṣīr Amīr al-Mu'minīn, " Assistant of the Commander of the Faithful ", which—as titles of this type always do—comes at the very end, was not hitherto attested for 'Abd al-Rashīd.[41]

IV. THE CALLIGRAPHY OF THE MANUSCRIPT

The historical information incidentally provided by the ex-libris—howsoever trifling—is welcome, but incomparably greater is the artistic importance of the manuscript, in regard mainly to its writing, but also to its illumination.

The book counts among the important documents of Arabic calligraphy, since, together with a few other MSS., it bears witness to a decisive stage in its history. In the early centuries of Islam we have to distinguish between three kinds of script—leaving aside epigraphical writing.[42] First there is the variety of scripts used for the Koran—all called conventionally, though rather inaccurately, Kufic. Secondly, there are the scripts, showing variations according to their time and place, used in copying books. Thirdly, we have the more cursive scripts used for letters, documents, and notes, out of which were evolved in the chanceries various formal scripts. The eleventh-twelfth century specimens confirm

[41] We see from the preceding that the evidence of the ex-libris fits beautifully with the information given by Gardīzī—which is not surprising, as Gardīzī wrote under 'Abd al-Rashīd's reign. In contrast, statements of later historians (Ibn al-Athīr, *Mujmal al-Tawārīkh*, Ḥamd Allāh Mustawfī, Sayf al-Dīn Faḍlī, quoted by Bosworth) about titles allegedly borne by 'Abd al-Rashīd, such as Shams Dīn Allāh, Sayf al-Dawla, Jamāl al-Dawla, Majd al-Dawla, can now be definitely dismissed.

[42] Cf. Ibn Durustawayh's classification: " As far as its fundamental character is concerned, writing is one, and the single letters of the alphabet have the same form in all the scripts. The letters are similar, though through their different uses they receive different shapes, as in the scripts of the Koran (*al-maṣāḥif*), the copyists (*al-warrāqīn*) and the secretaries (*al-kuttāb*), etc."; *Kitāb al-Kuttāb*, pp. 66–7.

that chancery script, in contrast to the Koranic and book scripts, always affected a certain cursiveness of ductus, though a highly stylized cursiveness.[43] In the fourth century of the Hijra (tenth century A.D.) there was introduced a new Koranic script, which I proposed to call " rhomboid " script.[44] This was at the beginning used side by side with the " Kufic ", which by the end of the fourth/tenth century went out of use. The rhomboid script survived until the sixth/twelfth century, but gave way in its turn to a competitor which appeared at the beginning of the fifth/ eleventh century: the *naskh* script. Here we have a somewhat different process from that which brought the rhomboid script into use. That script was a new invention, which the *naskh* script of course was not: it is, as its name shows, the " copying " or book hand. The novelty consisted in the new function of the *naskh* as a Koranic script, which was also accompanied by an improvement of the *naskh* in order to fit it for its new part. The first extant Koran in *naskh* was written by the famous calligrapher Ibn al-Bawwāb in 391/1000–1.[45] It is likely that in the improvement of the *naskh* script Ibn al-Bawwāb had predecessors in the fourth/tenth century,[46] but it is perhaps not far fetched to ascribe to him the novelty of using a *naskh* still further regularized by him for copying the Koran.[47] The next earliest Korans in *naskh* are the copies preserved

[43] The papyri show the writing used for correspondence in the early centuries of Islam. For the stylized chancery scripts developed in the third–fourth/ninth–tenth centuries we have no specimens, but the Fāṭimid documents from the fifth–sixth/eleventh–twelfth centuries (see my *Fāṭimid Decrees*, London 1964) allow to form a general picture, since the script employed in them is presumably derived from some ʿAbbāsid chancery script. The chancery scripts " in Ibn al-Bawwāb's manner " reproduced by al-Ṭībī (see below, p. 20 note 50) tally well with this conclusion.

[44] See my remarks in the *Bulletin of the School of Oriental and African Studies*, 1954, pp. 398 and 399. [I hope to show that the rhomboid script is based on a certain type of *naskh*, which was, however, so profoundly modified that it is not quite inappropriate to speak of a " new invention ". Note added during the correction of the proofs.]

[45] See D. S. Rice, *The unique Ibn al-Bawwāb manuscript in the Chester Beatty Library*, Dublin 1955.

[46] " Ibn al-Bawwāb observed that the Banū Muqla had improved the *tawqīʿāt* and the *naskh* scripts, but had failed to attain the highest degree of perfection: he completed their work. He also found that his master Ibn Asad was writing poetry in a *naskh* hand which approximated to the *muḥaqqaq*: he perfected this too ". This passage comes from an anonymous treatise on calligraphy; the original is published in *Majallat Maʿhad al-Makhṭūṭāt al-ʿArabiyya*, 1955, p. 126; an English translation is found in Rice, p. 7 (reproduced here with slight emendations).

[47] There is a reference to Ibn al-Bawwāb's improvement of the script of the Koran (*qalam al-maṣāḥif*) in the treatise referred to in the preceding note, loc. cit. One of the

in the British Museum, the Chester Beatty Library and the Türk ve Islam Eserleri Müzesi and discussed by Rice on pp. 24–7, belonging to the third decade of the fifth Islamic century.

This elevation of the *naskh* to the rank of a Koranic script and the fashion introduced (it seems) by Ibn al-Bawwāb of employing it in illuminated luxury Korans gave rise to use of *naskh* also in non-Koranic luxury books. We have not enough materials to be able to say with certainty which was the script usually employed for luxury books (other than Korans) in the early centuries of Islam. From the fifth/eleventh century onwards *naskh* is employed for luxury copies—i.e. illuminated books written for the libraries of rulers, high dignitaries, or other rich men. There is in the Bodleian Library in Oxford a copy of Miskawayh's *Ādāb al-Furs* dated 439/1047 which is the earliest luxury MS. of a non-Koranic text known to me written in the new style.[48] Our MS. is second in the chronological order. The lay-out of these two MSS. is related to that of the Koran MSS. insofar as they have rosettes dividing the sentences (corresponding to the verse-divisors in the Koran), panels for chapter headings, marginal palmettes. A copy of Salāma b. Jandal's collected poems, which belongs here through the use of calligraphic *naskh*, can be dated to between 445/1053 and 456/1063—probably to 455 or 456/1063–4. Its lay-out, however, follows a different pattern: whereas the commentary is written in *naskh*, the verses are in large characters said to be *thuluth*.[49]

Incidentally the use of the *thuluth* script in luxury books is due to a similar adaptation as that of the *naskh*. The *naskh* was adapted from its original sphere (ordinary secular books) to a new one: Korans and other luxury books. The *thuluth* was originally a chancery script, which was also adapted for the same new uses. Ibn al-Bawwāb was famous for his

followers of Ibn al-Bawwāb is said to have been famous for his Koranic script (Yāqūt, *Irshād al-Arīb*, v, 304, quoted by Rice, p. 10). Al-Ṭībī (for whose specimens of calligraphy see below, p. 20 note 50) gives a specimen of the *maṣāḥif* script according to the manner of Ibn al-Bawwāb (pp. 54–7) which on the whole corresponds fairly well to the script of the Chester Beatty MS. (This usage has to be distinguished from the older one, where " script of the *maṣāḥif* " refers to the so-called " Kufic " scripts.) The name " Koranic script " suggests that the *naskh* used by Ibn al-Bawwāb and his school for Korans was of a particular kind, distinguished from ordinary *naskh*. This point needs further clarification.

[48] I hope to discuss this MS. in the near future.

[49] See Rice, pp. 19–22. This MS. is then the first example for the alternate use of the two scripts, frequently practised afterwards. The idea itself to write verse and commentary in different scripts was, as I hope to show on another occasion, already known in the fourth/ tenth century.

improvement of various chancery scripts, the *thuluth* amongst them,[50] and one may perhaps risk the conjecture that the use of *thuluth* in books was also due to his example.[51]

Let us, however, come back to our MS. which is in *naskh* script. Not, however, in the style developed for the *naskh* by Ibn al-Bawwāb and accepted as canonical by his followers. The script of our MS. is strikingly idiosyncretic and shows that at the period the " manner of Ibn al-Bawwāb " (*ṭarīqat Ibn al-Bawwāb*) did not oust individuality. The scribe of the MS. and his customer have accepted the new idea that the ordinary book hand, the *naskh*, may, if given extra care, be used for luxury MSS., but did not yet think it essential to conform to the actual style of the standard *naskh* going back to Ibn al-Bawwāb. The scribe probably based the script of this MS. on his ordinary handwriting which he used for copying cheaper books commissioned by lesser persons. For the luxury MS. destined for the library of the amīr he gave his own handwriting a calligraphic quality rather than adapting Ibn al-Bawwāb's style. Strict followers of the school of Ibn al-Bawwāb would have no doubt condemned the calligraphy as unorthodox and therefore inferior, but I cannot help feeling—though it would be futile to try to award marks—that in writing and lay-out our MS. can vie with Ibn al-Bawwāb's Koran and the other luxury MSS. of its period.

Where it falls off is the illumination, which cannot stand comparison with the richness and refinement of the illumination in Ibn al-Bawwāb's

[50] See for example the passage (indicated above, p. 18 note 46) from the anonymous treatise on calligraphy. There exist specimens by later calligraphers exemplifying various scripts " in the manner of Ibn al-Bawwāb ", which seem to go back—through many intervening media, of course—to originals in the hand of Ibn al-Bawwāb. A collection made by Ibn al-Ṭībī for the Mamlūk sultan Qānṣūh al-Ghawrī is available in a facsimile edition: *Jāmi' Maḥāsin Kitābat al-Kuttāb*, published by S. al-Munajjid, Beirut 1962, and can give an approximate idea of the various scripts.

[51] The dīwān of Salāma b. Jandal bears a colophon purporting to be in the hand of Ibn al-Bawwāb. According to Rice this is a forgery, but may reflect the fact that authentic MSS. by Ibn al-Bawwāb were written in alternating *thuluth* and *naskh*. A MS. entirely in *thuluth*, allegedly by Ibn al-Bawwāb, is a forgery (Rice, p. 27). So are probably two others, accepted as genuine by A. Süheyl Ünver, who has written a naive book on Ibn al-Bawwāb, in which all the colophons allegedly containing signatures of Ibn al-Bawwāb are taken on their face value (I use the Arabic translation, *al-Khaṭṭāṭ al-Baghdādī ʿAlī b. Hilāl al-mashhūr b'Ibn al-Bawwāb*, Baghdad 1958, pp. 24 ff. [no. 1], p. 33 [no. 8]). I know of yet another *thuluth* MS. presumably forged on his name: Munich 791 of which I possess photographs. These MSS. may point to the existence of genuine MSS. written by Ibn al-Bawwāb in *thuluth*.

Koran, and the MSS. of Miskawayh and Salāma b. Jandal. The scrolling on the page of the ex-libris (Fig. 1) is rather trivial, and the panels of the first two pages (Figs. 2–3), though the general impression is pleasant, do not reach the level of the illumination of the other MSS. The palmettes forming the marginal decoration accompanying chapter-headings are rather poor if we think of the wide range of palmettes in Ibn al-Bawwāb's Koran.[52] Moreover, our stationer shows himself rather casual in his work, since he put such palmettes in four cases only, at the beginning of the book,[53] leaving the subsequent chapter-headings without this ornament. In short, as an illuminator, he does not rise above mediocrity.

V. THE LATER VICISSITUDES OF THE MANUSCRIPT

The volume does not seem to have remained long in the library of the Ghaznawids. Its first subsequent owner was a rich merchant whose ex-libris occupies, if my conjecture is acceptable, the place of the second and third lines of the original ex-libris of 'Abd al-Rashīd. The new ex-libris reads:

للشيخ الزكى فخ[ر] التجّار ابى
عبد الله محمد بن شبل الحمصى

" Belongs to the sheikh Zakī al-Dīn, Glory of the Merchants, Abū 'Abd Allāh Muḥammad b. Shibl al-Ḥimṣī ". This text is in Kufi script, which I shall not attempt to date accurately, but I hardly think it would be later than the twelfth century. The new owner bears the name " al-Ḥimṣī ",— so that he, or his family, came from Ḥimṣ in Syria; where he actually lived is unknown.

A slightly later owner put his motto into the upper left corner: [ور]يثق بالغفور، موسى بن يغم[" Mūsā b. Yaghm[ūr] trusts in the forgiving God ". The last two letters of Yaghmūr have been cut away, but fortunately they can be supplied, since the name is to rhyme with *al-ghafūr*. There was a famous amīr of this name in the reign of the Ayyūbid ruler al-Kāmil,[54] and I think it most probable that we have here his ex-

[52] See Rice, pp. 16–17.

[53] On pp. 8, 21, 26, 28, Figs. 4–8; cf. below, p. 23.

[54] Cf. Cahen's note in *Bulletin d'Etudes Orientales*, vol. xvi (Damascus 1958–60), Arabic ext, p. 14.

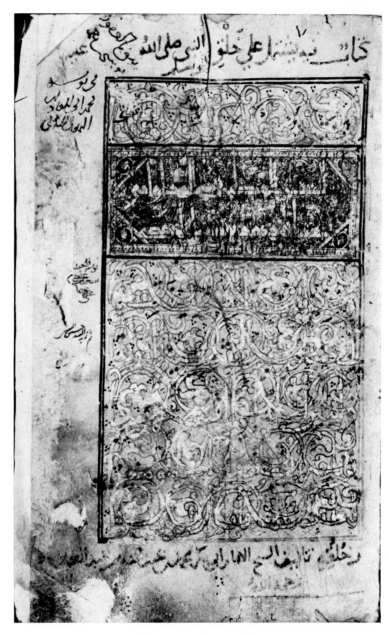

1. Page of the ex-libris

libris; if so the MS. has found its way to Egypt by the first half of the thirteenth century. Nothing can be said about the other owners: Muḥammad (with undeciphered *nisbas*), Saʻd b. ʻAlī, Ḥasan al-Faqīr. Finally, in the seventeenth century, the MS. was acquired in Istanbul by L. Warner, who bequeathed it to the University of Leiden.

VI. DESCRIPTION OF THE PLATES

The dimensions of the book are 24·5 × 16·7 cms., with only insignificant differences in the various folios. The written surface measures ca. 18 × 11 cms. and there are 10 or 9 lines to each page.

Fig. 1 shows the page with the ex-libris. As I have said, the ex-libris of ʻAbd al-Rashīd is in bad condition, and since most of the gold of the writing has disappeared, it can hardly be read in the photograph. The outlines of the scrolling are in red, which is then filled in with gold. The three-dots ornament is in blue, and the frame of the ex-libris is also blue.[55]

The ex-libris of the merchant Muḥammad b. Shibl al-Ḥimṣī has also deteriorated, but is clearly legible. It is in a panel in a frame with ornament of dots. The four corners are cut off and contain fleurons.

The verso of fol. 1 (Fig. 2) and the recto of fol. 2 (Fig. 3) contain the title of the book on two almost, though not entirely, mirroring panels with knobs (familiar from MSS. of the Koran). The sides of the panels are prolonged downwards to form, with a corresponding horizontal border, a frame for the whole of the page, furnished with an ornament of dots. In the outer lower corner of both pages half of the upper knob is repeated The colours employed in the panels, knobs, and frames, are gold, red blue, green.

There follows on fol. 1v the *basmala* and the author's name, all in thick gold letters framed within black contours. The text then begins with the author's preface.

The next plates provide specimens of the text and at the same time illustrate the style of the chapter-headings, which are in golden letters within black outlines of a different style from the writing of the text, with palmettes of various shapes on the margin opposite them. These palmettes only occur near the beginning of the volume, on pp. 8, 21, 26, 28. Afterwards the scribe made his task easier by omitting them.

[55] If my conjecture that the panel with the ex-libris of the merchant Muḥammad b. Shibl is later addition, the two lines above and below it, separating it from the first scrolling of the large ex-libris above, and the five below, must also be a later addition.

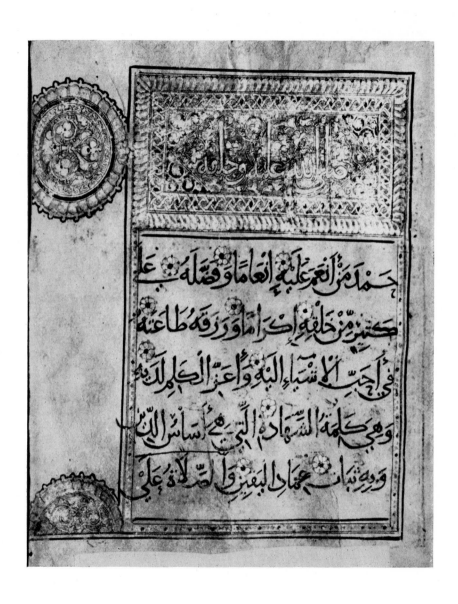

3. Title (*Left page*)

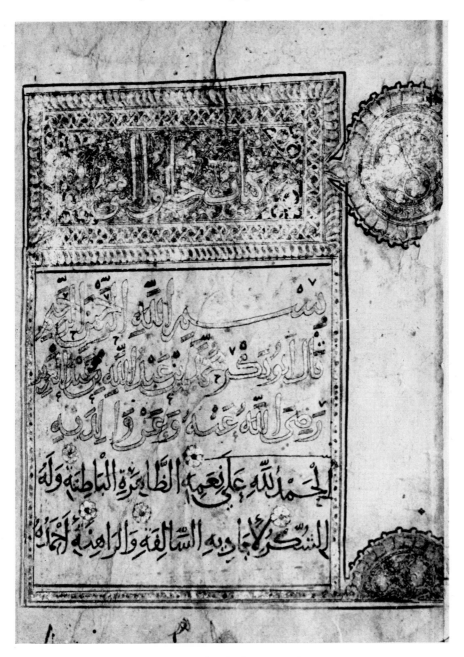

2. Title (*Right page*)

The frame of the palmettes is in blue, the scrolling inside is filled in gold within black outlines, the ground behind is partly left empty, partly coloured in red and green.

Fig. 4 shows p. 8, containing the end of the author's preface and the beginning of the chapter on the meaning of the words *khalq* and *khulq*, physical and moral characteristics, respectively. Fig. 5 shows p. 21, with the beginning of the chapter containing the traditions about the description of the Prophet ascribed to 'Alī b. Abī Ṭālib. The first tradition is derived from al-Tirmidhī's *Shamā'il* (Cairo 1889, p. 19) through the usual *isnād*: al-Tirmidhī—Abū Naṣr Muḥammad b. Khīw—Abū 'Umar Muḥammad b. Aḥmad al-Sijistānī—his son Abū Sa'īd—the author. At the beginning of p. 26, reproduced in Fig. 6, we see the end of the quotation, viz. al-Tirmidhī's critical remark about the tradition: " Abū Īsā [i.e. al-Tirmidhī] says: This is a beautiful and correct ḥadīth "— the adjectives being of course the technical terms employed in the science of Tradition for the designation of the most trustworthy traditions. There follows a note by the author on one of the authorities occurring in the chain of the tradition. The chapter-heading announces additional readings for the tradition discussed before.

Fig. 7 shows the beginning of the next chapter, still dealing with the tradition related from 'Alī; its subject-matter is apparent from the heading: " The explanation of the rare words occurring in these traditions."

Finally, in Fig. 8 there can be seen the last page (p. 387) of the text, with the colophon giving the name of the scribe, Abū Bakr Muḥammad b. Abī Rāfi' the stationer, and indicating Ghazna as the place in which the copy was made.

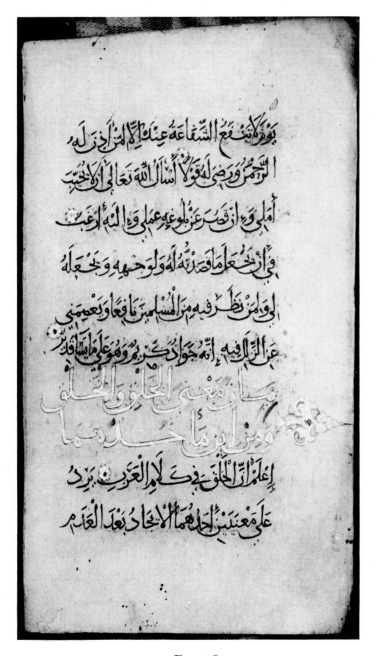

4. Page 8

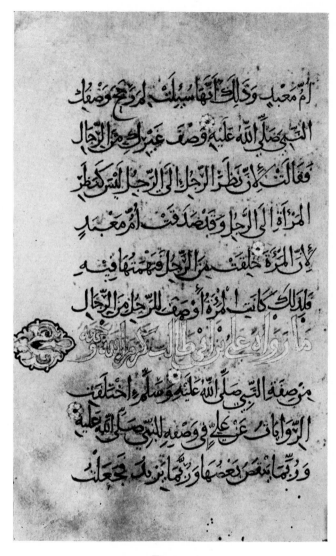

5. Page 21

6. Page 26

7. Page 28

8. Page 387

NOTES ON THE ICONOGRAPHY OF THE " DEMOTTE " *SHĀH-NĀMA*

by

O. Grabar

The unique character of the so-called " Demotte " *Shāh-nāma* has now been recognized for several decades and much has been written about its date (most probably the fourth decade of the 14th century with a number of later additions or retouches) and about the different hands involved in the execution of its miniatures.[1] Less effort has been devoted to its iconographic peculiarities or to its possible models except in so far as there is general agreement about the existence of " pathetic " scenes centring on death and about a clear influence of the Chinese inspired school of painting developed in Tabriz during the first two decades of the fourteenth century.[2] Without trying to solve or even define the bewildering number of problems which are posed by the iconography and the background of the manuscript, I should like to discuss two points which have seemed to me to be of particular significance in evaluating the expressive and narrative qualities of the miniatures. The first point concerns the manner in which one can define and explain the manuscript's interpretation of the text and the second one deals with one possible source for the manuscript which has only fairly recently come to light. In both instances it will be found that much still remains tentative and my remarks are based primarily on the assumption that it is only through a series of meaningful hypotheses that eventually the striking qualities of the manuscript will be fully understood.

A first remark to be made about the illustrations of the Demotte manuscript is the rather obvious one that they are the major *raison d'être* of the codex. The matter has long been recognized from the point of view

[1] The main detailed discussions of the miniatures were made by E. de Lorey, E. Schroeder, and I. Stchoukine. A bibliography and latest position of research will be found in I. Stchoukine, " Les Peintures du Shāh-nāmeh Demotte," *Arts Asiatiques*, v (1958).

[2] Among other places see B. Gray, *Persian Painting*, Geneva 1961, pp. 29 ff.

of the stylistic quality of the images and through the possible identification of the manuscript with the otherwise known revolutionary *Shāh-nāma* of Aḥmad Mūsā,[3] but it is further confirmed by a detail of the lay-out of the miniatures within the page. The standard image is a rectangular one set across the whole page and usually with a title woven into the miniature. The exceptions to this rule which had to have been planned when the text was written down can usually be explained through precise iconographic needs. Thus in a number of enthronement scenes [such as nos. 1, 14, 28, 58[4]] the central part of the image has been raised and, in most instances, contains a crenellation; the device is clearly used to emphasize the tripartite composition of the scene and suggests that the subject to be illustrated was planned for in advance. In one instance, no. 40 (Ardashīr and Gulnār), the motif has been used incongruously, but the image itself is a rather original one, whose significance and composition pose problems which need not concern us here. Of greater importance are miniatures which modified the standard format for iconographic reasons rather than simply for emphasis. Thus the staggered format of nos. 46 (Hanging of Mānī) and 38 (Alexander and the Talking Tree) serves to give particular relief to an unusual central feature of the subject matter: the Talking Tree and the tree with the body of the religious reformer. Imbalanced formats in nos. 34 and 35 allowed the artists to make particularly striking the text's indication that Alexander climbed up a mountain in the first case and in the second one travelled with his army through a valley on the side of a dragon-infested mountain " which went up to the stars ". Similarly, the odd structure of no. 9 (Zāl climbing up the wall to Rūdāba's room) gives particular strength to the movement of the image, although it may in part have been repasted at a later time. It may thus be concluded that the Demotte *Shāh-nāma* belongs to a very precise category of manuscripts like the Vienna Genesis, the Sinope or Rossano Gospels, the Utrecht Psalter, or a score of later Persian manuscripts, in which the *choice* of subjects to be illustrated was particularly meaningful and imposed some of its own iconographic necessities on the lay-out of the pages.

As a result it is of some interest to investigate whether any sense can be made out of the subjects which are illustrated. It is true of course that we only have somewhere between one third and one half of the manuscript. Yet enough has been preserved, especially in such more or

[3] E. Schroeder, " Ahmed Musa and Shams al-Dīn ", *Ars Islamica*, vi (1939).

[4] The numbers here and elsewhere in the paper refer to D. Brian, " A reconstruction of the miniature cycle in the Demotte *Shāh-nāma* ", *Ars Islamica*, vi (1939). Although there is little doubt that a number of miniatures in Istanbul originally belonged to this manuscript, we have eliminated them from consideration at this stage.

less uninterrupted sequences as the story of Farīdūn at the beginning and
the stories of Alexander and Ardashīr later on that some conclusions
may be hazarded.

A cursory glance at the list of 58 miniatures from the particular point
of view of their general subject-matter shows that 13 are essentially throne
scenes (14, 15, 45, 28, 1, 11, 12, 17, 44, 52, 54, 55, 57), of which the first
four are simple *topoi* of enthronements, while all the others are transformed
in varying degrees by specific iconographic details imposed by the text.
Then 15 images are battle scenes either involving whole armies (19, 25,
27, 30, 31, 41) or single combats (20, 21, 23) or incidental events closely
related to battles (3, still a rather difficult image to interpret, 6, 13, 16,
4, 42). Hunting images concern only Bahrām Gūr (51, 53) and dragon-
slaying is illustrated for Alexander the Great (33, 34) and also Bahrām
Gūr (49). Five miniatures (7, 8, 22, 24, 39) deal specifically with death
and mourning, while five other images, all of which illustrate the story
of Alexander (29, 32, 35, 36, 38), illustrate the moralizing theme of divine
revelation to which we shall return. The last 15 images are precise
illustrations of specific events in the text and do not lend themselves
to a general classification, even though many among them pose very
interesting iconographic problems.

The fact that 43 miniatures can be defined in general terms, regardless
for the moment of the presence of details which may or may not give them
a more precise literary context, is not in itself surprising, for, like most
epics, the *Shāh-nāma* is repetitive and the succession of princes symbolized
by enthronements or battles of heroes or of armies are constant motifs of
the story itself. Dragon slaying or hunting scenes, although less common,
also clearly belong to an epic cycle. If the preponderance of such images
is not unusual and finds ample confirmation in other illustrated *Shāh-nāmas*,
it is also true that, even though specific events such as the last battle of
Rustam, Alexander's defeat of the Indian army, Bahrām Gūr's hunt with
Āzāda, or the enthronement of Zaḥḥāk possess unique visually identifiable
iconographic features, these images belong as well to well-established
standard iconographic themes found outside of the context of the *Shāh-
nāma* in painting, ceramics, or metalwork; combat, hunting, or princely
activities. It is, at least in part, in their relationship to the standard that
these images of the Demotte manuscript must eventually be explained.
More original, at least within our presently available documentation, is
the existence of identifiable groups of images centring on death and
mourning and concerned with fantastic revelation.

The possible meaning of these miniatures can be made more precise
if we consider in slightly greater detail two cycles of images in their

sequential order, preferably cycles in which we can be fairly well assured that most of the illustrations have remained. For instance the twelve illustrations dealing with Alexander the Great show in that order the following subjects: the enthronement of the king when he became ruler of Iran (28), the trip of the Indian king to a mysterious sage who explains to him the irresistible character of Alexander's conquest (29), the extra-ordinary invention of iron horses to defeat king Fūr (30), the single combat between Alexander and Fūr (31), Alexander's visit to the Brahmans who tell him that his conquests do not affect the only true human reality which is decay and death (32), the slaying of the Ethiopian monster by the king alone (33), the slaying of a mythical beast (34), the visit to the Mountain of the Angel of Death with a message on the arbitrariness of human affairs and endless suffering (35, 36), the building of the wall against Gog and Magog at the end of the world (37), the visit to the Talking Tree with its message of impending death (38), the final victory of death in the celebrated image of Alexander being mourned (39). The simple list of the scenes suggests that the story of Alexander the Great was given in the choice of illustrations a precise moralistic aspect, that of the contrast between the conqueror of the universe who can defeat dragons and reach the outer limits of the world and the mortal man who fails to conquer wisdom by seeing the Brahmans refuse his offer of worldly goods and who is constantly warned of death through various more or less fantastic means.

A second cycle of images illustrates a different point. The five miniatures dealing with Ardashīr show Gulnār, daughter of Ardawān, coming to Ardashīr (40), the battle between Ardawān and Ardashīr (41), the execution of Ardawān (42), the failure of Gulnār's attempt at poisoning the king (43), and finally the revelation to Ardashīr of the existence of his son (44). The choice of illustrations emphasizes here another central idea of Firdawsī's book, the idea of the legitimacy of the Sāsānian dynasty, both in its lineage *par alliance* and in the protection it receives from fate.

These two central ideas, human frailty in the face of death and the legitimacy of Iranian kings, can be shown to exist as well in other groups of images, such as the cycle of the first eight images with the victory of the hero Farīdūn identified through his lineage over the anti-king Ẓaḥḥāk, and then the tragedy of his succession through the death of Īraj (nos. 1–8), or in the Isfandiyār and Rustam cycle (nos. 17–25) as well as in the striking miniature of Dārāb asleep (no. 26) who will mysteriously be identified as the legitimate heir to the Iranian throne.

Thus, in addition to the point that the miniatures were the main object of the manuscript, we may put forward the hypothesis that their

choice was directed, at least in part, by the desire to emphasize a number
of precise philosophical or national ideas ultimately tied both to the
literary themes of the *Shāh-nāma* itself and to a number of traditional
attitudes of the mediaeval Islamic world. But we may be able to make
these hypotheses more precise by analyzing in some detail a few miniatures
which are particularly striking in the illustration of these ideas.

A first instance involves miniatures nos. 41 and 42, the combat of
Ardashīr and Ardawān and the appearance of Ardawān in front of
Ardashīr. The text pertinent to both miniatures is fairly short.[5] The
battle has been raging for forty days.

> " So all the wise one day, when fight was fiercest,
> Asked quarter, and Ardshir charged from the centre;
> Arose a clashing while the arrows showered.
> Amidmost of the mellay Ardawan
> Was ta'en, and for his crown gave up sweet life.
> The hand of one Kharrad seized on his bridle,
> And bare him captive to the atheling.
> Ardshir saw him from far. King Ardawan
> Lit from his steed, his body arrow-pierced,
> His soul all gloom, and Shah Ardshir commanded
> The deathsman: " Go, seize on the great king's foe,
> Cleave him asunder with thy sword, and make
> Our evil-wishers quail."
> So did the deathsman:
> That famous monarch vanished from the world.
> Such is the usage of the ancient sky!
> The lot of Ardawan Ardshir too found;
> Him whom it raiseth to the stars on high
> It giveth likewise to the sorry ground! "

Quite obviously neither miniature follows the text very closely. The
first image (fig. 9) is one of two armoured knights galloping toward each
other in a simple and typical landscape setting and framed by elements of
two armies. A study of this miniature by Mrs. Joanne Travis will be
published in the *Art Quarterly*. It may be identified as an iconographic
cliché of a battle between two heroes in which nothing identifies either one
as the specific personages involved in the story and furthermore nothing is
said in the text about a battle between Ardawān and Ardashīr. The second
image (fig. 10), one of the most magnificent and most studied ones in the
whole book with its triangular composition and its fascinating use of a
repoussoir in front, is equally unrelated to the specifics of the text.

[5] A. G. and E. Warner, *The Shāhnāma of Firdausi*, London 1910, vi, 227–8.

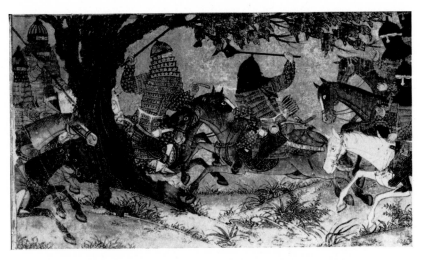

9. Battle between Ardawān and Ardashīr

Institute of Art, Detroit

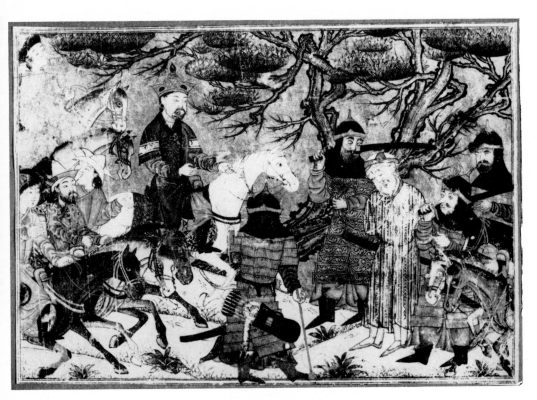

10. Execution of Ardawān

Two explanations may be provided for this anomaly. One is that the illustrations reflect here some more involved cycle of the story of Ardashīr, for instance some mediaeval version of the *Kār-nāmagh-i Ardashīr-i Pāpakān*,[6] in which the battle and subsequent execution of Ardawān would have received peculiarly strong emphasis. But, without necessarily denying this possibility of an influence from an otherwise unknown cycle of images, a second explanation would perhaps elucidate the peculiarities of these two images more adequately. It is that the artist of the Demotte *Shāh-nāma* interpreted and enlarged his images beyond the text in order to emphasize specific concerns of his. If we begin with the image of Ardawān in front of Ardashīr, its most striking iconographic feature is the contrast between the brilliantly impassioned victorious Sāsānian at the head of his troops and the dejected Arsacid prince surrounded by two grotesquely caricaturized soldiers with unusually long swords. The image does not illustrate so much a precise incident as two aspects of the mood of the story: the acceptance of a pre-ordained fate in the passage from one dynasty to the other through mute resignation on one side and noble acceptance on the other, but also the cruelty of fate which compels the execution of a man who was not evil, like Zaḥḥāk in earlier images, but who had fulfilled his destiny. It is this latter feature which transformed the executioners into horrifying instruments of fate rather than of justice, as, for instance, in the illustration of the beheading of the evil Nawdar (no. 13). Death, legitimacy, and fate as they appear in this particular image help also in explaining the one that precedes it. The transformation of a rather prosaic discovery of Ardawān in the midst of his defeated army by an obscure follower of Ardashīr into a heroic but standardized (i.e. without specific iconographic features which would make it clearly this particular battle) scene heightens the drama of the confrontation of kings and makes the following miniature all the more striking.

A second group of closely related images will help in defining even further the *modus operandi* of the artist or artists. It is the peculiar group dealing with death and mourning. The first two miniatures which belong to this group are nos. 7 and 8 illustrating the story as Farīdūn was making preparations to greet his favourite son Īraj.[7]

[6] A. Christensen, *L'Iran sous les Sassanides*, Copenhague 1944, p. 58. The existing version of the *kār-nāma* (tr. D. Sanjana, Bombay, 1896) does not, however, explain our images.

[7] Warner, i, 202–4.

" The eyes of Faridun were on the road,
Both host and crown were longing for the prince;
But when the time arrived for his return
How did the tidings reach his father first?
He had prepared the prince a turquoise throne
And added jewels to his crown. The people
Were all in readiness to welcome him
And called for wine and song and minstrelsy.
They brought out drums and stately elephants,
And put up decorations everywhere
Throughout his province. While the Shah and troop
Were busied thus a cloud of dust appeared,
And from its midst a dromedary ridden
By one in grief who uttered bitter cries;
He bore a golden casket, and therein
The prince's head enwrapped in painted silk.
The good man came with woeful countenance
To Faridun and wailed aloud. They raised
The golden casket's lid (for every one
Believed the words of him who bore it wild)
And taking out the painted silk beheld
Within the severed head of prince Iraj.
Down from his steed fell Faridun, the troops
All rent their clothes, their looks were black, their eyes
Blanched with their horror, for the spectacle
Was other far than that they hoped to see.
 Since in this wise the young king came again
The troops that went to meet him thus returned
Their banners rent, their kettledrums reversed,
The warriors' cheeks like ebony, the tymbals
And faces of the elephants all blackened,
The prince's Arabs splashed with indigo.
Both Shah and warriors fared alike on foot,
Their heads all dust; the paladins in anguish
Bewailed that noble man and tore their arms."

The first image (fig. 11) is once again not a direct illustration of the text in the sense that it does not involve an iconographically clear moment of the time in a precise sequence of events. It shows at the same time the arrival of the messenger with the head of Īraj (in a casket rather than in a box) and the transformation of the joyful crowd of greeters into a mournful assembly; there are no elephants and only the cymbals in the lower left corner refer to a precise term of the story. Yet this miniature is a remarkably meaningful and effective one, because in a series of stunning and highly complicated compositional combinations which do not concern us here, it has managed to identify a central feature of the story, the suddenness of the shift in emotion, and to translate it into visually striking terms by dividing the personages into closely set groups separate from each other like a military parade suddenly gone berserk

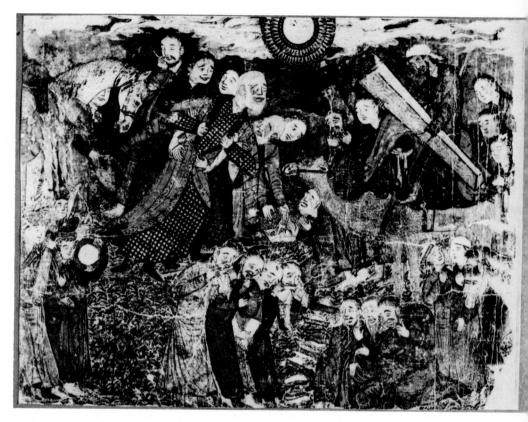

11. The coffin of Īraj brought to Farīdūn

and by emphasizing physical pain through the distortion of facial expressions. The following miniature (fig. 12) is easier to explain iconographically. It depicts Farīdūn holding his son's head and the destruction of the palace's garden, in which at the extreme left there appears a curious frightened cat. The architectural features or the natural elements of this miniature are fairly close to the text, but the image of the three women (one of whom was later interpreted as the mother of Īraj, even though the text does not mention her) and especially the strange personage disappearing through the door on the right give to the miniature a mysterious quietude rather than a sense of violent physical pain.

The following related image, that of the funeral of Isfandiyār (no. 22) (fig. 13), has an amazingly faithful central core with the bier, the mules, the horse, and the Chinese brocade over the bier, but the statement that the accompanying figures had " torn cheeks and hair, purple with blue dresses " is only followed to a degree with respect to the dominant colour

12. Farīdūn holding Īraj's head

effects in this linear image.　Otherwise it has been transformed into a
fascinating dance of death around the bier, which may have to be
connected with specific Mongol funeral practices.[8]　The funeral of Rustam
(no. 24) (fig. 14) is also faithful to the text in the details of the central
subject but the processional cortège was given here a Far Eastern character
which is in no way inspired by the story.　And, finally, the celebrated
and extraordinary image of the bier of Alexander (fig. 15) has been inspired
by the following lines: " the coffin was put in the plain . . . children, men,
and women gathered by the coffin and there were 100,000 of them.　In the
middle was Aristotle . . . he put his hand on the narrow coffin " and
pronounced a speech, followed by sages, noblemen, and finally Alexander's

[8] H. Howorth, *History of the Mongols,* London 1876–88, iv, 485, for a detailed descrip-
tion of royal funerals and mourning.

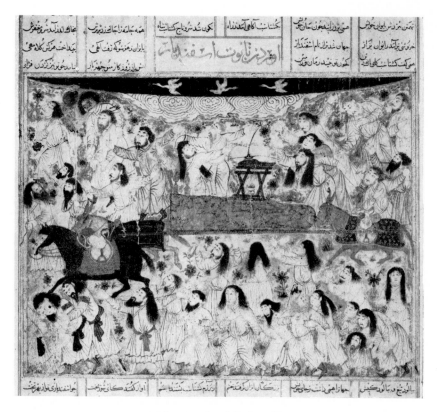

13. Funeral of Isfandiyār

mother.[9] The image was reinterpreted here in a different setting with a unique arrangement of personages and a striking mixture of many different stylistic devices of composition as well as of details of execution,[10] but with particularly clear Mediterranean, almost Giottesque, elements in the composition of three choirs around a bier, and with a more traditional but also definitely western robe on the mother of the hero.

Granted our original point that for some reason the planners of the manuscript wanted to give particular stress to the point of the death of heroes, the explanation for the various ways in which this emphasis was shown can be done in several ways. It may be argued that there were in each instances precise iconographic models available for the stories. We know of the existence of an *Iskandar-nāma*, so far unpublished,[11] which

[9] Warner, vi, 187.

[10] The last analysis of the painting is by B. Gray, *op. cit.*, p. 33.

[11] G. Lazard, *La Langue des plus anciens monuments de la prose persane*, Paris 1963, pp. 126–7.

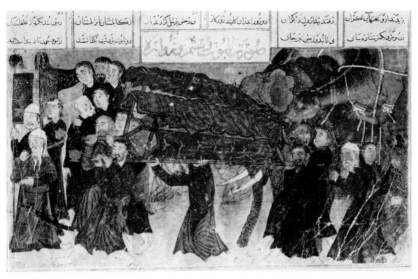

14. Funeral of Rustam

Museum of Fine Arts, Boston

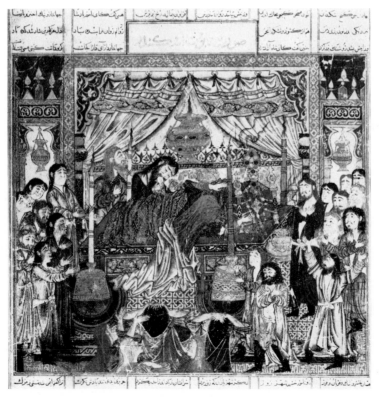

15. The Bier of Alexander

Freer Gallery of Art

may explain the Alexander scene, and it is possible that other epics existed around Isfandiyār, Rustam, or Farīdūn. It may also be thought that several different artists were involved, each of whom contributed his own version of the theme of mourning. But, from the point of view of the manuscript seen as a whole and without denying the possibility of either one of these explanations, it may be suggested that this variety of visual translations of a single theme served primarily to illustrate the specific intent of the manuscript's designer or patron who would have proposed a series of interpretations—emotional, simply illustrative, locally Mongol, Far Eastern, western—for the subject of mourning. This particular group of miniatures may then serve to show the great variety of artistic models and ideas available around Īlkhānid times and perhaps in Tabriz itself, a conclusion which is fully confirmed by the diplomatic and cultural history of the first third of the 14th century.

It remains to be seen whether the peculiar emphasis which were given to the manuscript's choice of illustrations and manner of execution should be considered simply as whims of an unknown patron or whether they may not be related to some characteristic trait of the time. The theme of legitimacy and the peculiar emphasis on mortality which occur in the Alexander cycle are clear reflections of the *Shāh-nāma* itself as Firdawsī had conceived it and interpret conditions around the year 1000, when non-Iranian dynasties were asserting themselves as champions of the Iranian past. But very much of the same situation prevailed in the Īlkhānid period, when world conquerors like Alexander the Great had become Iranian Muslim princes and in their architecture as well as in their mode of life sought to emulate and to outdo their Iranian predecessors.[12] The spectacular revival of the old Persian epic's central theme is thus particularly appropriate to the times and could have been sponsored by a Mongol prince or, as is perhaps more likely, by one of the high Iranian officials who surrounded them. As to the theme of death, it is perhaps more difficult to explain, for in both the *Shāh-nāma* and in the more general *ethos* of mediaeval times in the Near East the frailty of human endeavour in the face of death was a constant literary and philosophical *cliché*. Yet its striking appearance in the Demotte manuscript may be explained by one specific development of Iranian literary taste up to that time. It seems that during the 12th and 13th centuries the popularity of the *Shāh-nāma* itself was to a degree overshadowed by a large number of other epics, like the *Garshāsp-nāma*, the *Burzū-nāma*, the *Kush-nāma*, and

[12] D. Wilber, *The Architecture of Islamic Iran, the Ilkhanid Period*, Princeton 1955, p. 125, among other possible references.

many others which imitated the form of Firdawsī's masterpiece but gave different emphases to their characters and to their long speeches: fantastic prowesses against monstrous animals, mysterious visits to strange places at the confines of the world, discussions with sages, death in human affairs. To a degree, this shift of emphases begun with themes which were actually in the *Shāh-nāma*, but the overworking of a choice of motifs at the expense of the grandiose fresco drawn by Firdawsī served to illustrate a new taste, perhaps the taste of townsmen as opposed to that of an aristocracy.[13] At any event, it may be suggested that in the instance of the Demotte manuscript it is this taste of the preceding two centuries developed in other epics than the *Shāh-nāma* which inspired the illustration of the original model of all later poems.

These hypotheses about the manuscript are but one aspect of a more general problem which has always been brought up in discussions but never solved: the problem of the artistic background of the masterpiece. Most discussions so far have centred on stylistic criteria and puite consistently both contemporary relationships and possible older models have been brought into the pool of possible sources. Our own discussion of iconographic themes and of the taste implied in the images also led at the same time to contemporary and to older attitudes and practices. Thus, as a second aspect of this paper, I should like to comment briefly on one of the older strains which should be considered in attempting to understand the manuscript. It consists of the fresco paintings of the 8th century from Panjikent and of Soghdian art in general.[14] Although some controversy exists around the exact meaning of these paintings, it is generally agreed that many scenes illustrate subjects taken from the Iranian epics—such as the Siyāvush story—which were later codified by Firdawsī.[15] Also M. M. Diakonov, A. M. Belenitski, N. V. Diakonova, and O. N. Smirnova have at various occasions brought up the fact that some relation may be established between these frescoes and later miniature painting, while

[13] The preceding is based on J. Rypka, *Iranische Literaturgeschichte*, Leipzig 1959, esp. pp. 144–5, 152 ff., 165, and on articles by M. Molé, " Garshāsp et les Sagsār ", *La Nouvelle Clio*, iii (1951), " Un poème persan ", *ibid.*, iv (1952), with further references.

[14] Main publications are *Zhivopis Drevnevo Piandjikenta*, Moscow 1954, and *Skulptura i Zhivopis Drevnevo Piandjikenta*, Moscow 1959. Although important for Soghdian art, the paintings from Varahsha and Balalykh tepe are of lesser significance for our precise purposes here.

[15] In addition to the commentaries in the two works cited in the preceding note, see N. V. Diakonova and O. I. Smirnova, " K voprosu ob istolkovanii pendzhikentskoy rospisi ", *Sbornik v chest I. A. Orbeli*, Moscow 1960, and M. M. Diakonov, " Obraz Siiavusha ", *Krat. Soob. Inst. Ist. Mat. Kult., L* (1951), pp. 34–44.

conversely many a scholar dealing with 14th-century miniatures has thought of mural paintings as models for certain features of book illustrations.[16]

The problems are, in the latter instance, to discover or at least reconstruct the original mural paintings and, in the former instance, to explain how themes known in the 8th century survived until the 14th. The first problem is hampered by an almost total lack of appropriate remains and the few known texts referring to such paintings are usually quite brief and tantalizingly uninformative,[17] although it is conceivable that further work—especially systematic analyses of literary texts—could bring some interesting results. The second problem lends itself somewhat better to a more precise definition. It seems clear that certain compositions of the Panjikent frescoes—such as the triangular composition for battles between armies[18]—or such features as the contrast between a " pathetic " and an " elegant " figure style[19] find striking parallels in some of the pages of the Demotte manuscript.[20] Yet one may wonder how a Soghdian tradition depicting Iranian heroic themes would have been revived in the 14th century or where it continued in the intervening centuries. From a stylistic point of view Diakonov has already pointed out the close parallels to Panjikent found in the frescoes of the Tarim basin as late as in the 9th and perhaps 10th centuries. There, largely thanks to their considerable mercantile activities, Soghdians maintained themselves after the Islamization of Central Asia and appear to have participated in the cultural transformation of Turks and Mongols. As late as in the 13th century a Persian source relates that the Turks learned both the Soghdian and the Uighur alphabets.[21] It may be suggested then that to the new coming Mongols Soghdians or people influenced by them gave their first taste of the culture which will be theirs in Iran and that the ancient themes of the epics and especially certain modes of expression found in manuscripts like the Demotte *Shāh-nāma* were brought *back*

[16] B. Gray, *op. cit.*, p. 59.

[17] I hope to complete soon a list of such known texts; preliminary lists are found in Diakonov's article in the first of the two publications quoted in note 15.

[18] *Zhivopis*, pl. XXV.

[19] *Ibid.*, pls. XXII and XXXIII, for instance.

[20] In the Demotte manuscript the matter is somewhat confused by the question of retouches but the existence of a contrast seems assured if we compare some of the " pathetic " scenes we have examined with some of the ones at the beginning of the manuscript (nos. 2–4).

[21] E. D. Ross and R. Gauthiot, " L'Alphabet Soghdien d'après un témoignage du XIIIème siècle ", *Journal Asiatique*, 1913, pp. 521 ff.

by the Mongols rather than merely found by them in Iran itself and then transformed under their direct or indirect sponsorship.

The question whether to interpret the Demotte *Shāh-nāma*'s iconographic characteristics as a revival inspired from the outside or as the continuation in new forms of an art which was already flourishing in Iran itself cannot as yet be answered. But the problems may be posed and further iconographic studies either in pre-Mongol art or in the *Shāh-nāma* itself may eventually provide us with enough information about the ideas expressed in its miniatures so as to permit a more precise identification of the men who made it and a better appreciation of its striking aesthetic qualities.

THE TOPKAPU SARAY MANUSCRIPT
OF THE PERSIAN KALĪLA WA-DIMNA

(*dated* A.D. 1413)

by

Sofie Walzer

The Topkapu Saray Library in Istanbul possesses a manuscript of the Persian translation of *Kalīla wa-Dimna*, dated 816/1413 (from the Revan collection no. 1023). In this article I hope to show that the manuscript was produced in Shiraz and is related to the Muẓaffarid school of the preceding decades and is, on the other hand, a precursor of manuscripts made in Shiraz, such as the famous *Shāh-nāma* in the Bodleian Library (MS. Ouseley Add. 176), copied for Ibrāhīm Sulṭān ibn Shāh Rukh.

Shiraz itself was a creation of the Ṣaffārid (867/900) and Buwayhid (933/1056) dynasties and under the Mongols was a prosperous city with a great cultural tradition. It was the home of the poet Saʿdī who died there in 1294 and of Ḥāfiẓ who survived the conquest of the city by Tīmūr and died in 1398. It suffered many violent political changes during the 14th and 15th centuries.

The House of Injū was descended from the last governor of the Īlkhāns, and achieved independence on the death of Abū Saʿīd in 1338. From then until 1353 they ruled Fārs, when they were ousted by the house of Muẓaffar who had already become the ruler of Yazd. They held sway over all South West Persia until they were finally extirpated by Tīmūr in 1393. The manuscript miniatures produced in Shiraz in the Muẓaffarid period are characterized by a certain gaucherie which is even a feature of those produced in the period of their Tīmūrid successors, such as Baisunghur's Anthology of 1420 (Berlin) and the Bodleian *Shāh-nāma* copied for Ibrāhīm Sulṭān. The superb manuscripts made for Iskandar[1] in the first decade of the century do not seem to me to belong

[1] Iskandar ibn ʿUmar Shaykh was a great patron of the arts. Among the manuscripts made for Iskandar is an anthology of poetry and prose copied in 1410/11. Its miniatures

to this tradition of Shiraz manuscripts. There is therefore nothing to represent the development of Shirazi painting between the Muẓaffarids and the governorship of Ibrāhīm Sulṭān. I suggest that our manuscript may in part fill this long gap of time.

The book of *Kalīla wa-Dimna* takes its title from the two main characters, two jackals. This book was the Arabic version of a much older Indian collection of animal stories. The translator Ibn al-Muqaffa' (died A.D. 757) did not work directly from the Sanscrit original but from an intermediate 6th-century Persian version. In the foreword the translator states that he introduced animals to attract the interest not only of young people and common folk but more specifically of kings, since the Indian book of fables had been a mirror of princes. Illustrations in various colours, he says, had been used to increase the pleasure of the reader and to make the moral of the book more effective. He also expressed the hope that because of the illustrations the book may be in constant demand and repeatedly copied. It is to be assumed that many of the early copies were provided with illustrations, although no early manuscripts—illustrated or otherwise—have come down to us. Our most ancient illustrated Arabic *Kalīla wa-Dimna* manuscript was probably copied in Syria about A.D. 1200–1220 (Bibliothèque Nationale, arabe 3465). According to Firdawsī, Ibn al-Muqaffa''s book was translated into Persian under the Sāmānid Naṣr b. Aḥmad (914–43). It appears that the translation was never completed. By order of the same ruler the poet Rūdhakī put the book into Persian verse of which however only sixteen verses have survived. Ibn al-Muqaffa''s work was translated into Persian prose probably after the year 1144 by Niẓām al-Dīn Abu'l-Ma'ālī Naṣr Allāh b. Muḥammed b. 'Abd al-Ḥamīd, whose translation was very widely used; it is also the translation used in the present manuscript. Naṣr Allāh in his preface announces his intention to include illustrations in the work.

Our manuscript has 209 folios and 19 miniatures. It is written in

are a worthy prelude to Tīmūrid painting, having a harmoniously balanced composition, a satisfactory relationship between the protagonists and their setting and meticulous attention to detail. Although they are executed in Shiraz, they do not reflect the style of painting current in that city on the eve of the Tīmūrid invasion, but are rather connected with the style of painting which has developed at the Jalā'irid court in Baghdad towards the close of the preceding century. (For illustrations cf. R. Pinder-Wilson, *Persian Painting in the 15th century*, Faber Gallery of Art, Plates 1 and 2; also Jean Aubin, " Le Mécénat Timouride à Chiraz ", *Studia Islamica*, 1957, pp. 73 ff.

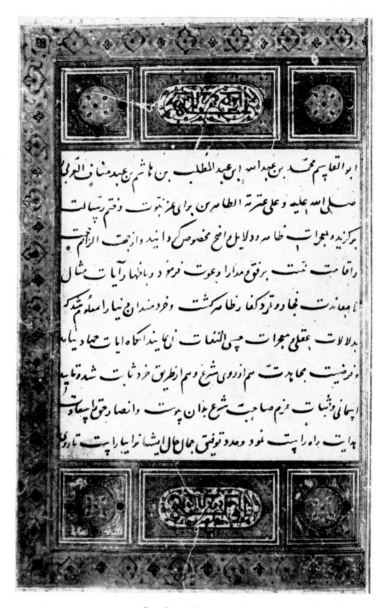

16. Opening page

ta'līq script and the page measures 7⅝ by 4⅞ ins. and the text area 5¼ by 3 ins. On folio 208 v. is the colophon which gives the name of the scribe and the date; it reads as follows:

[فرغ] يوسف المشهور باميرى من كتابه (كتابته or) وقت الضحوة
يوم الخميس الثانى من ربيع الاول سنه ست وعشرين وثما نمائة

It is now appropriate to give the contents of the miniatures represented in our manuscript and then to provide, as far as possible, a stylistic analysis.

Fig. 16: Folios 1–2 are the opening pages with illuminated framing bands.

The first story of the book, the long story about the Lion and the Ox and the intrigues of the jackal Dimna (who did not heed the advice of his friend Kalīla) which led to the death of the Ox by the hand of the Lion, but also to the ultimate fall of Dimna, is illustrated by nine pictures (figs. 17–25).

Fig. 17: Folio 33 v.[2] The two jackals Kalīla and Dimna come to the lion. Very typical of the miniatures of our manuscript is the high horizon, which offers a marked difference to the manuscripts both of the Mesopotamian and of the Injū schools where the figures are placed in a single plane in the foreground. The ground on the horizon is craggy, although this is not as pronounced as in later Tīmūrid manuscripts; it already appears in the Anthology of Iskandar Sulṭān in the Gulbenkian Foundation, Lisbon, made in Shiraz, in 1410 (for an illustration cf. e.g. Basil Gray, *Persian Painting*, p. 76). The ground is strewn with tufts of flowers which suggest bouquets of flowers placed on the ground rather than natural growth. On top of this the ground is ornamented with little scallops not unlike those used to indicate water. The ground on which the lion sits is slightly elevated. The sky is filled with blossoming trees which are reminiscent of Chinese drawings. The drawing of the animals reminds one slightly of the Mesopotamian or Mamlūk schools. The tail of the lion slightly overlaps the double border with which all the miniatures are provided. The mane of the lion is given in the form of a comb or a brush. It should be noted that all the miniatures have the oblong format in which the width is greater than the height. Most of the miniatures are placed on the lower part of the page.

Fig. 18: Folio 34 v.[3] The carpenter and the monkey, who tries to interfere with his master's work and is caught in the wood and mercilessly

[2] In the edition of Naṣr Allāh's Persian version of the text published in Teheran A.H 1368 by 'Abd al-'Aẓīm Qarīb the text corresponding to this page of the MS. is on p. 55, cf. also the Fables of Bidpai translated by Knatchbull, Oxford 1819, p. 88.

[3] Persian edition p. 56; Knatchbull p. 89.

يا حين اورسك اورضوان اكست نيت كرنده ودرنظاره اوراسمان قم

بهرسوكى اب دلاح دكلاب	شاورشش ماغ سروى اب
جورنكى ببسه روحشن كند	جو هندوك ايله روشن كند
واشعار درشرو ثنهى كاهشت	به زينت في نشوة خمرات

شنروان ابا مبهندبد وملازم كرفت جكنه اندراشال اذا ايشت
نائزل دكنه اند واذا انهبت الى البلاد مه في مداك فلا جاوز
جون سكمهندى انجا بود د قوت كرفت وفره دابادان شد بطراباتش
ونفت بدوراه بافت دبنشاطى همجه تماشه باكى كلكرد ودران جوالى فلزا
شبى بود وبا او سباع ودوحشش بسباد همه درتبا بعت فرمان او
واوجون عنابى ومستبدى درميان ايشان ودهركرا كا وندبد هبود وا واراد
شنبث جبابكت باكل شنزه به كموشش كى آمد مه سى بدوراه بافت وخرات

17. Kalīla and Dimna come to the Lion

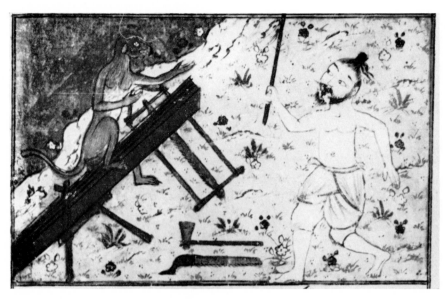

18. The Carpenter and the Monkey

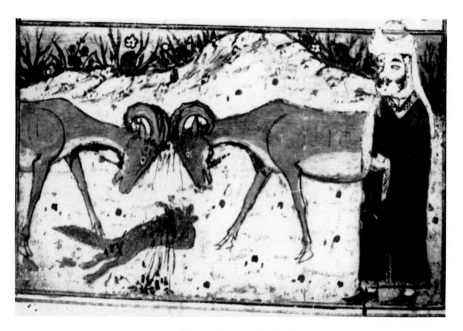

19. Two Rams fighting

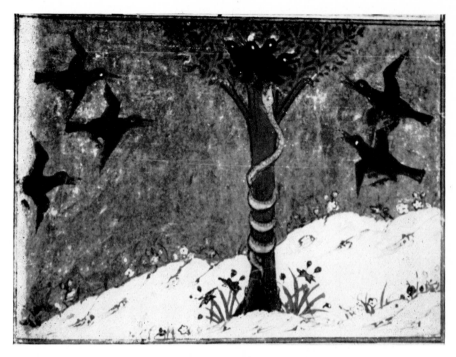

20. A Snake attacks the Crows

21. A Goose mistakes the Reflection of the Stars for Fish

hit by the carpenter. The landscape-details resemble those of the first miniature. The drawing of the monkey is very naturalistic. The raised stick of the carpenter again cuts into the border. The man is short and stocky, with wide-set eyes and a beard. His physiognomy is rather Mongolian. He wears short trousers and a sort of tunic.

Fig. 19: Folio 41 r.[4] Two rams fighting while a fox licks their blood. A man looks on at the scene. The sky is blue and on the horizon are flowers. This is a subject very often represented in *Kalīla wa-Dimna* manuscripts. The ground is again covered with the scallop pattern. Typical of our manuscript is the way in which both animals are cut into half, one by the border, the other by the man. The man has a long gown or mantle with lighter borders and a round turban with the *kulla* inside and a piece hanging down from it, all typical of the figures in this manuscript. In his hand he holds a staff.

Fig. 20: Folio 44 v.[5] A snake attacks the crows. A snake is coiled around a tree trunk attacking crows. The horizon here is low. The sky is gold with flowers on the horizon. Near the trunk of the tree are flowers which here have a more naturalistic aspect than the flower tufts of the other miniatures. The tree has a shape typical of the trees occurring in our manuscript. The trunk is completely bare, then comes the foliage which has a rather handsome pattern, rather like a lot of palmettes put together. Typical again, how the foliage of the tree is cut off by the border, leaving only one third visible. The birds which are finely drawn in a naturalistic way, occur several times in our manuscript.

Fig. 21: Folio 54 v.[6] A goose seeing the reflection of the stars in the water thinks they are fish but cannot catch them, and then, when there are in fact fish, he thinks they are stars. The water is rendered in blue: moon and fishes in gold. Against the blue sky to the right and left are blossoms. At the edge of the pool are blossoms and rocks behind them. The water is depicted by a slight whirly pattern. The miniature in this case is put in the middle of the page. The drawing of the goose is good and naturalistic and so are the fishes; the composition is very well balanced, and the whole has a dreamlike atmosphere.

Fig. 22: Folio 57 r[7] represents the lion and the elephant fighting. The elephant stands quite still, while the lion bites him furiously; his action is represented in a very lively way; it almost looks as if, in his great

[4] P. 67 of the edition; Knatchbull, p. 104.
[5] P. 73 of the edition; Knatchbull, p. 113.
[6] P. 89 of the edition; Knatchbull, p. 133.
[7] P. 93 of the edition; Knatchbull, p. 139.

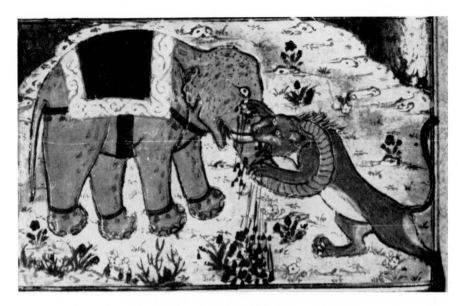

22. The Lion and the Elephant fighting

23. Two Geese carry the Tortoise

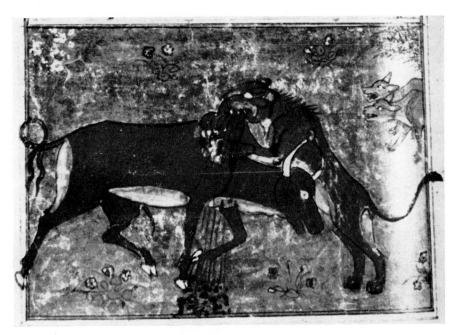

24. The Lion and the Bull fighting

effort, the end of his leg and tail have moved out of the picture. The horizon fills the whole picture.

Fig. 23: Folio 60 r[8] represents the two geese which carry the tortoise on condition that she refrains from talking, but she forgets all about it, and, opening her mouth to speak, falls to her death. In representations of the subject in other manuscripts people are watching the drama. It is characteristic of our manuscript, that the representation is reduced to essentials only. The geese are quite naturalistic, while the tortoise has a regular pattern like that of the tortoise in a Mamlūk manuscript.

Fig. 24: Folio 61r.[9] The lion and the bull fighting. This miniature has no sky at all, but the ground is gold with groups of flowers. Almost the entire miniature-space is taken up by the bull and the lion, while at the side the two jackals watch the fight with eager eyes. The drawing of the animals is very lively, the tail of the lion and the foot of the bull again come slightly out of the picture. Of the two jackals we see only about one third of the body, the rest is cut off by the margin.

[8] P. 98 of the edition; Knatchbull, p. 146.
[9] P. 100 of the edition; Knatchbull, p. 149.

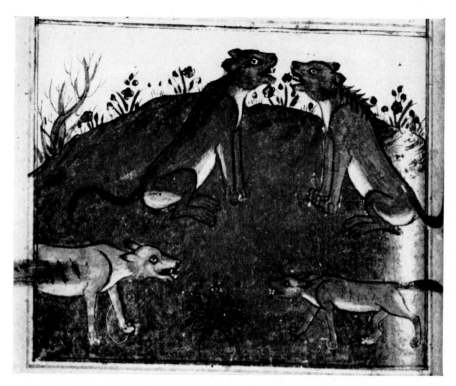

25. The Lion talks to his Mother

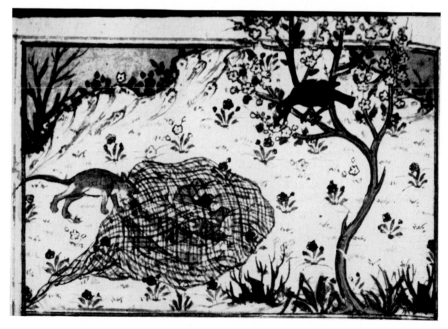

26. The Doves freed from the Net by a Rat

Fig. 25: Folio 74 r.[10] This miniature does not belong to this story, but to the eighth story (the Lion and the Jackal), and was inserted here by a binder's error. It shows the lion talking to his mother with two jackals looking on. The ground is golden, the sky blue with flowers on the horizon. The tails of the animals on the right come out of the picture. The two lions sit so high that their heads are shown against the sky. The decoration of the ground is very nearly reduced to one flower-tuft between the two jackals.

The next two miniatures belong to the second story of the book, that of the ring dove.

Fig. 26: Folio 81r[11] represents the doves who are caught in a net and are freed by a rat, while a raven is watching from a tree. The miniature is set in the highest part of the page with the tree overlapping the border. Only on the left-hand side of the miniature is there a little bit of sky against which a bare tree is growing and a very few flowers and leaves. The little flowers on the ground, although disposed very regularly, are in themselves here more naturalistic than in some other miniatures. The tree is again reminiscent of cherry blossom seen in Chinese paintings. The raven is always a stork type with a long tail and long slim legs. The whole scene again tells very lively and excellently the story under consideration. At the bottom of the tree are a few plants, also these very natural.

Fig. 27: Folio 86r.[12] A hunter kills a pig which wounds him with its horn. A wolf comes to eat the bow of the hunter. The bow, however, flies back and kills him. Only on the left-hand side is there a little bit of sky against which one of the usual cherry blossom trees grows. The horizon is formed of a flower border, similar to those depicted in other miniatures. The hunter wears a round cap (a feature which we will find later on again on figures of the *Shāh-nāma* manuscript made for Sulṭān Ibrāhīm and now in the Bodleian Library). The hunter is lying on the ground with his weapons by his side. Behind him the dead boar lies bleeding and on his left the wolf, again cut into half by the border. On the ground another species of small flowers will be noted.

The third story, that of the Owls and the Crows, is also illustrated by two pictures.

[10] P. 244 of the edition; Knatchbull, p. 308.
[11] P. 139 of the edition; Knatchbull, p. 195.
[12] P. 147 of the edition; Knatchbull, p. 203.

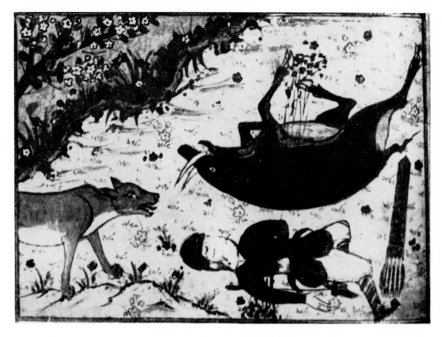

27. The Hunter, the Pig and the Wolf

28. The Elephant and the Hare

29. The Hare consults the Cat

Fig. 28: Folio 102 v.[13] This illustrates the charming scene in which the elephant is taken to a well by a hare, where he sees the reflection of the moon. Only the right and left corners show a little bit of sky. In the foreground is the well depicted by a wavy pattern; the elephant, here and throughout this manuscript, is fully caparisoned with an ornamental girth, a halter with little bells on it and a beautiful saddle cloth. The well is bordered with flowers. The legs of the hare again extend beyond the framing band of the picture. The story is eloquently depicted. This small miniature is again set at the top of the page.

Fig. 29: Folio 104 r.[14] This depicts a hare consulting a cat, while a nightingale is clawed by the cat. The miniature is curiously devoid of detail. Both the hare and the cat are in an erect position, a characteristic attitude of our manuscript. The horizon is high, with only a small area of sky in the top left corner; the ground is strewn with stones and tiny tufts of grass and three large flowering plants and flowers on a tree on the horizon; as in the first miniature trees, flowers and leaves are outlined against the horizon.

[13] P. 174 of the edition; Knatchbull, p. 225.
[14] P. 176 of the edition; Knatchbull, p. 229.

30. The Monkey rides on the Tortoise

The following miniature illustrates the fourth story, that of the Monkey and the Tortoise.

Fig. 30: Folio 121 v.[15] The monkey riding on the tortoise. This is a charming story in which a monkey is nearly trapped into being killed by a tortoise. The story lends itself so much to illustration that it occurs in nearly all *Kalīla wa-Dimna* manuscripts, both Persian and Arabic. Again, as compared to other representations of the same subject, the details are here reduced to the absolute minimum; the two actors, the monkey and the tortoise in the middle of the water, bordered by a few flowers and rendered by a scallop pattern. The old monkey is again in a very upright posture and almost conceals the tortoise.

The seventh story, The King and the Bird, is illustrated by two miniatures.

Fig. 31: Folio 127 r.[16] The King's son killing the young of the bird. Three figures fill very nearly the whole picture which has no horizon. The pattern on the ground seems to suggest tiny hillocks on which a little grass is growing. The three figures are quite symmetrically arranged.

[15] P. 203 of the edition; Knatchbull, p. 260.
[16] P. 222 of the edition; Knatchbull, p. 287.

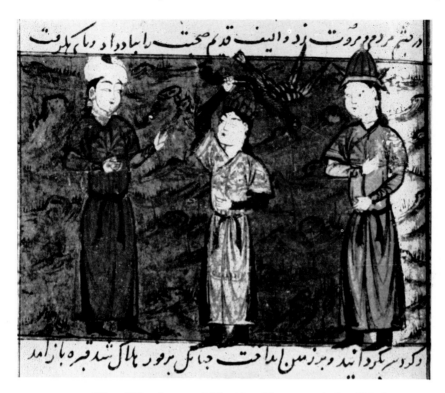

31. The King's son kills the Young of the Bird

Again they all wear the long belted garment, the figure on the left wears the small turban which we have already noticed, while the king's son wears a crown and the figure on the right wears a hat of decidedly Mongolian type. The prince holds the bird by his legs above his head and is about to dash it to the ground. The figures have pointed shoes and wear an undergarment which is apparent from the sleeves which protrude from the upper garment.

Fig. 32: Folio 140 r.[17] This shows a woman lying on a bed, another woman standing at her head and a black cow with a bucket over its head at her feet. It illustrates the story of the old woman whose daughter falls ill, and who prays that her own life might be taken in return of her daughter's. One day, when she was absent, a cow strayed into her house and put her head into a cauldron without being able to withdraw it. The woman returned and thought it was the angel of death, who had

[17] Pp. 224–5 of the edition. The scene occurs in verses by Sanā'ī, which were interpolated here by the Persian translator.

32. The sick Daughter and the Cow with the Cauldron

33. The Four Jackals

34. The Crow learns to walk like a Partridge

come for the soul of her daughter; she calls out in terror, that he might take her daughter's soul and not her own. The drawing of the bed is rather clumsy; half of the cow is cut off by the margin again, the background with a little flowery pattern is perhaps intended to indicate the area outside the house. The old woman also wears a long garment which covers her completely.

The following miniature illustrates the eighth story, that of the Lion and the Jackal. I have pointed out that Fig. 25 also belongs to this story and should have come here.

Fig. 33: Folio 147.[18] This is a very simple miniature. Four jackals, three of them in identical postures stand in a field, where there are tiny flowers and blades of grass.

The story of the Monk and his Guest (eleventh in the book) is also illustrated by a single picture.

Fig. 34: Folio 166 r.[19] The crow which wants to learn to walk like a partridge. To the right and left are beautifully drawn fernlike plants outlined against the sky, of which rather more is shown here than in the

[18] P. **237** of the edition; Knatchbull, p. **299**.
[19] P. **260** of the edition; Knatchbull, p. **345**.

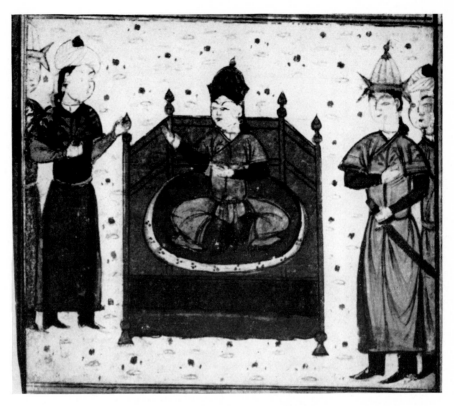

35. The King's son enthroned

other miniatures. The field is bordered in the background by a small version of the Tīmūrid craggy rocks. On the field are the usual flower-bouquets. The two animals are beautifully drawn and illustrate the story with great naturalness and sense of humour.

Fig. 35: Folio 204 v.[20] It illustrates the story of the son of a king who comes with his friends to a city and is there made king himself. In the middle is the throne set on the ground which is depicted with grass and flower patterns similar to those in the other miniatures. The king sits on the throne in the well-known posture with both legs in a horizontal position. To his right and left two figures are standing, the outer figures show very little, they are nearly completely cut off by the side of the page. The shape of the throne, the crown and the headgear of two of the men remind one strongly of the miniatures in the *Jāmiʿ al-Tawārīkh* of Rashīd al-Dīn (cf. Binyon-Wilkinson-Gray, *Persian Painting*, pl. XXb).

─────────

[20] P. 304 of the edition; Knatchbull, p. 367.

Having examined the manuscript in detail we may now compare it with its associated manuscripts, i.e. those from Shiraz. As mentioned above the Muẓaffarids ruled in Shiraz from 1353 to 1393; they, in turn, had taken over from the Injū dynasty, who had become independent of the Īlkhāns in Shiraz and Isfahan under Maḥmūd Shāh in about 1325. In the Injū miniatures we find Far Eastern elements introduced into an essentially Iranian style. But they also contain faint echoes of the Baghdad style, which was still practised in a rather sterile form under the Mamlūks of Syria and Egypt, for we find in many Injū miniatures a band of conventional vegetation running across the foreground of a miniature or bordering a stream or pool. The treatment of water also recalls miniatures of *Kalīla wa-Dimna* from the Mamlūk period. As pointed out, by both Barrett and Stchoukine, the style was essentially provincial. It seems to have vanished without a trace on the extinction of the Injū family by the Muẓaffarids in 1356.

Typical of the Muẓaffarid style are the squat figures with overlarge heads. On the whole it is an autochtonous style but it also contains Mongolian elements, especially the form of hats. The manuscripts lack the finesse of the great masterpieces of Tabriz and Baghdad. The drawing is naive and the palette simple and crude. These miniatures seem to be the work of a provincial school.

Of these Muẓaffarid manuscripts three are especially well known. The first is the *Shāh-nāma* copied in 772/1370–71 in Shiraz by Maḥmūd ibn Manṣūr ibn Aḥmad, and preserved in the Topkapu Saray Library in Istanbul. It contains 12 miniatures. The naturalistic way of landscape rendering of the first half of the century has been completely superseded by a conceptual approach. A few naturalistic trees make an incongruous appearance among the formal tufts and stumps. Introduced as stage properties, such details are treated as symbols rather than natural features. An army is suggested by three soldiers etc. For examples see Basil Gray, *Persian Painting*, p. 63.

Next I would like to discuss the *Shāh-nāma* in the Egyptian Library in Cairo, copied in 796/1393–94 in Shiraz by Luṭf Allāh ibn Yaḥyā ibn Muḥammad, which contains 67 miniatures. According to Stchoukine (*Les peintures des manuscrits tīmūrides*) the miniatures belong perhaps to two different artists. Those by one of the artists recall, by their horsemen mounted on little steppe horses and by their landscape, the *Shāh-nāma* achieved in Shiraz in 1370–71 (cf. Binyon-Wilkinson-Gray, *Persian Painting*, pls. XXLX–XXX). The other miniatures have a particular character; Binyon-Wilkinson-Gray find similarities to the *'Ajā'ib al-Makhlūqāt* of 1388.

36. The Jackal talking to the Lion
Bibl. Nat. 377

Of special interest for us, because the work is the same as our MS.,
is a manuscript of the Persian version of *Kalīla wa-Dimna* (Paris, Biblio-
thèque Nationale, fond persan 377), without indication of scribe or date.
It contains a frontispiece on two pages and 29 miniatures. The date of
the manuscript has been much discussed. Binyon-Wilkinson-Gray base
themselves on the similarity with the *Shāh-nāma* executed in Shiraz in
1393 and conclude that the manuscript must be roughly the same period
and from the same artistic centre. There are in fact many similarities in
the two volumes, so that their conclusion is acceptable and the execution
of the manuscript can be given with great probability to Shiraz about
1390, an epoch of intense artistic production under the auspices of the
last Muẓaffarids. The manuscript is of great beauty and this induces

Barrett (*Persian Painting of the 14th century*, p. 22) to opt for a Jalā'irid provenience for this book (and also for an anthology in Istanbul dated 1398–99), since according to his argument, the other work of the Muẓaffarid artists does not rise beyond mediocrity. It seems, however, to the present writer that the similarities with the *Shāh-nāma* of 1393–4 are so striking that a Shirazi provenience seems more likely. Also, if we want to compare this Paris *Kalīla wa-Dimna* to our manuscript, the high quality

37. The Tortoise and the Monkey
Bibl. Nat. 377

of this manuscript has to be taken into account. Very typical for these Shirazi manuscripts are the strangely bare trees, the squat figures, the large turbans. The ground is patterned with blades of grass and in certain places, preferably in the fore- and background, with large flowers, though not the flower-bouquets or tufts of our manuscript. The people, again, wear long tunics. The miniatures occupy only about one third of the page and are mostly of horizontal format. The number of figures on one page does not exceed two. In the miniature depicting the jackal talking to the lion, the ground and the tall tree extend far beyond the written page (fig. 36). In the story of the tortoise and the monkey, the middle part which contains the tree with the monkey, is " stepped up " (fig. 37). The tree depicted with many leaves is rather naturalistic and by separating the monkey from the tortoise the picture becomes more

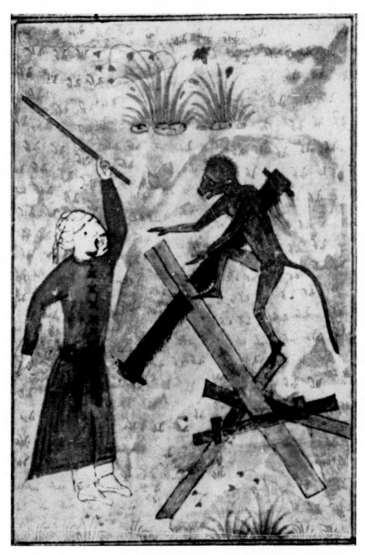

38. The Carpenter and the Monkey
Bibl. Nat. 377

lively than in our manuscript. In both manuscripts the story of the
carpenter and the monkey is depicted (fig. 38). In both mss. the monkey,
a very slim figure with his forearm raised and his mouth open, as if
imploring the carpenter not to hit him, is similar. In the Muẓaffarid
manuscript we have, however, a miniature of vertical format and one
which occupies much more space, the carpenter has in the Muẓaffarid

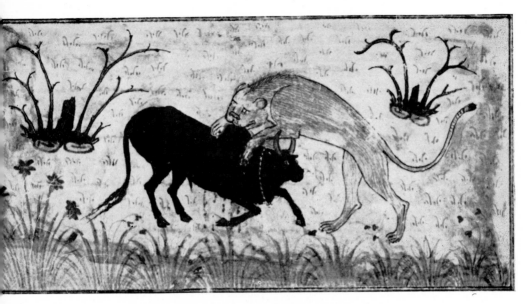

39. The Lion and the Bull fighting
Bibl. Nat. 377

manuscript a long mantle laced up in front, the usual garment depicted in this manuscript. In the fight between the lion and the bull which also occurs in both manuscripts, the attitude of both animals is also very similar; in the Muẓaffarid manuscript the head of the lion is rather roundish and the ground has again the typically small pattern and only flowers in the foreground between the typically bare trees (fig. 39). Also the scene where the rat frees the doves from their net occurs in both manuscripts (fig. 40). In the Muẓaffarid manuscript the raven on the tree is missing. In both cases the format is horizontal. The rat is in exactly the same position, even an identical part of its tail comes out of the picture; the representation of the pigeons in the net is much clearer in the Muẓaffarid manuscript. It is not possible here to compare other miniatures of the two manuscripts, but it seems to me that there is certainly a similarity in style in the way in which the miniature is put on the page, the reduction of the narrative to a very few essential figures, the treatment of the ground and the flowers and trees, although they in themselves are not so very similar. Strikingly lacking, however, in the Muẓaffarid manuscript is the high horizon.

The question is, where this style originated. Barrett in his *Persian Painting of the 14th century* has urged that it originated at Baghdad to which he assigns the Paris *Kalīla wa-Dimna* (Paris 377), and that the two

40. The Doves freed from the Net by a Rat
Bibl. Nat. 377

Shāh-nāmas are provincial imitations of it. But the Muẓaffarids in Shiraz and the Jalā'irids in Baghdad employed artists trained in the Mongol school, and there was hardly a great difference between the styles of Baghdad and Shiraz in the late 14th century. There are four important Baghdadi manuscripts of this period. (1) a manuscript of the *'Ajā'ib al-Makhlūqāt* of Qazwīnī, copied by Aḥmad of Herat 790/1388 (Paris, Bibliothèque Nationale, Sup. Pers. 332), containing 95 miniatures, of which only a few, however, are contemporary. (For illustration cf. Stchoukine, *Les peintures des manuscrits tīmūrides*, pl. I.) (2) Khwājū Kirmānī: Three *Mathnawīs* (London B.M. Add. 18113) with 9 miniatures by Junaid Naqqāsh (pupil of Shams ad-Dīn who was a pupil of Aḥmad Mūsā), copied by Mīr 'Alī al-Tabrīzī at Baghdad 798/1396 (for illustrations cf. Stchoukine op. cit. pls. IV–VIII). (3) the *Dīwan* of Sultan Aḥmad Jalā'ir, dated 805/1402 (Washington Freer Gallery of Art). It contains eight pages of lightly tinted marginal drawings. (4) a manuscript of the *Kalīla wa-Dimna* (Paris Bibliothèque Nationale Sup. Pers. 913) which contains 74 miniatures. The copyist is Ḥāfiẓ Ibrāhīm, its date: 794/1392; it has an ex-libris of Shāh Walad (A.H. 813–14), son of Aḥmad Jalā'ir.

It is fortunate that we have here a manuscript which deals with the same subject, and it seems to me that one can also detect quite striking similarities between the miniatures of both. The miniatures usually do not occupy more than one third of the page and are framed by a border. The number of figures represented is very limited. The ground is covered

by a small pattern, and on top of it there are the small flower-tufts which
we have found so typical of our manuscript. Usually we find the high
horizon. The trees are represented by a long bare trunk surmounted by
a dense mass of foliage in which there is no space between the leaves. In
the miniature depicting the two lions conversing, the animals are given
the same upright posture which we find in our manuscript (fig. 41). Where
the lion and the jackal appear, both animals have an unusually long tail;
the lion has the rather small, thin head in both manuscripts, which gives
him the appearance of a fox in contrast to the other Paris *Kalīla wa-Dimna*
(377), where the lion has a much rounder and more natural head (fig. 42).
The monkey riding on the tortoise (fig. 43) is reduced in very much the
same way, riding in an upright posture and almost completely covering
the tortoise, which makes it difficult to see exactly, what is going on. The
men have the same relatively small, round turban and a long belted

41. The Lion talking to his Mother
Bibl. Nat. 913

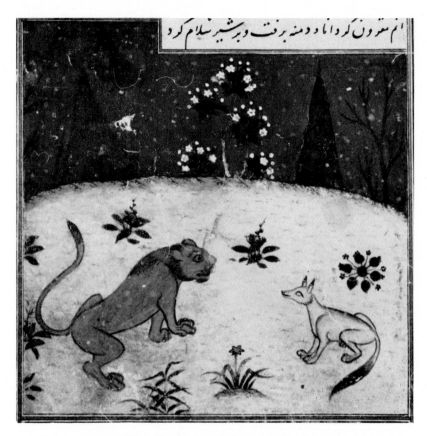

أم متردن كردوانا دمنه برفت وبرشير سلام كرد

42. The Jackal talking to the Lion
Bibl. Nat. 913

mantle over an undergarment of which only the sleeves are visible (fig. 44).
The drawing is finer than that of our manuscript, just as generally the
painting of the Baghdad school is of higher order. Despite this there are
striking similarities.

I hope that I have elucidated the background and the connections
of our manuscript. The period is a critical one in the development of the
Persian canon which was to prevail in the 15th century. It is generally
thought that Shiraz was the cradle of Tīmūrid art. Barrett thinks—since
painting in Persia was a court art in which style and painting were handed
over from master to pupil, and fine painting presupposed a generous court
patronage—that such a patronage was unlikely to have existed at Shiraz,
whose history during these troubled years is obscure. It seems to me that
much is to be said for Shiraz as the origin of the above mentioned manu-

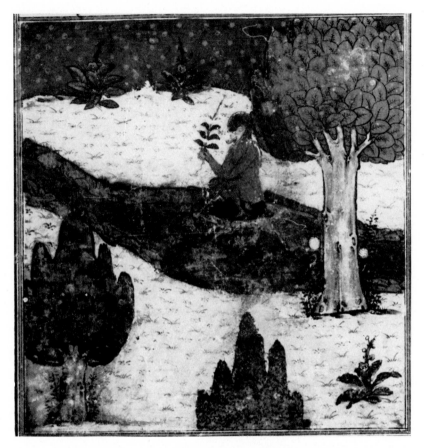

43. The Monkey rides on the Tortoise
Bibl. Nat. 913

scripts, although the Jalā'irid style had, as we have seen, great similarities. Perhaps the most acceptable interpretation of this difficult time is given by Eric Schroeder.[21]

It was to Shiraz that Baysunghur seems to have turned for supplying

[21] Eric Schroeder, *Persian Miniatures in the Fogg Art Museum,* Harvard 1942, p. 57. S. describes the development of art in the 14th and 15th centuries, which he characterises as very intricate, the time critical for the formation of the Persian canon which prevailed in the 15th century. He adds that it is difficult to distinguish between different schools in times in which sovereign princes were numerous and the importance of the various capitals shifted.

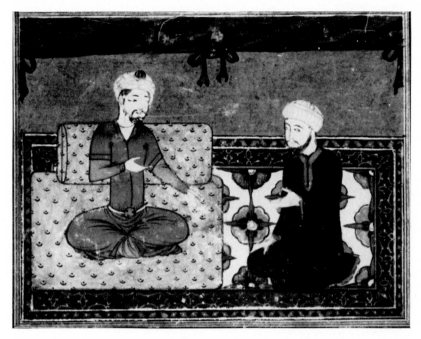

44. The King and the Sage

Bibl. Nat. 913

the first book illuminated for him; this is the Berlin Anthology of 1420. It has the simple but vigorous manner of composition as the Cairo *Shāh-nāma* and the volume of Epics of 1397.

The last of this group of Shirazi manuscripts is probably the Oxford *Shāh-nāma* dedicated to Ibrāhīm Sulṭān (the illustrated dedication is on fol. 12a). Ever since its first appearance at Burlington House this manuscript of the *Shāh-nāma* had been dated about 1420, until Stchoukine advanced it to 1425 (*Les peintures des manuscrits tīmūrides*, p. 43). But apart from the fact that its miniatures show a considerable advance over the work of the Berlin Anthology of 1420, it contains the Baysunghurī preface and can thus hardly antedate the Baysunghurī preface of the Gulistan *Shāh-nāma* of 833/1430 which, as Schroeder has pointed out (*Ars Isl.*, vi., p. 129 note 74), was probably the first official copy of Prince Baysunghur's recension of the text. It must therefore be dated about 1430–5.

After the appointment of Ibrāhīm Sulṭān and his brother Baysunghur as governors of Shiraz and Herat respectively the style of painting in the former city diverges completely from the painting of the court style carried

on at Herat under Baysunghur. The reason seems to be that Baysunghur drew off all the most gifted artists from Shiraz and other Persian cities, when he set up his school in Herat. At any rate the work of the Shirazi artists under Ibrāhīm Sulṭān shows traces of the Muẓaffarid work of the previous century. (For the Berlin Anthology cf. E. Kuehnel's article in *Jhrb. Prs. Kslg.*, lii, pp. 133 ff.). Undoubtedly some of the artists who had worked under the Muẓaffarids in Shiraz were still alive and a few perhaps escaped the mass deportations carried out by Tīmūr, or perhaps they made their way back to their home town after his death. It is quite likely that by the time Ibrāhīm Sulṭān arrived in Shiraz, they had seen the type of work produced in the early Tīmūrid court style by artists imported by Iskandar Sulṭān and others. They must have realised the superiority of this other style, and tried to assimilate it. Their hopes were not disappointed, because Ibrāhīm Sulṭān was himself an accomplished calligrapher and one, who had a very fine understanding of the art of the book (figs. 45–49 and Binyon – Wilkinson – Grey, pl. 38 and frontis-piece).

When the Berlin Anthology was produced, the painters had not yet evolved a homogeneous style. But they had certainly done so by the time of the production of the *Shāh-nāma* in the Bodleian Library, probably a little over a decade later. In this manuscript the Shirazi style is at its height. It retains many of the features of earlier books, such as the high horizon, the simple landscape background and the vigorous action. The colouring remains in a low key. Compared with the Baysunghur *Shāh-nāma* it is rough and homely, but it is just this which gives it its particular charm, which some may find more attractive than the highly polished Herat style. Many pages show an inclination for symmetry and some achieve a grandeur just because of the simplicity of the composition. (A few points about this manuscript are discussed by B. W. Robinson, *Apollo Misc.*, 1951, pp. 17 ff.) By about 1440 the style had lost some of its boldness and vigour; and both the miniatures and the figures in them have become smaller. By the middle of the century the " Turkman " style had begun to be evolved in Shiraz manuscripts, and by about 1460 it had completely ousted the older style.

I hope to have established the connection between the style of our manuscript and that of Ibrāhīm's *Shāh-nāma*, so that our manuscript may help to fill the gap between the Muẓaffarid MSS. and Baysunghur's Anthology of 1420 (cf. above pp. 48/9, 67 ff., 76).

The advance in style represented by the *Shāh-nāma* manuscript is, of course, quite considerable. There the stocky figures have become more elongated and elegant. The miniatures of Ibrahim's *Shāh-nāma* are much more effective than anything in our manuscript. To start with the number

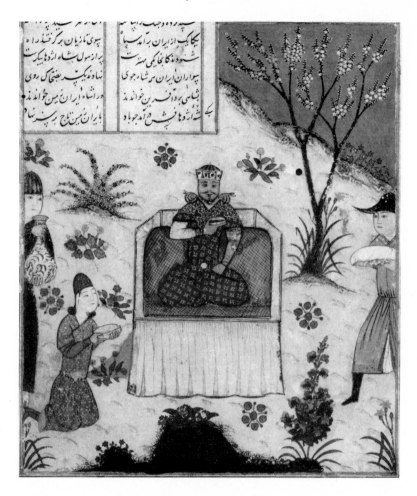

45. King enthroned

Ibrāhīm's Shāh-nāma

of persons depicted in a scene is now considerably greater. The complete interior of a room in perspective is attempted. Nevertheless, the shape of the four-cornered throne, whose lower part is draped by a curtain, is similar to our manuscript; and the way in which two of the figures are cut off by the margin, leaving only the heads visible (fig. 45). In the frontispiece we find again the cherry blossom of our manuscript, the tufts on the ground and the strange way in which a hill is bordered: it is almost, as if some flowery material has been put over the border of the little plot of garden, where the man is digging.

In some of the miniatures we see the high horizon of our manuscript

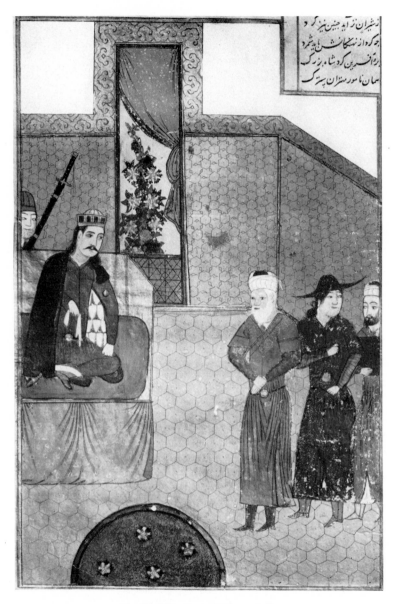

46. Zāl before Minūchihr
Ibrāhīm's Shāh-nāma

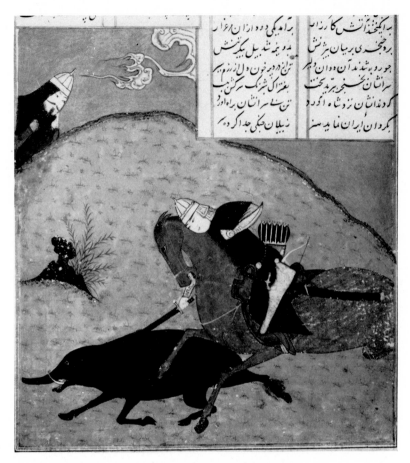

47. Bīzhan hunting the boar
Ibrāhīm's Shāh-nāma

and of the Cairo *Shāh-nāma*, where it is the general rule. As in our manu-
script the eye is not distracted by excessive detail, but is allowed to
concentrate on the main features. There is a certain stiffness in the
drawing as in the *Kalīla wa-Dimna* manuscript. The feeling of harmony
and tranquillity is achieved with an extraordinary economy of means.

Of special interest for comparison are four photographs reproduced
here (figs. 46–49). Firstly, in Zāl before Minūchihr (fol. 52), the shape of
the four cornered throne with a curtain at the lower part is exactly the
same as in our manuscript. The elongated figures with finely drawn faces
are, however, much beyond the powers of our artist, as also is the elaborate
room, in which the scene is set, with the window at the back looking on to
the garden, a device often used to give some perspective.

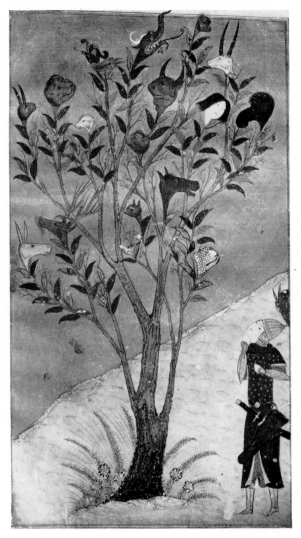

48. Alexander and the Talking Tree
Ibrāhīm's Shāh-nāma

The second (fol. 175) represents Bīzhan hunting the boar. The boar is almost identical with the one in our manuscript. The Chinese clouds in the blue sky, the horse with the fierce look are very different: while the tree stump flanked by shoots recall those often found in miniatures of the Muẓaffarid style.

The third miniature I want to compare, is on fol. 311. It shows Alexander and the talking tree. The very high horizon and the pattern

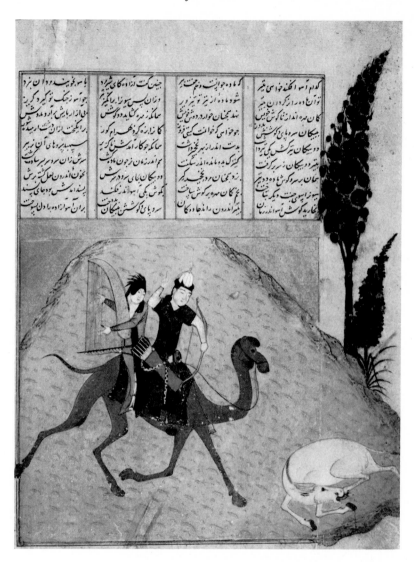

49. Bahrām Gūr hunting with Āzāda
Ibrāhīm's Shāh-nāma

on the ground are again comparable, also the flowering plants at the foot of the tree. The tree, however, and the human figures are very different.

The last miniature is Bahrām Gūr hunting with the slave girl Āzāda. Again we have the high horizon and the golden sky. The trees and plants are completely outside the frame of the miniature. The pattern which

covers the whole ground is very similar to our manuscript. The elongated figures and animals are, however, quite different.

It may be mentioned that some similarity can be detected between our manuscript and a copy of a *Majma' al-Tawārīkh*, produced by a studio working for Shāh Rukh, ca. 1425 (cf. the very interesting article by R. Ettinghausen, *Kunst des Orients*, ii, 1956). In particular the throne scene in our manuscript can be compared to the miniature of Sultan Sanjar enthroned (*Journ. of Walters Art Gallery*, No. 10, 676 ff.). The shape of the throne is similar in both MSS., and in both the ruler is seated with one leg under his body, the other sticking out. In the Sultan Sanjar scene we have the high horizon, the ground covered with a small pattern and on top of it with our small evenly distributed flower tufts; the courtiers have the small round turban, and in the case of two of them barely more than a third of their figure is visible, the rest being cut off by the page. This rather dry style, which Ettinghausen thinks must have been practised in a great many studios, has produced manuscripts with hundreds of miniatures, so that " it came to pass that, depending on the artists' ability and that of their assistants, some of these follow the Mongol prototype rather closely, while others are more independent." He calls this style very aptly the historical style of Shāh Rukh.

We may now put forward some conclusions from our investigations. The break between the Mongol and Tīmūrid style was complete. In particular the new style developed the technique of the high horizon. Only in a few manuscripts is one still reminded of the convention of the single plane which was a legacy of the 'Abbāsid style of Baghdad and the Mongol period. The earliest known examples of the new style is a *Shāh-nāma* of 772/1370, the first of a small group of manuscripts apparently executed under the Muẓaffarids in Shiraz and it is, with this group, that our manuscript is related. By about 1390 the new style has reached maturity under the Jalā'irids of Baghdad and between these manuscripts and our manuscript we have established certain similarities. But the Jalā'irid style is much more refined.

In general it is difficult at this period to think in terms of local styles. Only after the appointment of Ibrāhīm Sulṭān and his brother Baysunghur to Herat and Shiraz respectively does the style of painting practised in Shiraz diverge considerably from the court style of Herat. Perhaps Baysunghur drew off the best talents from Shiraz and other cities, when he established his school in Herat. Our MS. looks forward to the style of Ibrāhīm, which shows traces of the earlier Muẓaffarid style, of the previous style, since we observe a very strong progress from our manuscript to the Bodleian *Shāh-nāma* for Ibrāhīm. That there should be such a

connection is perhaps not surprising, because some of the artists, who have worked for the Muẓaffarids were probably still alive. From a blending of the Muẓaffarid and early Tīmūrid court style sprang the court style of Ibrāhīm. In the Bodleian *Shāh-nāma* the treatment is broad and vigorous. The eye is not distracted by excessive detail, but is allowed to concentrate on the main action. A certain stiffness in the drawing is noticeable in all Shirazi manuscripts of the period. Finally the throne scene has suggested a connection with the studios which worked for Shāh Rukh about 1425, a style which, first described by Ettinghausen, is rather stereotyped and archaistic in character.

HERAT, TABRIZ, ISTANBUL
THE DEVELOPMENT OF A PICTORIAL STYLE

by

E. Grube

Painting in the Muslim world has always been associated with the main centres of political power and was largely dependent on the personal patronage of the ruler or the dignitaries of the state. It was at the courts of the Shahs of Iran and India and the Sultans of the western lands and of Turkey that the great schools of painting flourished. Painting seems almost always to have suffered when royal support was either lacking or withdrawn and to have flourished when the ruler took a personal interest in the development of the art of the book.

The history of Muslim painting is therefore closely related to the political history of the Muslim world and to the fates of dynasties, courts and cities. Styles develop and disappear with the development and decline of a school; and only rarely does a tradition survive in any one place or even more rarely is it transmitted from one school to another. This makes for a striking variety in Muslim painting of which the history appears to be a succession of clearly defined schools identifiable with particular cities and limited to particular periods.

Recognizing the special position of painting in the Muslim world, scholars have devoted themselves mostly to classifying the surviving material, to identifying the various court schools and to establishing their chronology.

A great many paintings have survived that cannot be readily associated with any of the known schools. Detailed study of a large body of material, hitherto unidentified, suggests that a style did not in all instances originate, develop and decline in a single place and at one particular court. In other words a particular style was not always the creation of one school, but rather the result of such circumstances as a shift of political power involving the transplantation of artists from one city to another, often far removed and where entirely different circumstances prevailed. There have been many such upheavals which have usually resulted in the destruction of another. In certain instances, however, the very fact of

upheaval and change seems not only to have contributed to, but to have been an essential factor in the full development of a style.

One such instance is well illustrated by a large number of paintings that have mainly been preserved in albums in the Saray Library in Istanbul; and other paintings related to these can usually be found to have been at one time in the collections of the Sultans of Turkey. The fact that so many of these paintings are preserved in the Saray and that parallels can be found in the arts of the Ottoman Turks of the 16th century, led the writer to conclude that these represent a " School of Turkish painting ".[1] This is only partially true and now, after five years of detailed study of the entire material, it has become clear that the " Turkish School " is only one manifestation of the style. The style itself is indigenous neither to Turkey nor to any other specific place in the Islamic world; rather, it seems to have developed while travelling possibly from Samarqand and Herat to Tabriz and finally to Istanbul. In fact the possible connection of the Turkish phase of the style, with a centre of painting in the east had already been recognized when the first survey of the material was made, but only now does it seem possible to establish what then was supposition.

The basic elements of the style which is the subject of this paper are a preference for a subdued palette of grey and brown tones, and an emphasis on the calligraphic element in design.

A number of surviving landscape paintings follow a common pattern (figs. 50–52): groups of gnarled trees with large leaves are set in a rocky ground presented in several planes. The ground is strewn with large leafy plants some bearing large multi-petalled flowers, but some without blossoms. These landscapes are inhabited by monkeys, birds, dragons, phoenixes, lions and kylins, butterflies and foxes, turtles and cranes, gazelles and stags, bears and leopards, often all together in one painting. The animals are usually depicted in lively movement, often in combat with one another. The narrative element in these paintings distinguishes them from the rest; monkeys have escaped into a tree from the approach of a lion or dragon; dragons glower at one another from behind trees or rocks; cranes attack turtles that try to escape into ponds; bears wielding

[1] See E. J. Grube, " A School of Turkish Miniature Painting ", in *First International Congress of Turkish Arts*, Ankara 19th–24th October 1959; Communications presented to the Congress, Ankara 1961, pp. 176–209, pls. CXXI–CLXIII; idem, " Miniatures in Istanbul Libraries ", i; " A Group of Miniatures in Albums, Hazine 2147, 2153, and 2162 in the Top Kapi Sarayi Collection, and some related material " in *Pantheon*, xx (1962), pp. 213–26, and pp. 306–13.

50.

51.

52.

sticks like swords defend themselves against dragons, lions or kylins.[2]

Many of the animal figures are obviously derived from Chinese models, notably the dragon, phoenix, kylin and many of the birds. Other details also reveal direct contact with Chinese painting such as the highly stylized cloud formations, the decorative ribbons which flutter around some of the kylins, the flames issuing from shoulders of the dragons and kylins, and many more. Many details of the landscape such as the rendering of rocks, and the shrubs with large leaves and blossoms are inspired by the same source.

[2] Of these drawings only a few have so far been published. See M. S. İpşiroğlu and S. Eyüboğlu, *Sur L'Album du Conquérant*, Istanbul s.a., p. 146, fig. **123**; *Handbook of the Nelson Gallery of Art*, Atkins Museum of Fine Arts, Kansas City, 1st ed. 1959, p. 250, below (**43–6/2**).

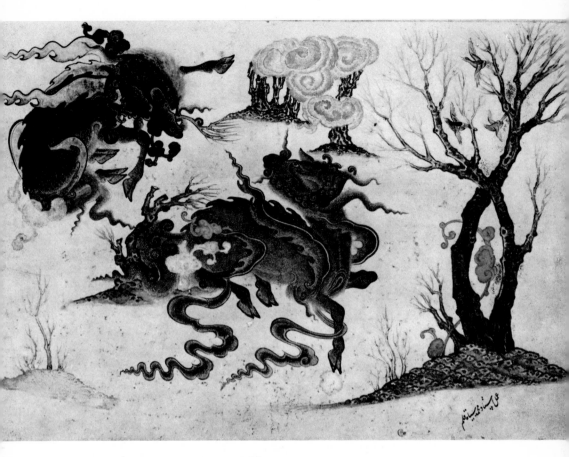

53.

But the finished painting has not the least resemblance to any one kind of Chinese painting. Chinese models have provided inspiration only for details and for the use of subdued tones of grey and brown; the final result is an original and successful work of art.

These landscape compositions, together with a related group of paintings consisting of greatly enlarged renderings of individual motives used in the landscape paintings, constitute the earliest stage in the development of the style. These single motif paintings may even be the next step after the landscapes since they continue a trend of intensification of contrast in colour and dramatization of form, occasionally encountered in the landscapes. In fact many, if not most of these paintings show groups of kylins or dragons in combat (fig. 53) and in landscape settings that have been reduced to an absolute minimum, such as a few large rocks, two

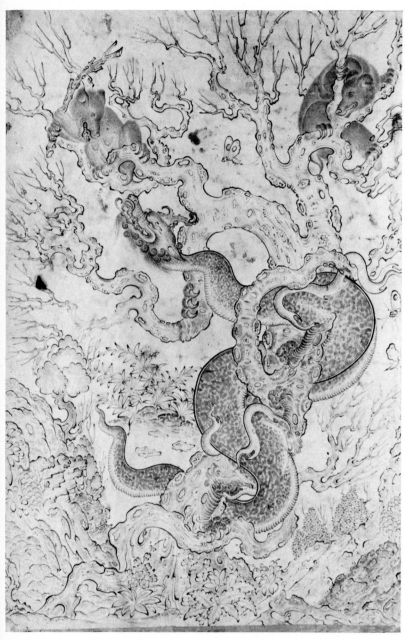

gnarled trees, or just simple indications of ground, a piece of rock, a plant or a tree trunk.

Many of these paintings retain the idea of narrative. There are still pages with dragons pursuing bears that climb to the top of elaborately designed trees (fig. 54) but more generally the attention is focused upon the individual motif. Some of these paintings seem, in fact, mere studies, even though every detail is executed with the greatest care.

It appears that many of these paintings, although intrinsically beautiful, were actually made as models for other artists working in the *kitāb-khāna*.

The closest parallel that can throw light on the provenance and date of these paintings is a group of richly decorated bindings of manuscripts made during the 15th century in Herat for the libraries of Shāh Rukh, Baysunghur, and Sultān Ḥusayn Mīrzā Bayqarā.

54.

Among the bindings, decorated in all the known techniques including blindtooling and relief stamping and gilding in high relief, one in particular stands out (figs. 55/6, 59). This is the binding of a manuscript of Farīd

55.

al-Dīn Aṭṭār's Poems copied in Herat for Shāh Rukh in A.H. 841 (A.D. 1438).[3]

The exterior of the binding (fig. 55) is decorated with a freely drawn landscape with trees in blossom, deer, dragons, and ducks flying among undulating cloudbands. The design of this front cover, so far unknown in Tīmūrid art, has many parallels among the elaborate decorative drawings of the Saray album H. 2153. Landscapes of a very similar nature, with almost identical trees, small rock formations, deer and dragons, birds and especially ducks in flight among decorative cloud formations frequently occur in these drawings. Indeed one might suppose that some of them may have been created as models for the designers of just such book-bindings.

The inside of the same binding (fig. 56) decorated in filigree, a technique popular in the Tīmūrid period, corresponds to the pattern of the exterior and again has many parallels in the decorative drawings of the Saray. In the centre of the field two kylins appear to the right and left of a tree; lions, hares, monkeys and ducks are set against a background of elaborate, floriated scrolls that fill the oblong and small quatrefoil medallions in the border. Parallels for almost all animals and floral motives can be found in the Saray drawings.

Especially noteworthy in this respect are a few drawings that seem to be direct designs for such border decorations as, for instance, one with a continuous beautifully drawn foliated scroll with large chrysanthemum and lotus flowers(fig. 57). In front of these scrolls are flying birds (cranes ?) in exactly the same manner in which birds and monkeys are presented in the border designs of these bindings. Other drawings, such as those showing a snake writhing round a foliate scroll, and through openings in large fan-shaped leaves (fig. 58) have even more the character of models from which the leather tooling artists worked.

Both the inside and outside decoration of the flap (fig. 59) are obviously derived from drawings such as fig. 60 which again may have been made as models for the binders. Especially noteworthy are the monkeys in the filigree border of the inside of the flap for which there are exact parallels in a number of drawings (fig. 51).[4] The kylins on the stamped relief decoration of the outside of the flap again seem to have been taken direct from a drawing (see fig. 60).

[3] Istanbul, TKS. No. 270/3059. Mehmet Ağa-Oğlu, *Persian Bookbindings of the Fifteenth Century*, Ann Arbor 1935, pls. I–III. The binding was actually first published by Arménag Sakisian, " La reliure persane au XVe siècle sous les Timourides", in *La Revue de l'Art*, lxvi (1934), pp. 145–168; the binding is illustrated in figs. 8–11.

[4] The monkey motif continued to be very popular in Tīmūrid bindings where it is often

56.

used in the same way as in the drawings. Compare the group of monkeys in a tree on the exterior of the front cover of the binding of Jalāl al-Dīn Rūmī's *Mathnawī* copied in A.H. 849 (A.D. 1446), Istanbul, Türk ve Islam Eserleri Müzesi, no. 1543, Ağa-Oğlu, op. cit., pl. IV; or the same motif in the central medallion of the exterior of the binding of Firdawsī's *Shāh-nāma*, made for Shāh Ismāʿīl's brother, Sultān ʿAli Mīrzā who died in 1493, in the same collection, no. 3079, Ağa-Oğlu, pl. XXII.

57.

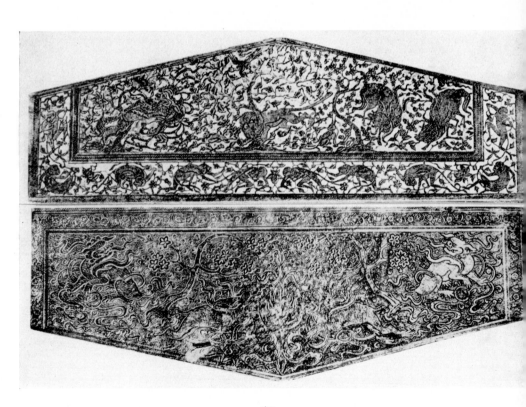

59.

58.

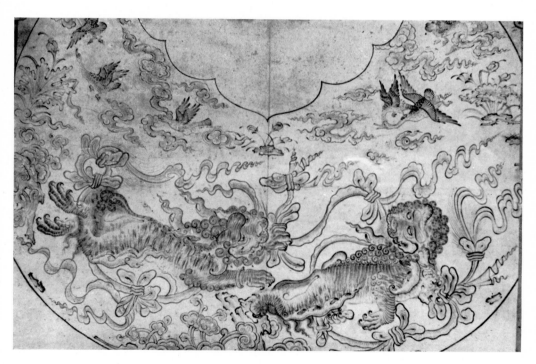

60.

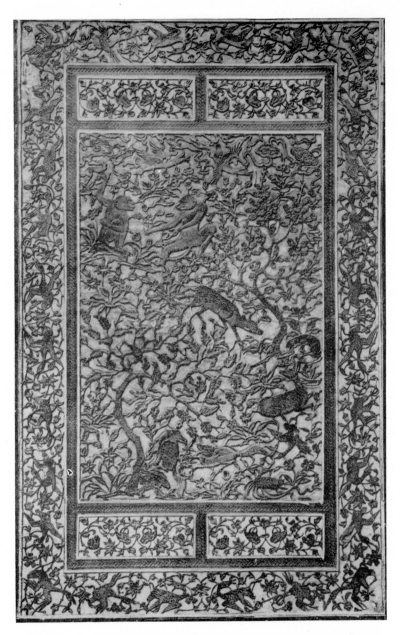

61.

The same type of decoration is still used fifty years later in Herat as can be seen from a magnificent binding of a manuscript of Jalāl al-Dīn Rūmī's *Mathnawī* made in A.H. 887 (A.D. 1483) for Sultān Ḥusayn Bay-

62.

qarā.[5] While for the outside a different, abstract floral design has been adopted, the inside of the front cover is decorated in filigree with a landscape design framed by a decorative border of flying ducks in front of a foliated scroll (fig. 61). There are the same trees with large oblong multi-lobed leaves, the same curiously shaped rock formations, the same palmette blossoms, and rosette flowers, the same foxes, stags, monkeys and ducks among cloudbands as are found in the drawings.

Most noteworthy is perhaps the figure of the magnificent dragon that appears on the inside of the flap (fig. 62). It might, indeed, be the work of one of the artists responsible for the dragons of the Saray albums.

These two bindings, both securely dated and attributable to Herat, attest to the continuity of this type in the Tīmūrid capital.[6] It is clear,

[5] Istanbul, Türk ve Islam Eserleri Müzesi, no. 1537. Ağa-Oğlu, op. cit., pls. X–XII; Sakisian, loc. cit., fig. 12.

[6] Compare other bindings of this type, e.g. a copy of Jalāl al-Dīn Rūmī's *Mathnawī* in Istanbul, Türk ve Islam Eserleri Müzesi, no. 1543, dated A.H. 849 (1446 A.D.) decorated still in delicate, low relief with a freely drawn landscape with monkeys in trees, a bear and a man fighting, kylins, foxes, and a dragon and phoenix fighting. All these are motifs taken from drawings. The phoenix motif is quite common in the decoration of central medallions of such bindings. See Ağa-Oğlu, op. cit., pl. V, for the inside of the binding from the same manuscript. From bindings designed in the same fashion but which belong to manuscripts not made in Herat, it appears that either the tradition established in Herat was soon followed by other centres of bookmaking in Tīmūrid Persia, or that the school of decorative drawing and painting active in Herat spread also to other courts in the 15th century. Compare, for instance, the binding of an Anthology in the same collection (Ağa-Oğlu, op. cit., pl. VIII) of about 1430, which may have been made for Ibrāhīm Sulṭān in Shiraz (although it may, of course, also have been sent to him by his brother as a gift from Herat). The similarity between the design of the central medallion with two kylins and the drawing illustrated in our fig. 6 is striking. The ducks in front of a floral spray, decorating the corners of the binding have many parallels in the drawings from Herat. Compare also the filigree decora-

63.

64.

too, that the related school of decorative drawing also continued through out the 15th century.

If these drawings and paintings can be attributed to Herat and given a fairly precise date by means of the bindings then another large and related group of drawings and paintings that have so far eluded secure definition can be given to that city. There are the strange representations

tion of the inside of the same binding, Ağa-Oğlu, op. cit., pl. IX.

Sakisian, loc. cit., p. 167, fig. 16, illustrates a binding of this type from a Sa'dī manuscript in the Musée des Arts Décoratifs in Paris, made in Herat in 1503, which shows the last step before the style was transplanted to Tabriz.

65.

of monsters, some fighting among themselves, some with dragons and other animals. Some also play curious and often fantastic instruments, prepare lurid dishes and engage in frightening games and dances (figs. 63–65).[7] The stylistic affinity of these paintings—their monochrome tonality, the striking resemblance of many of their iconographic details to those of the paintings already attributed to Herat through the bindings —is so overwhelming that they must undoubtedly belong to the same milieu and to about the same period.[8]

[7] Many of these paintings, which are usually connected with Siyāh Qalam, have been published by Ipşiroğlu-Eyüboğlu, op. cit., also Oktay Aslanapa, " Türkische Miniatur-malerei am Hofe Mehmet des Eroberers in Istanbul ", in *Ars Orientalis*, i (1954), pl. 16, figs. 36–37; R. Ettinghausen, " Some paintings in four Istanbul Albums ", ibid., pl. 24, Fig. 55, and M. S. Ipşiroğlu and S. Eyüboğlu, " Aus dem Album des Eroberers, Ein Beitrag zur türkischen Malerei im 15. Jahrhundert ", *Du*, 220, June 1959, with some magnificent colour reproductions.

[8] A special study by the writer about the relationship of the " monster-paintings " to the early phase of the style here discussed will appear soon in *Pantheon*.

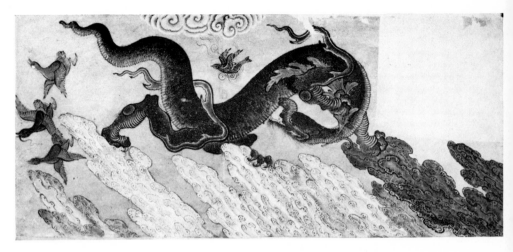

66.

Now that the drawings can be attributed to Herat there remains the problem of their chronology. The earliest phase of the style would be represented by the delicately drawn landscape paintings(figs. 50–52), the still largely monochrome studies of dragons and monsters (fig. 54), and the many scenes of the monsters and their various activities (figs. 63–65).

These all reveal a delicacy in the executing of minute detail, especially the rendering of fur, curls of hair, the scales of fish or dragon-monsters, and an almost complete absence of contrast whether in composition or in density of colour.

This delicate style of painting finds its perfect counterpart also in the softness of forms and flatness of relief in the bindings of the early Timurid period.

A later phase, probably from the death of a Baysunghur to about the middle of the century, is represented by the many studies of basically the same subjects, but with a new emphasis on counter-balance in composition and on light and dark shading of colour (fig. 53). There seems too to be greater interest in the complete execution of individual elements of the earlier designs, a stronger accent in the drawing of floral and animal motifs, and a tendency to introduce colour into the subdued palette of the earlier style. Motifs only adumbrated in the early stages of the style, such as landscape features, rock formations and even trees, are now developed into major motives within the still basically unchanged imagery of the early phase. Some of the paintings can therefore be compared with the contemporary manuscript illustrations of which most are dated or datable.

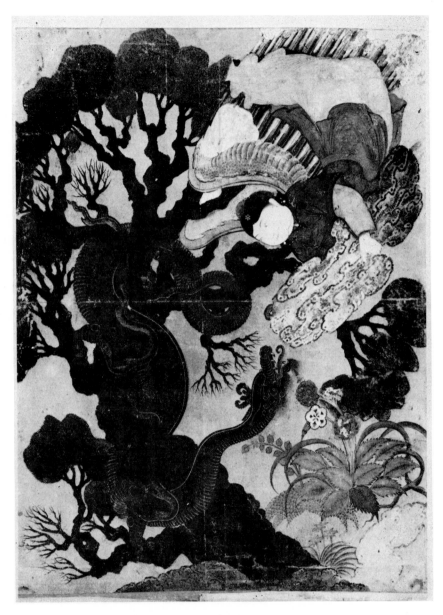

67.

Here we can mention only a painting showing a monumental dragon against brightly coloured rocks (fig. 66), the beautiful painting of a dragon climbing down a tree defending itself against an angel who is about to cast a rock at the monster (fig. 67). In both paintings the colour element

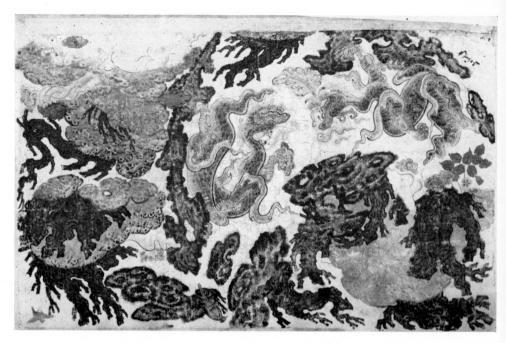

68.

predominates, and most of the design, especially the elaborate rocks in the
first, and the beautiful floral motive to the right of the tree in the second
painting can be paralleled in Herat painting of the 1430's and 1440's.
The figure of the angel may best be compared with the figure of Jabrā'īl
in the *Mi'rāj-nāma* of 1436,[9] and the rocky landscape can be found in
many of the paintings in the *Shāh-nāma* of about 1440.[10]

Although little is known about painting in Herat in the mid 15th
century,[11] it is likely that the tradition was carried on without interruption
and change, and many of the paintings in which the landscape motive
with animals, dragons, and birds are further developed (fig. 68) belong
probably to this period. It seems that out of this intermediary stage
when actual painting and the drawing of the decorative style meet, there

[9] Paris, Bibliothèque Nationale, Suppl. turc, 190. Ivan Stchoukine, *Les Peintures des
Manuscrits Timurides*, Paris 1954, pp. 54–55, no. xxxvii, pls. LVIII–LXIV.

[10] London, Royal Asiatic Society, Pers. MS. 239. Ibid., pp. 55–56, no. xxxviii,
pls. LXV–LXVIII; compare pl. LXVIII. For an illustration in colour see Basil Gray, *Per-
sian Painting*, Geneva 1961, p. 90, and p. 91, for another painting from the same manuscript.

[11] See. B. W. Robinson, *A Descriptive Catalogue of the Persian Paintings in the Bodleian
Library*, Oxford 1958, pp. 62–64.

developed the third phase of the 15th-century Herat school again corresponding to the decoration of bindings (figs. 69, 70). In this third period, the painters seem to have provided many of the ideas and models for the decorative arts.

Many drawings are executed in a purely linear style which is probably the result of an attempt to give greater clarity to the designs as well as a further development of a more graphic approach. These drawings usually have a special shape, suggesting fans (fig. 69), embroidery panels or roundels (fig. 70) and could be adapted for book illumination, leather tooled designs, painted tile work, or centres of ceramic bowls.

Although the largest number of drawings are of this type, there are still freely executed landscape compositions with animals which follow the earlier tradition (fig. 71).

So far the style belongs clearly to the milieu of the Tīmūrid East, but it appears that in the 16th century it underwent fresh developments.

There is overwhelming evidence that the style of binding decoration which flourished at Herat in the 15th century was continued almost unchanged in Tabriz during the 16th century. This would indicate that not only bookbinders who had been brought from Herat to Tabriz at the

69.

70.

71.

beginning of the 16th century continued working in the Ṣafavī Capital, but also the school of decorative and fantastic drawing was transferred to Tabriz where it carried on unchanged. This is all the more remarkable since the style of painting that flourished in Tabriz in the early 16th century differs considerably from that of Herat, granted that the Herat style of the late 15th century played a decisive role.

The binding of the copy of Niẓāmī's *Khamsa* (fig. 72) made in Tabriz in 1524–5, now in the Metropolitan Museum, may serve here as an example as it is securely dated with the manuscript.[12]

Both the fields of the front and the back cover and the outside of the flap are decorated in gilded relief with a landscape design clearly derived from the Herat tradition as represented both in bookbindings and drawings. There are the same trees with long feathery leaves, the same dragon warding off the attack of a phoenix, the same stags, bears and monkeys among leafy plants, reeds and shrubs, which appear both in Herat bindings and landscape drawings.

There are many more bindings of this type,[13] and there is a group of lacquer bindings with similar scenes painted in silver, gold, brown, red and grey, that reflect both the iconography and the style of an entire series of decorative drawings that follow the earlier Herat tradition (fig. 73).[14]

[12] New York, Metropolitan Museum of Art **13.228**. F. R. Martin, *The Nizami Manuscript from the Library of the Shāh of Persia, Now in the Metropolitan Museum of Art*, Vienna 1927, pl. 1.

[13] Compare the two bindings in the Gulbenkian Collection: *Oriental Islamic Art, Collection of the Calouste Gulbenkian Foundation (Exhibition)*, Lisbon 1963, with the section on the Art of the Book by Basil Gray; nos. 129 and 130, both illustrated; no. 130, especially, is still very close to the early Herat phase of landscape design. As many bindings are separated from their original manuscripts, it is not always possible to determine where a binding may have been made. It would appear that the tradition of binding design of this type was taken over also by Bukhara, as is documented in the binding of a Niẓāmī manuscript in Paris (Bibl. Nat. Supp. Pers. 985: E. Blochet, *Peintures des Manuscrits Orientaux*, 1911–1914, pl. I, and G. Migeon, *Manuel d'Art Musulman*, Paris 1927, p. 198 fig. 6i), which according to the colophon of the manuscript was copied in Bukhara (see also Robinson, *Bodleian*, op. cit., pp. 134–35). From this the "school" of decorative drawing (together with the "official style" of Herat painting) can be assumed to have continued—also in Bukhara: alternatively, Bukhara, which had been an important centre of Tīmūrid culture before the rise of the Uzbeks, may already have had a school of painting during Ulugh Beg's reign. It may well be that here and in Samarqand at the very beginning of the 15th, if not already at the end of the 14th century, the style was first formulated and that it was then transmitted to Herat when it became the capital of the Tīmūrid empire.

[14] Compare also Ernst Kühnel, *Islamische Kleinkunst*, 2nd ed., Brunswick 1963, p. 86, fig. 45, lacquer-binding in the Museum für Kunst und Gewerbe, Hamburg. The flap illustrated in our fig. 73 is illustrated in colour by F. Sarre, *Islamische Bucheinbände*, Berlin

72.

s.a. pl. XXIX; apart from the general style of this lacquer painting, and the typical foliated scroll in the border, it is the characteristic motif of the floral shrub with a fan-shaped leaf with the circular opening and the rock with an equally typical opening through which a cloud-band "grows", that relates this piece to the school of decorative drawing discussed here

How long this type of binding lived on in Persia can be seen in the decoration of both the front and back covers and the outside of the flap of an undated Shāh-nāma manuscript in the Metropolitan Museum (Acc. no. **13.228.14**, A. V. Williams Jackson and Abraham Yohannan, " A Catalogue of the Collection of Persian Manuscripts presented to the Metropolitan Museum of Art by Alexander Smith Cochran ", New York 1914, no. 5, pp. **38–44**). The manuscript, judging from its illustrations, cannot be much earlier than the very end of the 16th century, and was probably made in Isfahan. The gilded relief decoration consists of all the elements of landscape design with gnarled trees, long-tailed birds, stags, lions, wolves and cranes, ducks, and even butterflies in the sky among magnificent cloud patterns, first developed in Herat. See Julie Michelet, *Loan Exhibition of Islamic Bookbindings*, Oriental Department, Art Institute of Chicago, March 20–May 20, 1932, no. 21, frontispiece, and *Exhibition of Islamic Art*, De Young Memorial Museum, San Francisco 1937, no. 7, ill. pl. 7.

Conclusive evidence of the " Tabriz phase " of the style is provided by the title pages of one of the great Saray Albums (Hazine 2154). These consist of large compositions executed in gold on a deep blue ground with dragons fighting, floral patterns inhabited by birds, snakes, dragons, cranes, lions and kylins in landscape settings.[15] These pages must have been executed in Tabriz before A.H. 951 (A.D. 1544) when the album, incidentally containing a large number of decorative drawings both of this and the earlier phases of the style, was presented to (or at least owned by) Abu'l Fatḥ Bahrām Mīrzā, brother of Shāh Tahmāsp.[16]

It would appear that many of the more schematic drawings of birds, and other animals, of plant forms and decorative composition, all of which seem to have been intended as models for bookbinders, lacquer-painters, marginal illuminations, and possibly textile weavers and embroiderers, and which rigidly follow the tradition of the late Herat phase of the style, were made during the first half of the 16th century in Tabriz.

The Turks invaded Persia many times throughout the first half of the 16th century and finally forced the Ṣafavids to remove their capital to Qazwin. Booty included the leading court artists and a large number of manuscripts and albums, most of which are still preserved in the Topkapu Saray Library.

The importation of artists, craftsmen, and actual artifacts from Tabriz resulted in a new development of the art of the book in Istanbul. Very typically and in exact parallel to the contact between Herat and Tabriz before, the official court painting, documented in richly illustrated manu-scripts, does not follow the Tabriz tradition, although painters and their work had come from the Ṣafavi capital to the Ottoman court. Never-theless, the tradition of decorative painting and drawing that we have followed from early-15th-century Herat to mid-16th-century Tabriz, is continued, and further developed and brought to its final perfection in the magnificent achievements of book painting, textile design, and pottery decoration of Turkey in the 16th century.

This last stage of the style has already been discussed at length else-where.[17] The Ottoman Turks seem fully to have appreciated the decora-tive value and all the possible variations of this style. In their court school in Istanbul the further and final development of the decorative and

[15] See Grube, " *A School . . .* ", loc. cit., pl. CXLVII, figs. 39 and 41, pl. CXLVIII, figs. 42–3, and pl. CXVIX, fig. 44.

[16] Ivan Stchoukine, " Notes sur des peintures persanes du Sérail de Stamboul ", in *Journal Asiatique*, 226–7 (1935), p. 133.

[17] See note 1.

especially calligraphic elements
of the style were emphasised.
This produced, on the one hand
the magnificent lancette and
palmette designs, which are
securely documented in the
Album of Murād III of 1575 in
Vienna,[18] and, on the other
hand, the monumental dragon
figures.

Other crafts again benefited
from the ingenuity of the pain-
ters, especially textile designers
and ceramic painters. The tiles
in the Sünnet Odasi and the
Baghdad Kiosk in the Saray
are probably the finest achieve-
ment of this co-operation be-
tween painter and designer at
the Ottoman Court.[19]

When the time comes for
its history to be written, this
school of painting may well be
found to have originated in
Samarqand where perhaps the
paintings of monsters were
executed. It reached maturity
at Herat in the early 15th
century as a basically pictorial

[18] Grube, " A School ...", loc.
cit., pl. CXXXVII, figs. 18–19, pl.
CXXXVIII, figs. 20–1, and pl.
CXXXIX, fig. 22.

[19] Kurt Erdmann, " Die Fliesen
am Sünnet Odasi des Top Kapi Sarayi
in Istanbul ", in *Aus der Welt der Isla-
mischen Kunst, Festschrift für Ernst
Kühnel*, Berlin 1959, pp. 144–53;
idem, " Neue Arbeiten zur türkischen Keramik ", in *Ars Orientalis*, v, (1963), pp. 191–219,
pl. 10, fig. 34, pl. 11, figs. 35–6, pls. 12–13, figs. 37–42.

73.

style in which were depicted landscape and animals in a subdued palette. Towards the end of the 15th century in Herat, the decorative intention in painting and drawing predominates. Characteristic of the early phase at Herat are soft, mellow tones, elaborate compositions and a progressive emphasis on individual elements. In the later phase, the pictorial tradition of the school of Baysunghur is combined with the decorative tradition of the new style. It is the latter which predominates at the close of the century and to this period belong the designs for bindings and book illuminations, possibly for tiles and pottery—of which little or nothing has survived—and for embroidery and textile weaves which although no actual examples have survived, can be adduced from contemporary paintings.

When the style was carried to Tabriz, the narrative aspect again becomes more prominent and individual and figural motives are isolated and enlarged.

The style reaches its apogee in Ottoman Turkey in the calligraphic drawings of the Murād Album and the Saray tiles of the second half of the 16th century: and survives into the 17th and 18th centuries in floral and figural drawings which have acquired almost the character of abstract decoration.

A COPY OF THE RAWẒAT AL-ṢAFĀ
WITH TURKISH MINIATURES

by

G. M. Meredith-Owens

A series of miniatures by a Turkish artist has recently been discovered in a manuscript of the *Rawẓat al-Ṣafā fī Sīrat al-Anbiyā wa'l-Mulūk wa'l-Khulafā*, the well-known Persian history compiled by Mīr Khwānd (Muḥammad b. Khāwandshāh b. Maḥmūd) who died in 903/1498.[1] This manuscript (Or. 5736 in the British Museum collection) contains only the sixth of the seven volumes (*qism*) which covers the history of Amīr Tīmūr (Tamerlane) and his successors to the death of Abū Sa'īd in 873/1469. The copyist, 'Alī b. Muḥammad Tustarī, gives the date of transcription as 1008/1599–1600. The hand is a calligraphic *naskh* with section headings in blue and gold. A number of words, including some which are not by any means unusual or obscure, like numerals, have been provided with Turkish glosses in red in a smaller but not less elegant hand of approximately the same date. There are eleven full-page miniatures representing the work of an extremely talented artist. The colours are entirely Persian but the vigorous and exuberant layout of each composition, the shortening of the forequarters of some of the horses, the frequent use of profile and full face, and the Turkic racial types which are displayed with a great skill in characterization indicate the Turkish origin of the painter. Other features which leave us no doubt that we are dealing with a Turkish artist are the treatment of a scene at the court of Bāyazīd I (173b), a mosque with pointed minaret of the Ottoman type (303b) and the elaborate, almost overloaded decoration of Ulugh Beg's audience chamber. The miniatures are for the most part inspired by a Timurid chronicle, possibly

[1] See Storey, *Persian Literature*, p. 92. The manuscript, purchased from J. J. Naaman in 1900, consists of 412 folios and measures 36·5 × 22·3 cm. According to a note at the beginning, it belonged to a certain İbrāhīm Paşa in 1247/1831–2 and it also bears the seal of a later owner, 'Abd ül-Qādir Paşa. It has been incorrectly described as the *Shāh-nāma* of Firdawsī on the first folio. There is a rather dark-coloured *'unwān* on 1b with some gilt floral designs.

a copy of the *Ẓafar-nāma*.[2] Apart from their lively and realistic approach they have little in common with other " campaign " illustrations from the close of the 16th century. The dress of the armies of Tīmūr and other Turkic princes is very distinctive—the soldiers wear the usual splinted armour (called Tartar-Mongolian by Pope)[3] and a high-crowned white-banded (lacquered ?) helmet with a brass top, adjustable vizor and cheek-pieces (perhaps of fur or felt) which, in most cases, are turned up to expose the face.

Some of these are cylindrical like Mamlūk[4] helmets and some with brass neck-protectors; while others are triangular resembling the 15th-century European bycochet (303b) or heavy headpieces with a patterned brim reminiscent of a Chinese or Japanese helmet (97a). In contrast to these peculiar headgear, many of the combatants are depicted wearing pointed brass helmets of ordinary Timurid or Safavid type with turbans twisted round them. In at least two cases the principal figures wear the large irregular turbans similar to those which appear in the later Safavid miniatures. The riders carry lances with tufts of horse-hair and daggers, sometimes without a guard like a short *yataǧan*.

The difference in dress from the other illustrated copy of the *Rawẓat al-Ṣafā* in the British Museum collection[5] is very marked, in that this and all later examples show the usual contemporary dress and no attempt has been made to give the figures such an original touch. The most out-standing contribution which the artist has made to realism is the face of Tīmūr—in some of the illustrations depicting incidents towards the end of his career his beard changes from brown to grey-white. Practically all the miniatures are " two-dimensional " and show two or more actions occurring at the same time which are placed in different registers with much skill.

[2] At least three copies of the *Ẓafar-nāma* of Sharaf al-Dīn Yazdī with Timurid minia-tures are known—notably a copy dated 872/1467 with miniatures attributed to Bihzād (published by Arnold in 1930) which is now at Princeton. For illustrations from the others see Robinson, *The Kevorkian Collection*, pl. XXI (at New York, dated 839/1436) and Sakisian, *La miniature persane du XIIe au XVIIe siècle*, fig. 109 (Türk ve İslam Eserleri Müzesi, Istanbul, dated 891/1486). The illustrations in the latter bear some resemblance to those in Or. 5736.

[3] Pope, *Survey*, iii, 2558 and Martin, *Text*, p. 29, fig. 17 (portrait of Tīmūr). The helmets are a military development of the Tatar bonnet (*qalpaq*).

[4] Kühnel, *Islamische Kleinkunst* (new edition), p. 204, fig. 162.

[5] Add. 23506 (dated 1030/1621) contains ten miniatures in a rather coarse style. Another copy (Add. 18540) bears paintings on the binding which have no connection with the text.

Two of the illustrations reveal certain differences from the other nine. These are the scene when Tīmūr's envoys are shown at the Ottoman court which has been already mentioned (173b) and the very last miniature where the costume is rather different from the others (402b). The former is typical of Ottoman " court " art—the Sultan dwarfs all the other figures which are grouped about him somewhat rigidly; and these in turn tower above the two small isolated figures of the Tartar envoys.

The question now arises as to whether the same artist was responsible for the whole group of eleven miniatures. In all of them the convention appears whereby the most important characters are shown larger than the others; but in no. 4 (173b) the treatment of the court scene with its accurate representation of Ottoman costume suggests that another artist, more experienced in depicting this kind of subject, may have been brought in to paint this miniature. With the exception of the envoys, all the figures are large in 4 and it thus contrasts strongly with the other pictures where the artist works on a smaller scale for the most part, crowding the picture with detail and movement. But perhaps this is evidence of some patriotic feeling on the part of the artist who has deliberately made all the Ottoman Turks larger than the others. There are not sufficient grounds for attributing 4 to another artist, when we take this into account.[6] The same applies to 11 where there are some differences in detail but none so striking — as for example, the brass helmets of the troops behind Ḥasan Beg.

Here again the artist aims at a definite contrast—in this case between the stalwart and menacing soldiery cutting down the smaller fugitives among the rocks on the right—or what is more likely, he is trying to show that the figures are diminished in size by distance.[7] A description of the miniatures follows. Some of them seem to have been detached from the manuscript at one time and folded, suffering some damage in the process.

1 (*f. 37b*) (fig. 74). The attack of Tīmūr's army on Balkh, held by the forces of Amīr Ḥusayn who had built a strong fortress there. In the foreground Tīmūr is seated in an elaborate pavilion receiving Ḥusayn's envoy. The non-combatant inhabitants of Balkh are wearing turbans for the most part to distinguish them from the Tatars. Some, however, wear turbans twisted round brass helmets, while some on the extreme left wear helmets very like those of the Tatars. Ḥusayn, wearing a golden

[6] Perhaps in this miniature the artist reverted to his normal style as an illustrator of chronicles, except for the portrayal of the two envoys.

[7] Compare the relative size of the figures on the ramparts in 1 and 8 with those in the foreground.

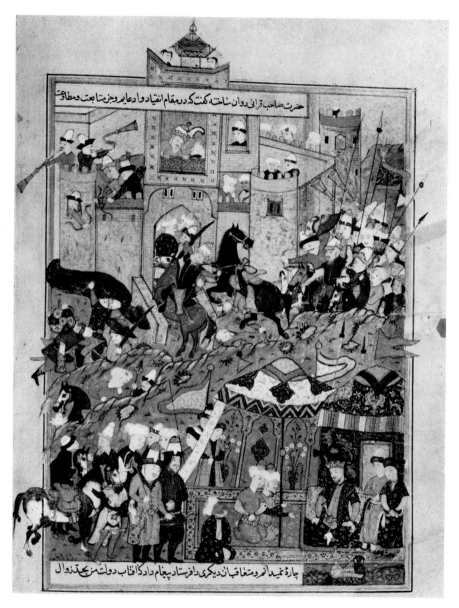

74. Tīmūr attacks Balkh

diadem with aigrette, watches the progress of the battle and the negotiations from a tower in the citadel. Women and other onlookers gaze apprehensively from behind the battlements. The face of a man with protruding teeth occurs in this scene and reappears in others. Two types of trumpet are shown, one straight and one curved. The ground is

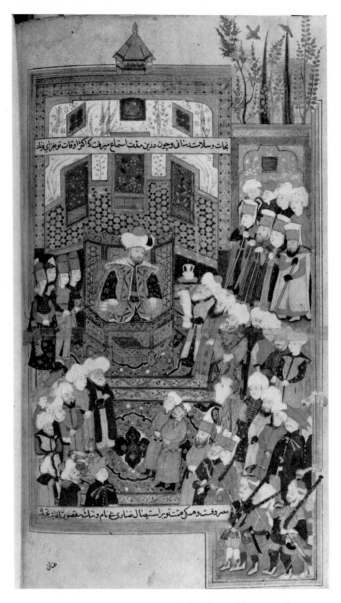

75. Tīmūr's envoys before Bāyazīd

coloured blue-grey, and the stone masonry and bricks of the town walls
indicated.

　　2 (f. 97a). A battle between Tīmūr and Toqtamish, Khān of the
Golden Horde. Tīmūr is to be seen in the left background, followed by
lancers and standard-bearers. On the right Toqtamish appears with his

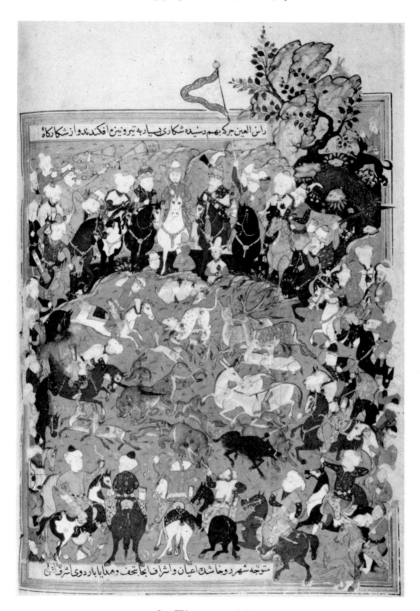

76. The royal hunt

troops, one of whom wields a war-flail having three tails. There is a kettle-
drummer in the top left-hand corner. The ground is buff-coloured.

 3 (f. 122b). Another battle between Toqtamish and Tīmūr who is on
the right, holding a flanged mace (*shaspar*), at the head of a body of horse
and foot including archers kneeling to aim their arrows. Toqtamish,

surrounded by his lancers and accompanied by his standard-bearer, is routed by the Tatars who have almost surrounded him and cut off his escape. Tīmūr's standard bears a dragon's head and elaborate trident finial.

4 (*f. 172b*) (fig. 75). This miniature shows something of the pomp and dignity of the Ottoman court. The two rather insignificant figures wearing the distinctive Tatar dress in the centre are envoys sent by Tīmūr, one of whom is reading a letter to Bāyazīd I, a magnificent figure in a furred pelisse seated upon a throne. In the foreground are ʿAzebs with shouldered muskets (!), and pages on the left by the throne wearing tall gilded hats and red hoods. On the right are a group of Qapijis bearing gold staffs, while in the right foreground a Janissary officer stands with two of his men. In front of the throne are a party of ʿulemā with the large turbans often seen in Turkish miniatures. Here and there are single *sipāhīs* of Rumeli wearing their peculiar bonnets with projecting points surmounted by a plume. The walls are covered with coloured octagonal tiles and mural painting.

5 (*f. 187b*) (fig. 76). A *jargeh* or hunt in the Mongol fashion in which the riders form a ring round the quarry. According to custom, the hunters enter in order of rank and despatch the game. Two princes are in the centre. One is wounding a lion while the other transfixes with his arrow a leopard in the act of pouncing on a deer. Many animals appear in this picture—gazelles, wild asses, hares, foxes, wild boar and a bear which is being attacked by troops from the tightly-drawn circle. Some of the dead gazelles have already been attached to the riders' saddles. A man with a saluki is to be seen near the stream under the tree by the rocks on the right. Another hound is attached by a leash to one of the horsemen. This hunting scene is a good study of animal life and vigorous action. The view of the horses from the rear and full face is somewhat unusual.

6 (*f. 232b*) (fig. 77). Tīmūr is here seen in the wooded country of Māzandarān on his expedition to fight Sulṭān Ḥusayn. Troops are winding their way through the mountain defiles to cross a deep ravine by means of an improvised bridge. One trooper leads his horse across; another, less careful, rides on a pack-horse. Another on the right bears a club, while one rider carries a war-flail with three tails. Tīmūr is resting under a canopy in a grassy clearing. In the top right corner the forces of Sulṭān Ḥusayn made a sortie from their fortress from the embrasures of which trumpets are protruding. In the foreground a fox sits in a tree. Behind Tīmūr a bear hiding up a tree is menaced by a snow-leopard. The green of the vegetation is in two shades; the ground is coloured bluish with brown for the hillocks.

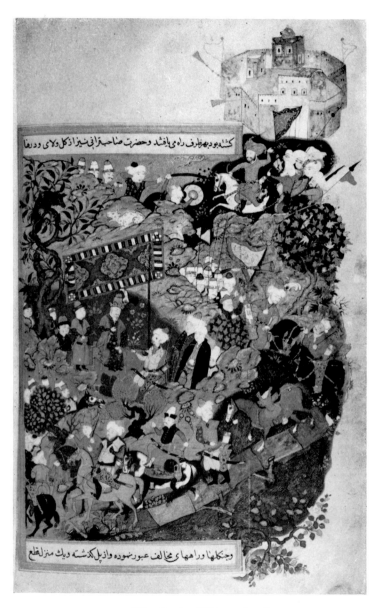

77. Tīmūr in Māzandarān

7 (*f. 277a*). A battle between the armies of Abū Bakr Tabrīzī, the son of Mīrānshāh, and Qara Yūsuf Qaraqoyunlu who is shown wearing a scaled cuirass seated upon a richly caparisoned and armoured horse in the centre. He is attacking a man-at-arms with his sword. On the right rides Abū Bakr bearing a mace, followed by three men carrying ensigns.

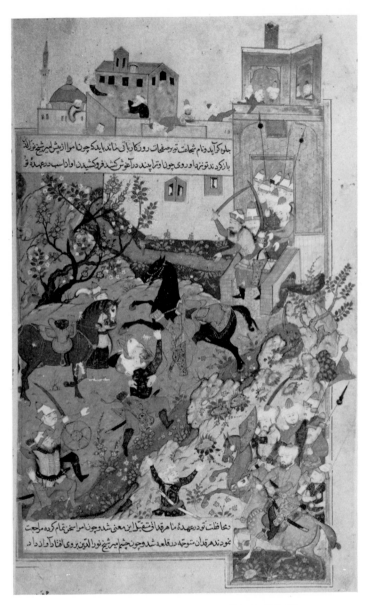

78. Encounter between Shāh Malik
and Amīr Shaykh Nūr al-Dīn

Beside his horse's head a man (probably a *payk*) with an axe or halberd
is walking. Facing him are the followers of Qara Yūsuf, wearing large
turbans, in some cases twisted round brass helmets. They also have three
ensigns each in a different colour. The ground is here pale green.

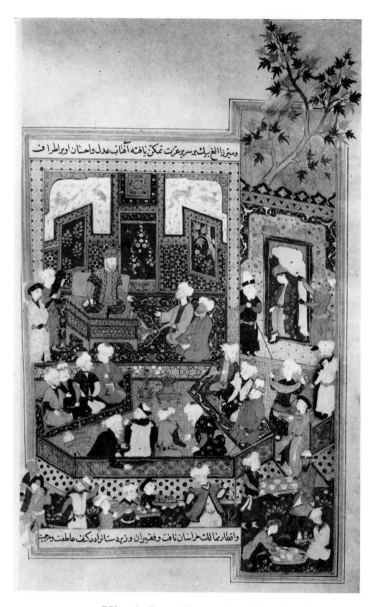

79. Ulugh Beg dispensing justice

8 (*f. 303b*) (fig. 78). The encounter between Shāh Malik and Amīr Shaykh Nūr al-Dīn. The latter is being dragged from his horse into the arms of Harqadāq whose horse is being held while he runs up to seize Nūr al-Dīn. Two swordsmen are rushing on the left to support Harqadāq. All the horses are greatly excited. Another two men brandishing swords

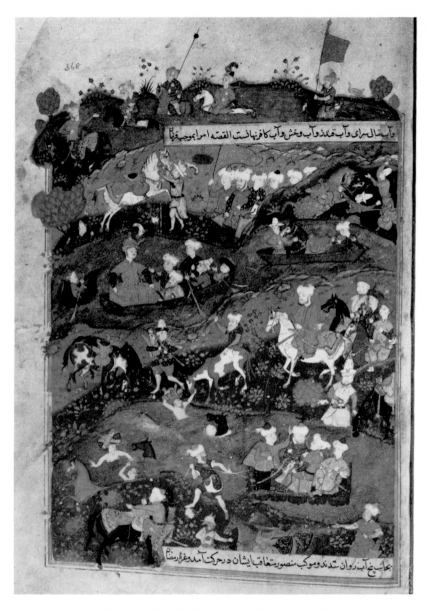

80. Mīrzā Abu'l-Qāsim fording the Oxus

are coming out of the city to attack Harqadāq. On the right a body of
cavalry rides across the bare ground (coloured grey) with lances and drawn
swords. Spectators look out of every turret, embrasure and window. In
the left background is a mosque of Turkish type with dome and slender
pointed minaret.

9 (*f. 346b*) (fig. 79). Ulugh Beg dispensing justice in Khurāsān. He is seated upon an elaborate throne, flanked by one of his cupbearers (*sāqī*), and his swordbearer. Two men are kneeling before him. One of these, a dark-skinned man, is holding a letter or petition. The dignitaries of the court are sitting before him in three rows, forming a triangle facing their sovereign. They are engaged in animated conversation. One of them in the back row is turning to watch the servants bringing refreshments accompanied by two stewards with their wands of office. These are ordering two cooks out of the chamber somewhat officiously. On the right a dish of pilau is held by a servant while another pours wine into a goblet. Two others are bearing a large tray with a number of drinking cups on it. Two attendants carry robes of honour. In the doorway on the extreme right the curtain is being held back to allow a *sāqī* to enter the hall. The doorway is guarded by an usher leaning on his staff. In the middle of the half-circle of dignitaries stand an incense-burner and a vase with tapering neck containing plants. Part of the leaves are growing through apertures in the sides of the vase. Flagons of wine and bowls of fruit are being set out. The windows look out on to a pleasure garden with a single large plane tree. The walls are decorated with mural paintings of foxes and deer.

10 (*f. 368a*) (fig. 80). Mīrzā Abu'l-Qāsim and his supporters crossing the Oxus at the ford of Qunduz on their way to Transoxiana by way of Panj-āb.[8] The winding course of the river is shown running down the folio as in a map. At the top the leading figure whose horse is shown climbing on to the bank is followed by four men riding their swimming horses. One carries a sheaf of arrows to keep it dry, another a pennant, a third is plainly an *amīr*, and the last carries the prince's standard. On the bank below, grooms are holding three restive horses while troops stand at the edge of the water where Abu'l-Qāsim has embarked in a boat rowed by two men, preceded by a man in a skiff and followed by another boat containing his horse, groom and one oarsman. On the next bank are two grazing horses, and a man, carrying his weapons, barefooted and with rolled-up trousers, prepares to go into the river. One man is already wading across the river, holding his saddle and clothes in a bundle above his head. He tries to persuade a skewbald horse to enter the river and a man is urging it from behind with a stick. In the rear rides another *amīr* accompanied by three men. One man is knee-deep in the water, leading his horse. In midstream a swimmer in difficulties clutches his horse's neck for support; another swims past his horse with a bundle of accoutre-

[8] A term used for the upper Āmū-Daryā (Oxus), the basin of five rivers.

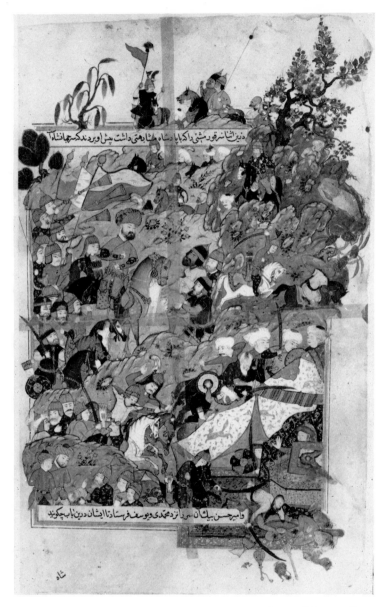

81. The head of Qūrmishī shown to Mīrzā Hasan Beg

ments on his head while yet another man drives his horse out of the water. A ferryboat containing four men is being towed to land by a man on the bank. Two more horses are held by a soldier to whom a second man is gesticulating. This miniature with some kind of activity going on every-where is perhaps the finest in the series.

11 (402b) (fig. 81). This illustration has several different features from the others, notably the huge turbans of irregular outline,[9] the brass armour and spiked helmets, two of which are of a Turkish type provided with a nasal, and the landscape and action in the extreme right could almost be early Mughal. In this scene the head of Qūrmishī is being shown to Mīrzā Ḥasan Beg as the head of Jahānshāh Qaraqoyunlu. Behind Ḥasan Beg, who wears a cloth of gold turban with aigrette, are three standard-bearers, lancers and trumpeters whose cheeks are puffed out with blowing their instruments. Behind an *amīr* beckons to two horsemen who are leading two prisoners with ropes tied round their necks. In the foreground a massacre of the occupants of two tents is taking place, with wine-flagons overturned. There are more bound captives, archers and lancers. The detail is shown minutely—even the flight-feathers of the arrows in a quiver. Some of the figures are shown full-face and some are in profile, as in the other four miniatures.

In all these illustrations, especially the last, the eclectic quality of Ottoman painting is evident but none of them belong entirely either to the court or the popular style. The reason is probably the following: in view of the subject the artist for greater accuracy and realism chose the best examples he could find among illustrated copies, contemporary or near contemporary with the scenes he was describing, and made his own interpretation of them, giving here and there his own contribution to the subject in a way which would be certain to appeal to his patron. The result has been a series of miniatures of high quality in a category not hitherto recorded by those who have written about Ottoman miniatures. Their vigour and freshness show what a Turkish painter of outstanding ability could achieve.

[9] For similar turbans typical of Turkish miniatures from the 16th century onward, compare those in a recently acquired single miniature (*c.* 1600) in the Department of Oriental Antiquities (1962, 10–13, 01).

L'ÉCOLE DE SHIRAZ ET LES ORIGINES
DE LA MINIATURE MOGHOLE

(*A propos de la découverte d'une miniature persane de l'Inde*)

par

A. S. Melikian Chirvani

La naissance de la miniature " moghole " est l'événement le plus singulier d'une histoire qui fut pourtant extraordinaire. Rien n'avait annoncé la floraison étonnante de manuscrits enluminés qui sembla commencer tout à coup entre 1570 et 1580, au moment où un prince de culture iranienne nommé Akbar faisait édifier sur un plateau désert sa nouvelle capitale de Fathpur Sikri. Rien non plus n'avait laissé deviner l'aisance avec laquelle la manière persane, les influences venues d'Europe, et l'héritage de l'Inde—réduit, il est vrai à sa plus simple expression—se fondirent en un seul langage.

Fusion si complète, si rapide que l'on chercherait en vain à déceler, en examinant les miniatures produites après 1570, à quel moment et de quel lieu provinrent cet enseignement de la Perse.

La découverte fortuite d'une miniature incontestablement peinte dans l'Inde mais en tout point marquée par le style de Shiraz tel que nous le connaissons par les manuscrits peints entre 1430 et 1450 ne peut suffire à elle seule à éclairer le problème des origines de la miniature moghole. Mais elle livre un document capital dans la suite des miniatures pré-mogholes marquées par l'influence de Shiraz. Elle m'a incité à examiner sous un nouvel angle certains documents connus. Dans un domaine aussi mal exploité, il n'est de conclusions que fort provisoires. Il me semble pourtant que deux points ne sauraient désormais être tenus pour douteux: (1) à trois reprises différentes au moins, au milieu du XIVe s., au milieu du XVe s. et au début du XVIe s., l'influence de Shiraz s'est manifestée dans la peinture musulmane de l'Inde avant même l'époque d'Akbar, (2) certains traits d'écriture qui n'allaient plus disparaître de la miniature indienne semblent bien tirer leur origine de cette influence shirazi. Ils suggèrent qu'elle fut beaucoup plus profonde qu'on ne peut le supposer au vu de documents infiniment rares.

Il faudra attendre de nouvelles découvertes pour mesurer plus exactement quelle fut la part de Shiraz dans la formation de l'idiome pictural indo-persan. Je crois qu'elle dut être d'autant plus importante qu'elle exerça ce rôle à plusieurs reprises, ce qui n'a rien pour surprendre: nous savions que les Shirazi émigrèrent fréquemment en Inde. J'aurais aimé avoir l'argent nécessaire pour disposer des archives photographiques qu'aurait supposé une étude systématique. Que l'on me pardonne de ne livrer ici qu'une brève esquisse qui doit beaucoup aux travaux d'Islamisants fort illustres, Richard Ettinghausen, R. Skelton et Basil Gray et aux suggestions de D. Barrett et R. Pinder-Wilson. Ma seule excuse est d'avoir eu hâte de livrer un document qui est totalement inconnu et de suggérer les recherches auxquelles il incite.

LA PLUS ANCIENNE MINIATURE PERSANE DE L'INDE?

La miniature de la collection S. (fig. 82) semble, en effet, être pour l'instant le plus vieux témoin d'un art dont nous commençons à entrevoir confusément la naissance: la miniature persane de l'Inde pré-moghole.

On rêve devant cette page isolée, épave d'un manuscrit sans doute détruit. On voudrait avoir l'assurance qu'elle fut remontée sur une page provenant du même manuscrit. Ce n'est hélas qu'une possibilité assez incertaine: l'image dépasse d'un millimètre la marge du texte composé sur quatre colonnes. Du moins a-t-elle été conservée dans son format initial, sans être rognée, comme l'assure le trait continu à demi-effacé qui lui tint lieu de cadre. Telle quelle, elle demeure suffisamment étonnante: elle suggère que l'école persane de l'Inde produisit ses premières œuvres dès le milieu du XVe siècle.

On ne peut douter en effet qu'elle fut tracée par un miniaturiste formé à l'école persane. Elle évoque plus précisément la manière qui fut en vogue à Shiraz dans la première moitié du XVe siècle. La composition est fondée, comme à Shiraz, sur de grands groupes également répartis dans un espace que l'architecture ou le paysage divisent en registres nettement séparés. La symétrie des silhouettes dissimulées à demi par le cadre de la miniature est un procédé caractéristique. On songe à la page extraite d'un *Ẓafar-nāma*,[1] qui appartient à la Freer Gallery de Washington. Le rythme est rendu dans l'un et l'autre cas par le même procédé: deux silhouettes symétriques s'inclinent l'une vers l'autre mais l'une

[1] Basil Gray, *Persian Painting*, Geneva 1961, p. 97.

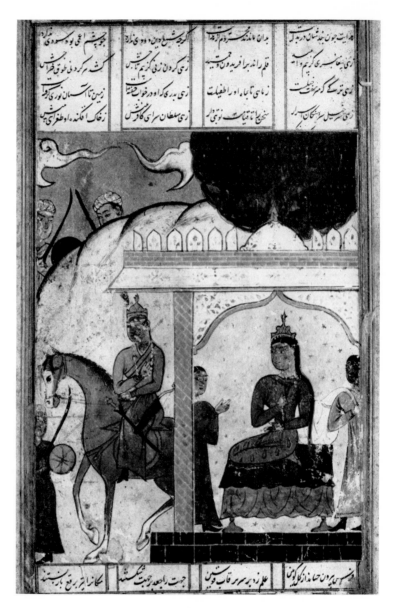

82.

d'elles fait aussi pendant à une troisième. Comme à Shiraz encore, de grandes figures emplissent l'espace inférieur de la miniature et prennent directement appui sur le cadre.

Le traitement des figures invite, au moins autant que la composition, à rapprocher cette œuvre isolée de celles que composèrent les artistes de

l'école de Shiraz entre 1430 et 1450. La courbe calligraphique des plis,
l'ovale des visages tournés de trois quart, ne laissent guère de doute. Tout
est semblable, jusqu'aux gestes des deux bras, dont l'un est maintenu
presque à l'horizontale tandis que l'autre se lève obliquement, jusqu'à la
longue robe croisée que porte le cavalier, jusqu'à la pose même du cheval
une jambe levée et le col penché selon le mouvement exact cher aux
miniaturistes de cette école et de ce temps. Un détail, que ne révèle
malheureusement pas une reproduction en noir et blanc, est capital: la
gamme des couleurs est très exactement celle de Shiraz. A nouveau l'on
peut faire un rapprochement avec la miniature du *Zafar-nāma* conservé à
la Freer Gallery. Le jaune safran et le rouge bordeaux, le bleu pâle et la
teinte rose de la brique se retrouvent dans leur nuance exacte sur tous les
manuscrits de ce temps. Une dernière précision: le ciel en dos de mouton
placé très haut, l'absence totale de la perspective et la surface rose-saumon
des collines réduites à un fond uniforme sont autant de détails qui caractéri-
sent la première moitié du XVe siècle Iranien. Tout inciterait donc à voir
dans cette image une œuvre peinte en Iran vers 1430 ou 1440 dans un
atelier provincial mais vigoureux. Tout sauf quelques détails qui dé-
montrent qu'elle a été conçue dans l'Inde. Si le style est purement
iranien, l'iconographie porte déjà la marque indienne.

Seul un peintre familier des choses de ce pays pouvait au XVe siècle
dessiner les turbans des guerriers qui apparaissent derrière les collines.
Il fallait une connaissance exacte de l'architecture de l'Inde musulmane
pour représenter le pavillon dont les bâtisseurs moghols devaient cent ans
plus tard répéter le modèle à l'infini. Aucun manuscrit persan du XVe
ni même du XVIe siècle n'a conservé une telle image. D'autres détails
de moindre importance sont étrangers à l'Iran, les pieds du trône, qui ont
une courbure fort indienne, la coiffe de l'idole, l'épée droite du cavalier
sembleraient appartenir plutôt à l'Inde.

Mais au moment même où il s'attachait à donner une note indienne
à son œuvre, des réminiscences de la Perse parurent hanter le miniaturiste.
Au lieu de représenter les piliers de pierre qu'eût sans doute édifié un
bâtisseur indien, il préféra le dessin de la brique, matériau Iranien par
excellence. Sur les écoinçons et l'auvent, il traça un fin décor bleu sur
fond blanc: représentation assez fidèle des revêtements de céramique
émaillée chers aux architectes Iraniens. Sans doute de tels revêtements
ne furent-ils pas tout à fait inconnus de l'Inde. Le mausolée Bahā' al-
Ḥaqq de Multan[2] construit au XIIIe siècle reçut un parement de *kāshī*,

[2] P. Brown, *Indian Architecture (Islamic Period)*, Bombay, 1942 p. 31; pl. XXIII, i.

selon l'usage iranien. Ceux-ci restèrent cependant exceptionnels. Le
détail même des *kāshī* représentés ici n'est pas sans intérêt car il semble
confirmer la date du XVe siècle. C'est alors que la Perse connut la vogue
du bleu-et-blanc imité de la céramique Ming amassée dans les collections
princières. Au XVe siècle encore, la fleur de lotus venue de la Chine
continuait d'être représentée comme elle l'était déjà au XIVe siècle sur
telle miniature de Shiraz conservée à la Freer Gallery. Un siècle plus
tard le motif profondément altéré n'en sera plus reconnaissable.

La conclusion semblerait donc simple : la miniature publiée ici fut
peinte par un maître Iranien travaillant dans l'Inde au XVe siècle. On
pourrait assurément se demander un instant si elle ne fut pas plutôt
l'œuvre d'un Iranien épris d'exotisme. Le cas paraît toutefois peu
vraisemblable. Un détail intéressant mérite au surplus d'être souligné :
la miniature se trouvait en Inde depuis deux siècles au moins avant
d'entrer au XXe siècle dans une collection Iranienne après un bref séjour
en Europe. Elle fut restaurée par un Indien qui noircit le visage de l'idole,
des personnages qui la saluent, du cavalier et du guerrier. Il ajouta en
outre au cavalier un collier de perles. Si la certitude absolue est im-
possible, il reste infiniment probable que cette miniature fut l'œuvre d'un
miniaturiste persan émigré, sans doute après avoir été formé à l'école de
Shiraz aux alentours de 1430 ou 1440. L'œuvre elle-même parfaitement
conforme aux canons de cette école fut exécutée dans les vingt ou trente
années qui suivirent son émigration. Il serait vain de prétendre préciser
dès aujourd'hui si ce fut en 1440 plutôt qu'en 1450 ou 1460.

LA PREMIÈRE NAISSANCE DE L'ART
INDO-SHIRAZI

Pour en mesurer l'importance il faut la comparer d'abord aux œuvres
qui la précédèrent. Aucune autre miniature persane exécutée en Inde
avant 1450 ne semble avoir survécu.

Mais il existe au moins un manuscrit peint dans l'Inde dans lequel
apparaît clairement une influence venue de Shiraz au XIVe siècle. C'est
un *Khamsa* de Amīr Khusraw Dihlawī dont les miniatures sont aujourd'hui
dispersées. Richard Ettinghausen a publié deux d'entre elles conservées
à la Freer Gallery (figs 83 et 84) et en a établi le caractère Indien : les
aiguières dépourvues d'anses, les marmites, les trônes, le voile des femmes,
le " chauri " sont inconnus au Moyen-Orient.[3] Il en a également souligné

[3] R. Ettinghausen *Paintings of the Sultans and Emperors of India in American Collections*,
Bombay 1961, pl. 1.

l'évidente parenté avec l'école de Shiraz. Le double lignage qui encadre chaque colonne de texte, la disposition de la miniature qui coupe la page à la façon d'un bandeau semblent dûs à l'influence des miniaturistes de l'époque Injū. Mais ajoute Ettinghausen, l'époque Injū ne connaissait pas ces couleurs vives, ces yeux en amande à l'iris noir, ni ces plantes pareilles à des arbres. Il attribue à l'Egypte ces trois détails, en précisant

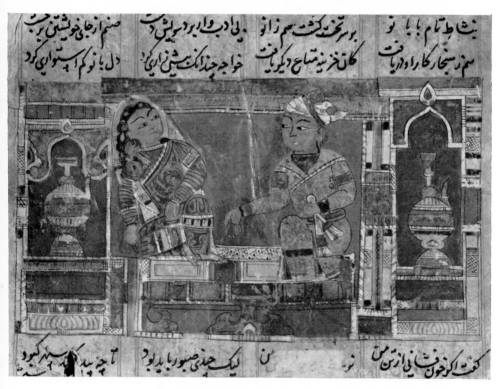

83. Le traitre vizir essaie de seduire la reine
Freer Gallery of Art

toutefois que c'est de Perse seulement que pouvaient provenir le format allongé, le goût pour l'architecture et le paysage et les scènes intérieures à trois registres. On pourrait objecter que même pour les trois détails énumérés par Ettinghausen il n'est peut-être pas absolument nécessaire d'invoquer l'exemple de l'Egypte. Les plantes pareilles à des arbres sont en fait fréquentes en Iran: un *Manāfiʿ al-Ḥayawān* peint à Tabriz au XIIIe siècle en avait offert maint exemple.[4] Le combat de Rustam et

[4] E. J. Grube, *Miniature islamiche dal XIII al XIX secolo da collezioni americane*, Venice 1962, nos. 4–6 et *Mostra d'arte Iranica, Roma, Palazzo Brancaccio*, Milan 1956, pl.

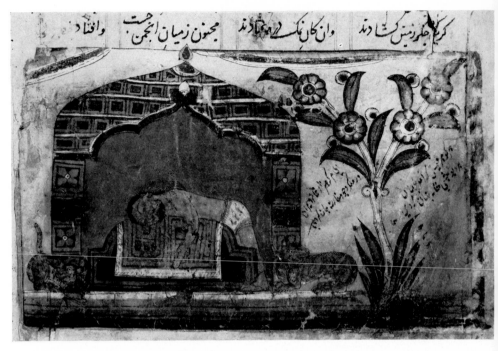

84. Majnūn au tombeau de Laylā
Freer Gallery of Art

d'Ashkabūs de la Freer Gallery, une page du *Kalīla wa-Dimna* daté 1933
confirment que l'école de Shiraz en offrit d'autres au XIVe siècle, sous la

LXXVIII. Il est vrai que sur telle miniature du manuscrit des *Maqāmāt* de Ḥarīrī daté
1337 et conservé à la Bodleian Library (L. Binyon, J. V. S. Wilkinson and B. Gray, London
1931, pl. 3.) l'arbre-plante ressemble bien davantage à l'arbre-plante indien. La similitude
du ciel est tout aussi évidente. Mais trop peu de manuscrits persans de haute époque ont
survécu pour ne pas inviter ici à la plus grande prudence. On pourrait peut-être ajouter
en faveur de la thèse égyptienne un autre argument que R. Ettinghausen n'invoque pas:
le vêtement empli de rinceaux du personnage féminin, trait qui a existé sur les représenta-
tions des céramistes persans au XIIIe siècle, mais guère dans la miniature du siècle suivant,
alors qu'il est encore assez fréquent au XIVe dans les miniatures arabes. La même remarque
encore pourrait être faite au sujet de la représentation des lions qui pour l'Iran du XIVe
siècle serait étonnamment archaïque : ils sont proches au contraire de telle miniature probable-
ment égyptienne du XIVe siècle : voir R. Ettinghausen, *La Peinture Arabe*, Genève 1962,
p. 141. On notera pour finir combien les brassards des personnages seraient eux aussi
archaïques dans l'Iran du XIVe siècle. Je me demande en fait s'il ne convient pas, plutôt
que de rechercher une source égyptienne, de discerner dans ces miniatures indiennes (1) un
héritage de la miniature persane du XIIIe siècle recouvert par (2) un héritage Shirazi du XIVe
siècle, le tout confondu et parvenu jusqu'au seuil du XVe siècle, sinon même au milieu. Si cette
hypothèse se vérifiait—et il faudrait pour cela d'autres découvertes—elle attesterait alors
un lien encore plus ancien entre la miniature persane et celle de l'Inde.

dynastie des Injū.[5] Pour ce qui est des visages des personnages du *khamsa* indien, il est amusant de noter que s'ils diffèrent assurément de ceux qu'ont peint les miniaturistes, ils évoquent curieusement les figures tracées sur les céramiques de Ray au XIIIe siècle. Quant aux couleurs vives, elles sont, il est vrai, différentes de la gamme plus sobre de l'école Shirazi comme le souligne Ettinghausen, mais il convient d'ajouter qu'à un siècle de distance elle avait eu le temps d'être altérée. Or, ainsi que le précise Ettinghausen, les miniatures sont du XVe siècle, sans doute des années 1440–50. De plus elles sont indiennes. Une dernière précision: le costume à grand revers, croisé vers la droite que porte le vizir est celui de l'Iran pre-mongol. Il était connu à la cour de l'Egypte Mameluke. Celle-ci fut-elle à l'origine de certains détails, comme le veut l'hypothèse du plus éminent des Islamisants? La chose est possible sans être vraiment évidente. Mais à vrai dire peu importe ici. L'essentiel est que Shiraz fut au moins pour une part l'inspiratrice de ces miniatures. Au demeurant, une autre miniature conservée au Worcester Art Museum (Acc. No. 1935–22) (fig. 85) fait apparaître très nettement l'influence de l'art de Shiraz sous les Injū sans rien conserver qui puisse être attribué à l'Egypte.

Il existait donc au milieu du XVe siècle dans l'Inde musulmane une école qui avait assimilé un enseignement venu de Shiraz au moins un siècle plus tôt. La graphie du *nastaʿlīq* prouve en effet que ce manuscrit ne peut être antérieur à 1450.[6] Mais en 1450 les illustrations du *Khamsa* étaient d'un archaïsme prodigieux selon les critères de la Perse. Il est remarquable qu'une tradition Shirazi née au début du XIVe siècle ait laissé des souvenirs somme toute aussi précis cent ou cent vingt ans plus tard en Inde. Tant d'exactitude dans le souvenir suppose davantage que l'influence de manuscrits parvenus jusque dans l'Inde et copiés par des artistes locaux. Elle suggère qu'il y eut vraisemblablement un atelier fondé par un miniaturiste persan, apparemment émigré de Shiraz vers 1350. Plus tard il n'en resta rien. Ettinghausen dont la science est inépuisable mentionne un autre manuscrit qui m'est inconnu et qui reflète dit-il le style du *Khamsa*. Ce fut en tout cas le dernier vestige de cette peinture issue de l'école Shirazi du XIVe siècle.

Il y avait ainsi vers 1450 au moins deux écoles de miniaturistes marqués par l'influence de Shiraz, l'une entièrement indianisée, lointaine

[5] W. Lillys, *Persian Miniatures, the story of Rustam*, Rutland, Vermont and Tokyo 1958, plate 4. Grube, op. cit. pl. 29.

[6] Tel est l'avis d'Ettinghausen. A vrai dire, le *nastaʿlīq* n'en est pas très caractéristique. Rien n'interdit de le faire remonter vingt ou trente ans plus tôt, me semble-t-il.

héritière d'un art né un siècle plus tôt, l'autre purement Iranienne et
reflétant l'art qui régnait au même instant à Shiraz. Elles furent évidem-
ment indépendantes l'une de l'autre. Elles prouvent que durant le siècle
qui s'écoula entre 1350 et 1450, des influences vinrent à deux reprises
différentes d'Iran en Inde où elles donnèrent chaque fois naissance à une
école locale, et que leur source géographique fut chaque fois encore Shiraz.

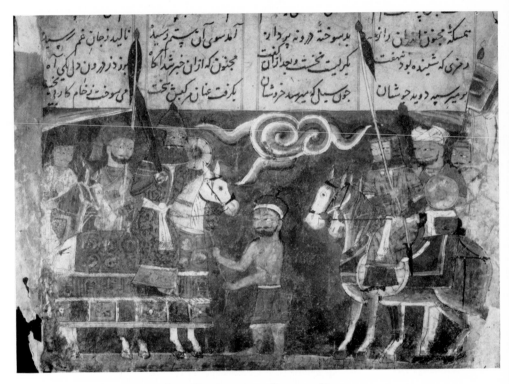

85. Rencontre de cavaliers
Worcester Art Museum, U.S.A.

S'il est difficile de mesurer l'importance du courant le plus ancien, il
est évident qu'elle ne fut pas négligeable. Très tôt les échos s'en firent
sentir dans la peinture Hindoue du Nord-Ouest. Il est intéressant de
comparer le portrait du roi Saka tel qu'il apparaît dans le manuscrit du
Prince of Wales Museum à Bombay, publié par Barrett et Gray,[7] aux
visages du *Khamsa* étudié par Ettinghausen. L'un et l'autre ont les
mêmes faces rondes, qui avaient été familières aux céramistes Iraniens du

[7] Douglas Barrett and Basil Gray, *Painting of India*, Geneva 1963, p. 59.

XIIIe siècle, l'un et l'autre font apparaître un traité de la chevelure assez semblable. Tandis que des influences Iraniennes se glissaient dans la peinture Indienne de manuscrits, celle-ci laissait sa marque sur les écoles persanes: la composition du *Khamsa* en donne maint exemple. Il se forma ainsi un idiome indo-persan si l'on nous permet d'employer un mot auquel s'attache aujourd'hui la plus grande défaveur mais qui dans ce cas précis paraît rendre très exactement compte de la réalité.

Il ne semble pas qu'il eut lui-même de successeur immédiat. Mais il prépara peut-être le renouvellement d'expériences semblables.

L'ART INDO-SHIRAZI DANS LA PREMIÈRE MOITIÉ DU XVIe SIÈCLE

Deux manuscrits persans[8] exécutés en Inde attestent en effet qu'au début du XVIe siècle les artistes Iraniens émigrèrent à nouveau pour travailler dans les cours Indiennes.

Le *Bustān* de Sa'dī qui appartient au National Museum de Delhi est capital parce qu'il porte une date, 1502–3, donnée dans le colophon, et une dédicace au Sultan Nāṣir Shāh Khaljī. Richard Ettinghausen a magistralement analysé le caractère des 43 miniatures.[9] Elles sont exécutées dans un " style uniforme que l'on peut appeler une version simplifiée du style pratiqué à Herat à la fin du XVe et au début du XVIe siècle ". Herat donc devenait à son tour le point de départ des artistes persans vers l'Inde. Je ne crois pas que ce manuscrit resta sans influence sur l'art Indien ultérieur comme l'écrit R. Ettinghausen. De multiples traits archaïques du XVIIe siècle tels que les rochers de style timouride, qui survivent dans telle ou telle miniature purement moghole, ont sans doute leur origine dans cette introduction de la miniature Herāti, même s'il serait absurde de vouloir évaluer l'influence de ce manuscrit particulier.

Mais Shiraz ne cessa pas pour autant de marquer l'art de la miniature dans les cours Indiennes. Un second manuscrit[10] brièvement commenté par G. M. Meredith-Owens est à peu d'années près contemporain du *Bustān*, et témoigne dans chacune de ses miniatures qu'il fut le produit d'un artiste issue de l'école dite *Turkmène* de Shiraz. Aucune indication ne nous apprend qui fut l'auteur des illustrations de ce *Miftāḥ al-Fuẓalā'*. Mais le

[8] Je tiens à remercier le Dr. Barrett et Mr. Pinder-Wilson qui m'ont suggéré de commenter ces deux ouvrages.

[9] R. Ettinghausen, " The ' Bustan Manuscript ' of Sultan Nasir Shah Khalji", *Marg*, xii.

[10] G. M. Meredith-Owens, *Persian Illustrated Manuscripts*, London 1965, p. 20 f. pl. XIII.

texte a été rédigé par Muḥammad ibn Dā'ūd ibn Muḥammad ibn Maḥmūd Shādīyābādī, qui vivait en Inde dans la seconde moitié du XVe siècle. Un glossaire qui donne l'équivalent Hindi de nombreux mots a presque certainement été copié en Inde.

Une fois de plus, la peinture Shirazi de l'Inde donna naissance à une école indo-persane dont nous connaissons deux manuscrits.

Le *Ni'mat-nāma*, d'abord étudié par Robert Skelton[11] et plus récemment par Basil Gray, a sans doute été peint dans les premières années du XVIe siècle. Toutefois, ses miniatures sont d'un style qui procède en partie de la manière Shirazi telle qu'elle était pratiquée dans les années 1460–80. Les visages tournés de trois-quart, les turbans, la stylisation du nuage sur un ciel bleu intense, du folio 79 v., évoquent par exemple le Khāvarnāma de Téhéran (fig. 86).

Mais la composition est simplifiée à l'extrême comme si le miniaturiste n'en connaissait plus du tout les règles. Dans la mesure où elle est encore liée à l'Iran, elle est singulièrement archaïque : les figures posées de plain-pied sur le cadre inférieur, l'absence totale de perspective, l'élément architectural, les figures à moitié dissimulées par le cadre et presque symétriques dans leur opposition appartiennent plutôt à une tradition antérieure de près d'un siècle en Iran. On a le sentiment qu'un héritage Shirazi ancien, celui dont témoignait la miniature de la collection S., a guidé l'artiste pour l'essentiel et que d'autres emprunts plus récents, toujours à Shiraz, s'y sont ajoutés. Fait important, l'esprit indien a laissé une marque indélébile. L'absence de rigueur dans la composition, les visages, qui rappellent ceux de Mewâr en sont autant d'exemples.

Un second manuscrit prouve que cette école Indo-Shirazi du XVIe siècle ne fut pas éphémère. Le *Laur chanda* conservé en partie à la John Rylands Library de Manchester a été commenté par Barrett qui en a publié une miniature dans la " Peinture Indienne " paru à Genève.[12] Manifestement l'artiste et l'atelier ne sont pas les mêmes que ceux du *Ni'mat-nāma*. Mais ces différences sont précieuses car elles n'en font que mieux ressortir le commun héritage : l'école Shirazi de la première moitié du XVe siècle, celle à laquelle avait appartenu l'auteur de la miniature de la collection S. La composition architecturale, les grandes silhouettes posées de plain-pied sur un sol qui est en fait le cadre de la composition— car la bande dorée qui la prolonge lui est presque étrangère—tout cela

[11] Robert Skelton, " The Ni'mat Namah : A Landmark in Malwa Painting ", *Marg*, xii: Barrett-Gray, op. cit., pp. 60, 61.

[12] Barrett and Gray, op. cit., pp. 69–71.

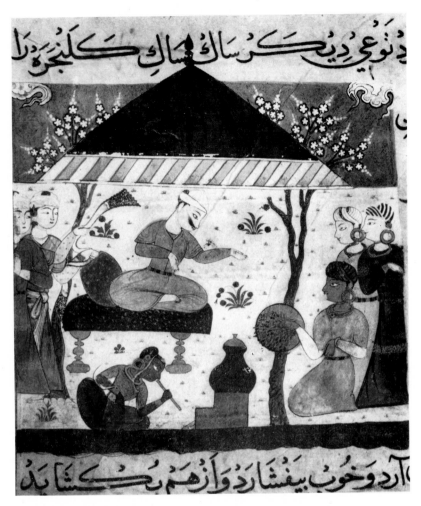

86. Scène intime de la vie d'un roi
India Office Library, London

dérive de l'ancienne Shirâz (fig. 87). Et l'on trouve à nouveau des
détails empruntés à des manuscrits comme si le miniaturiste avait entendu
moderniser sa manière persane sans très bien comprendre l'usage des
nouveaux éléments: les rinceaux délicieusement absurdes qui courent sur
l'auvent du pavillon et le chapiteau de la colonne proviennent des *sarlawḥs*
persans et non de la miniature figurative. Ils suggèrent que l'artiste
cherchait à renouer avec une tradition Iranienne dont il était coupé en
recopiant des manuscrits faute d'avoir auprès de lui des maîtres persans.

La mesure de l'influence du style Indo-persan dérivé de Shiraz qui se

constitua alors, nous est donné par le *Chaurapanchasika* de l'ancienne collection Mehta.[13] On sait l'importance de ce manuscrit dans l'histoire des origines de la miniature indienne. Or les emprunts qu'il a fait à l'idiome indo-persan sont marqués par cet héritage Shirazi ancien, depuis

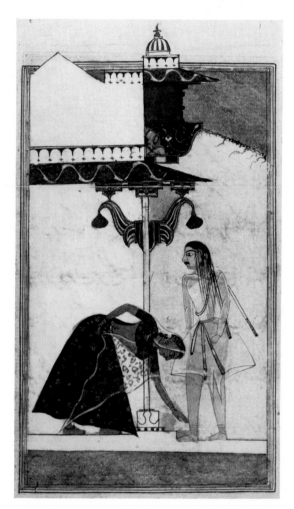

87. Illustration du roman de Laur Chanda
John Rylands Library, Manchester

longtemps indianisé par les auteurs du *Ni'mat-nāma* et d'autres œuvres disparues sans doute. L'importance de l'élément architectural sur la scène montrant Champavati devant la mare au lotus, la grande figure posée

[13] Ibid., pp. 66, 68.

sur le cadre de la composition, tout cela en dérive. Que l'on compare l'auvent du pavillon rigide, tracé à la règle, à celui de *Laur Chanda* de Manchester et l'on en percevra la parenté. Le *Chaurapanchasika* est daté par Barrett des années 1500.

Au seuil du XVIe siècle l'Inde pratiquait donc un peu partout un art Indo-Shirazi. Même le Kashmir n'échappa guère à la prodigieuse émigration d'artistes Shirazi. H. Goetz a signalé le premier dans un article très court un *Khamsa* de Niẓāmi[14] qui se trouve aujourd'hui encore à la Dogrā Art Gallery de Jammū. Le colophon donne le nom de Ibn Maḥmūd 'Ināyat-Allāh Shīrāzī et la date: 1569 J. C. Plusieurs miniatures sont du plus pur style Shirazi dont Grace Dunham Guest a magistralement étudié les caractéristiques au XVIe siècle, soulignant en particulier le grand archaïsme de la composition et de l'absence absolue de perspective.[15]

Un détail intéressant mérite d'être noté. Deux miniatures au moins, reproduites par Goetz, sont d'une main différente. Elles ont à l'évidence été peintes par un Kashmiri ce que Goetz suggère sans être aussi formel. Nous avons ainsi la preuve qu'en l'année même où Akbar montait sur le trône il y avait une école Shirazi dans le nord de l'Inde et qu'elle eut à cette date tardive des disciples dans le pays même.

L'influence de cet l'art Indo-Shirazi, à la veille du règne d'Akbar, fut très considérable.

L'HERITAGE SHIRAZI DANS LA MINIATURE MOGHOLE

Un dernier maillon vient en effet d'être révélé par la découverte remarquable du Dr. Sherman Lee.[16] Mais faute peut-être de connaître l'étonnante miniature de la collection S. ou simplement d'envisager le problème sous l'angle Iranien, le Dr. Sherman Lee et Pramod Chandra n'ont fait aucune allusion dans leur étude à la relation qui existe entre le *Ṭūṭī-nāma* publié par eux, et l'école de Shiraz.

Plusieurs miniatures de ce manuscrit qui appartient aujourd'hui au Musée de Cleveland illustrent ce que fut l'ultime métamorphose du style Shirazi indianisé avant l'épanouissement de l'art que l'on appelle moghol et que je préférerais pour ma part appeler art de la cour persane de l'Inde. Le folio 70 v. (fig. 88) révèle clairement ce qui survivait de la tradition

[14] H. Goetz, " Two Illustrated Persian Manuscripts from Kashmir ", *Arts Asiatiques*, ix.

[15] Grace Durham Guest, *Shiraz Painting in the Sixteenth Century*, Washington 1949.

[16] Sherman E. Lee and Pramod Chandra, " A newly discovered Tuti-Nama and the continuity of the Indian tradition of manuscript painting ", *The Burlington Magazine*, cv.

Shirazi des années 1430–40—celle qu'avait connue l'auteur de la miniature de la collection S. dans un manuscrit qui dut être peint dans les premières années du règne d'Akbar (1556–1605). Deux traits méritent d'être notés :

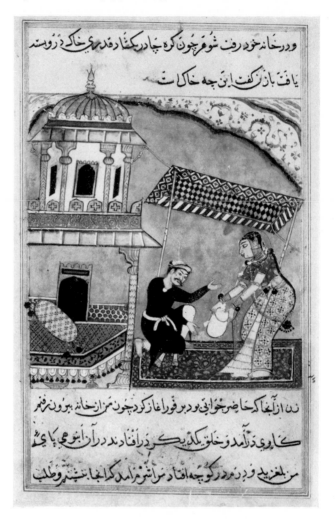

88. Histoire de la femme qui alla au marché
pour acheter du sucre
Cleveland Museum of Art

la ligne d'horizon très élevée reprend la ligne cotelée de Shiraz et le pavillon trahit encore le goût pour l'emploi des éléments d'architecture. La perspective en est particulièrement curieuse. Elle est totalement négligée pour certains éléments : le tapis sur lequel se tiennent les deux personnages,

le pavillon sont dessinés dans un espace à deux dimensions exactement semblable à celui de la miniature de la collection S. Au contraire le dais qui domine les deux personnages et le lit placé sous le pavillon sont représentés selon la perspective conventionnelle des manuscrits de Bokhara du milieu du XVIème siècle.[17] Enfin on peut observer le même contraste sur de nombreux autres folios (fol. 112 r., 278 v. etc.) qui attestent cet amalgame singulier de l'ancien héritage de Shiraz et des influences plus récentes parvenues de l'école persane d'Asie Centrale, le berceau de la dynastie qui venait de Babour. Il est amusant aussi de noter la présence des rinceaux décoratifs qui courent contre la ligne d'horizon et le ciel, héritage de l'époque du *Laur Chanda* de Manchester: les emprunts faits une ou deux générations plus tôt par des miniaturistes héritiers de l'école Shirazi des années 1430–40 qui voulaient se rattacher à la tradition persane devenue lointaine et ne disposaient que de manuscrits pour le faire, subsistaient ici encore, ajoutant un troisième élément à l'amalgame d'influences persanes successives. Parmi celles-ci cependant celle qui provenait de l'école Shirazi des années 1430–40 reste considérable. Les personnages qui prennent appui sur le cadre inférieur (fol. 43 r., 70 v.), les éléments importants acotés contre les cadres de la miniature ou à demi dissimulés par eux (silhouettes des fol. 100 v. et 10 v., pavillons de nombreux folios), la composition étagée en registres nettement séparés par un élément d'architecture (folio 10 v.) sont autant de principes venus de Shiraz (fig. 89). Certains folios attestent même une juxtaposition étrange de l'héritage Shirazi des années 1430–40 et de l'héritage Bokhari des années 1530–50: sur le folio 10 v. (fig. 89) la moitié supérieure appartient au premier, la moitié inférieure à la seconde. De l'Inde même rien ne subsiste que le type " aux yeux allongés " et rien ne subsistera dans l'art de la cour.

Il est important de noter qu'aucune influence européenne n'apparaît encore dans ces folios du *Ṭūṭī-nāma*. Il existait déjà un idiome indo-persan, profondément marqué par Shiraz et Bokhara, mêlé d'influences indiennes extrêmement réduites, quand celle-ci parvint enfin à la cour d'Akbar. La miniature " moghole " naquit seulement après que se fût déjà formé un langage pictural issu d'influences venues de la Perse parmi lesquelles celles de Shiraz joue un rôle décisif.

Il en resta au moins un trait caractéristique: l'utilisation du pavillon dans la composition des miniatures. On le retrouve dans le *Ṭūṭī-nāma* de

[17] E. Blochet, *Les Peintures des Manuscrits Orientaux de la Bibliothèque Nationale*, Paris 1920, pl. XLV.

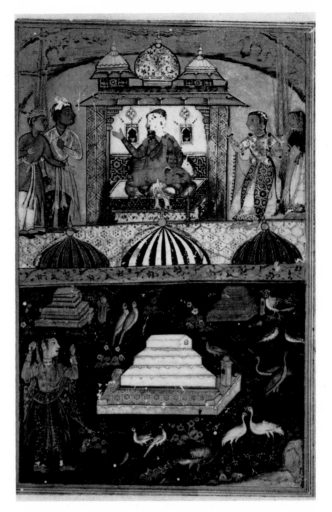

89. L'épouse de Farrukh Beg
devant un tombeau
Cleveland Museum of Art

Dublin que Basil Gray[18] date des années 1580–1605. On le retrouve encore dans le Rasikapriya exécuté vers 1610–15 (fig. 90) et dans le *Lalita Ragini* peint par Sahibdin à Oudaïpour en 1628, où chaque procédé de composition, même si les détails sont profondément marqués par la touche indienne de l'école du Mewar, tire sa source de l'art Shirazi.[19] La division en

[18] Barrett and Gray, op. cit., pp. 82, 85.

[19] Ibid., pp. 135–7.

registres séparés géométriquement par les lignes de l'architecture, les figures posées de plain-pied, sur le cadre de la miniature rappellent étrangement la miniature de la collection S.

Tant de réminiscences suggèrent que ce moment particulier de l'art Shirazi tel qu'il apparaissait vers 1430–40 laissa une marque plus profonde que tous les autres sur la peinture indo-persane en train de naître.

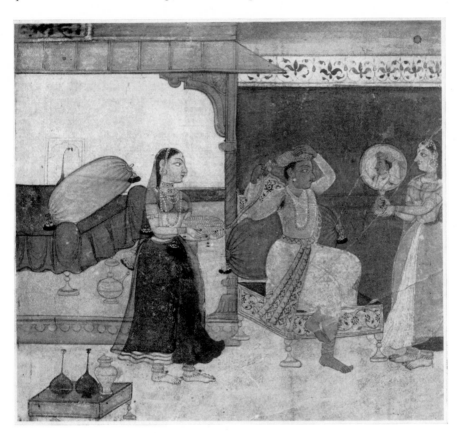

90. Illustration du Raskapriya
Museum of Fine Arts, Boston

PAINTING AT BIJAPUR

by

Douglas Barrett

A certain amount of evidence, accepted by all students of the subject, has accumulated in recent years for painting in the Islamic kingdoms of the Deccan during the 16th and first quarter of the 17th centuries A.D. Ahmadnagar, Golconda and Bijapur have been established as the three main schools or, perhaps one should say, as the three main centres of activity. For Ahmadnagar the evidence is small but sound. No-one doubts that the *Ta'rīf-i Ḥusayn-Shāhī,* in the Bharata Itihasa Samshodhaka Mandala, Poona, was painted at Ahmadnagar. Most students, correctly in my view, would date it about A.D. 1565 to 1569: a minority would wish to bring it up to the last decade of the 16th century A.D. The magnificent painting in the Bibliothèque Nationale is now generally accepted as a contemporary portrait of Burhān Niẓām Shāh II of Ahmadnagar, who ruled from A.D. 1591 to 1595. For Golconda two documents have survived from the reign of Ibrāhīm Quṭb Shāh (A.D. 1550–80): the Medical Encyclopaedia in the Chester Beatty Collection, written at the capital by Faqīr Bābā Mīrak of Herat in A.D. 1572 (A.H. 980), which contains a fine illuminated double frontispiece; and a *Shīrīn wa-Khusraw* of Hātifī in the Bankipore Library, written for Ibrāhīm in A.D. 1569 (A.H. 976) and containing a good *'unwān* and seven full-page miniatures. Both however are in Persian styles and merely indicate the choice of models available for the development of a truly local style. The only sure example of the latter is the portrait of Muḥammad Quṭb Shāh (A.D. 1611–26) in the British Museum. I have recently suggested that five miniatures inserted in a *Dīwān* of Ḥāfiẓ in the British Museum also belong to the Golconda style of about A.D. 1586 to 1590. This attribution seems to have received fairly general acceptance. For Bijapur there is only one document which has never been disputed, the Bikaner portrait of Ibrāhīm 'Ādil Shāh II (A.D. 1580–1627). This may be dated about A.D. 1595, when the monarch was twenty-four years of age. Question that this portrait was painted at Bijapur and it will be difficult to proceed. But accept the picture as an

authentic *portrait* of Ibrāhīm II and it is open to doubt whether the famous British Museum " portrait " represents the same personage. Painted at Bijapur the British Museum " portrait " may prove to be, but the identity of the subject may not perhaps be used as evidence for that conclusion. The various copies, good and indifferent, of contemporary portraits of Ibrāhīm II, together with the coldly observed portrait by Hāshim, taken either from life or a contemporary Deccan painting, do seem to establish the physionomy of the monarch and some may find it hard to believe that a large, curved nose can be painted as a short straight one. Again the two illustrations in the Hyderabad *Ni'mat-nāma* cannot be accepted as evidence for Bijapur painting on the basis of the portraits, since on both the features are effaced. They may however be accepted on other grounds—Yazdani has in fact given sufficient reason for doing so— whence it may be argued that the seated central figure of the two paintings was probably the young Ibrāhīm II. The generally accepted date for the Hyderabad *Ni'mat-nāma* is about A.D. 1590 to 1600.

There is in the British Museum an unpublished manuscript of great importance which can be attributed to the Bijapur School with as near certainty as one can hope to achieve in this field. The subject of the manuscript (Add. 16880) is the romance of Ratan Sen, Raja of Chitor, and the princess of Ceylon. It contains the bookplate dated September, 1805, of William Yule, whose sons presented it to the British Museum. The manuscript consists of 239 folios, measuring $9\frac{3}{5}$ by $6\frac{2}{5}$ inches. The poem, of 199 *chopais* and 999 *dohas*, is written, the *chopais* in red ink and the *dohas* in black, in Arabic characters within ruled and gilt borders. It is composed in an archaic form of Deccani Urdu, with a large admixture of Arabic and Persian words. The author was Ḥasan Manjhu Khaljī, who assumed the poetic name of Hans. The plot is presumably borrowed from Malik Muḥammad Jayasi's *Padmāvatī* composed in A.D. 1520, but I have been unable to find any mention of Hans' poem in the standard histories of Hindi and Urdu literature, and know of no other copy of this work.

The poet opens conventionally with the enumeration of the ninety-nine attributes of God, prayers to God, and praises of the Prophet Muḥammad, 'Alī, Fāṭima and the *Ma'sūmīn*. He then praises his Murshid Pīr, Shāh Burhānji, himself a writer of prose and poetry, who died in A.D. 1582 (A.H. 990) and was buried in his father's tomb at Bijapur. The poet continues with a eulogy of Ibrāhīm 'Ādil Shāh II, his learning, penmanship and knowledge of music and the nine *Rasas* (*Nauras*). The King had written a book, in which after much study he had collected great gems of knowledge (Folio 23b). The musician Moti Khān is then lavishly praised for his playing of the *tambūrā*, which comprehends and has complete

mastery over the *Nauras,* thus ravishing the souls of his listeners. This
is no doubt the same Moti Khān whose playing of the *mridanga* receives
special mention in Ibrāhīm II's own work, *Kitāb-i Nauras.*[1] There follows
a long passage devoted to Ātish Khān, to whom reference is also made in
Kitāb-i Nauras. Scholars have been in doubt as to the identity of this enig-
matic personage. The introduction to the " Ratan Kahan " makes it clear
he was an elephant, the pride of Ibrāhīm II's stables. He was an avatar
of Gajaraja, always in must, attracting people by his beauty as a lamp
attracts moths. If all the painters, no matter how gifted, essayed his
likeness, they would fail. Much the same sentiment is expressed in the
Kitāb-i Nauras, together with the prayer—for this is how the line given
by Gayani[2] must now be translated—that Ātish Khān, the elephant who
is always in must, might live for ever. There follows a brief and difficult
reference (folio 31a) to Chanchal, who, it seems, had crossed the salt sea.
Then follows an enthusiastic description of Bidyapur (Bijapur) and its
environs. In the citadel, now generally called the Arq-qil'ah, the drums
were beaten thrice daily. The moat, now dry, was as deep as the ocean
and full of alligators, the latter statement probably not merely a poetic
conceit. Special praise is lavished on the Anand Mahal, which is said to
have been built by Ibrāhīm II in A.D. 1589, and to which he rode in state
in A.D. 1591 after his victory over Ismā'īl Niẓām Shāh of Ahmadnagar.
The poet goes on to describe the gardens of Bijapur, its roads, shops and
markets. Every house, he claims, had a mosque, for the people were as
religious as the King himself. Of course special mention is made of the
Jāmi' Masjid, begun by 'Alī 'Ādil Shāh I after the victory of Talikota over
the empire of Vijayanagar in A.D. 1565. Reference is also made to three
famous suburbs outside the walls of Bijapur: Ibrahimpur, about a mile
from the Fath Gate to the south-east, Allahapur to the east and Nauraspur
to the west. After modest protestation of his lack of virtue and general
unsuitability for the task the poet says he composed his " Ratan Kahan "
at the instigation of his friends in A.H. 999 (A.D. 1590–1591). The long
introduction now ends and the poem proper begins. The manuscript
contains no colophon.

 Before discussing the illustrations to the manuscript a few words may
be said of its relevance to the problem of the composition of Ibrāhīm II's
Kitāb-i Nauras. In the introduction to the " Ratan Kahan " the word
nauras frequently occurs in references to the King's musicianship and to
that of Moti Khān. Obviously Ibrāhīm II, though only nineteen years of

[1] B. G. Gayani, " Kitab-i-Nauras ", *Islamic Culture,* xix (1945), p. 151.
[2] Ibid., p. 151.

age in A.D. 1590, was already an enthralled student of this aspect of Hindu music and aesthetics. Also the building of the new suburb at Nauraspur, though perhaps never completed, had evidently begun. There is moreover, in the " Ratan Kahan " clear and explicit mention of a book into which the King had collected great gems of knowledge. B. G. Gayani,[3] after a study of the surviving manuscripts, has said that the *Kitāb-i Nauras* " is a collection of stray songs composed by the King from time to time, and that the songs were meant to be sung in different tunes or Ragas of Indian music. There is nothing like a continuous narrative on any particular subject ". Gayani held the Sir Salar Jung copy of the *Kitāb-i Nauras* to be the earliest. It is said to bear the date A.H. 990 below the name of the scribe 'Abd al-Rashīd, and contains less songs than other manuscripts, thus suggesting the continuance of the King's poetic activity, the new songs being incorporated in later copies. Nāṣir al-Dīn Hāshimī has also placed the compilation of the book between A.H. 990 (A.D. 1582) and A.H. 1015 (A.D. 1606). The date in the Sir Salar Jung copy is puzzling. It would mean that the King had composed most of his songs by A.D. 1582, when he was eleven years old. Such Mozartian precocity may be doubted, but it is clear from the introduction to the " Ratan Kahan " that he was at nineteen already an accomplished musician, at least in the eyes of his courtiers, and had written a book. Internal evidence for the date of the *Kitāb-i Nauras* is unfortunately small. Moti Khān and Ātish Khān, and here the introduction to the " Ratan Kahan " is helpful, were already well-known personalities in A.D. 1590 to 1591. A reference to Chand Bībī, Ibrāhīm II's famous aunt, wishing her long life, obviously antedates her tragic death at Ahmadnagar in A.D. 1600, and may possibly be earlier than A.D. 1588 when she left Bijapur to accompany Khadīja, Ibrāhīm II's sister, to the latter's shortlived and unhappy marriage with Ḥusayn, the son of Murtaẓā I of Ahmadnagar. Ẓuhūrī's famous prose preface to the *Kitāb-i Nauras* is, one supposes, not earlier than A.D. 1595. Ẓuhūrī had dedicated his *Sāqī-nāma* to Burhān Niẓām Shāh II of Ahmadnagar, whom and whose court it eulogises, and is not likely to have left Ahmadnagar for Bijapur until after the death of his patron in A.D. 1595. Presumably one at least of the versions of the *Kitāb-i Nauras* is later than this date. Nevertheless the introduction to the " Ratan Kahan " makes it clear that the young king had already begun to write by A.D. 1590. No doubt a great deal more useful information could be gleaned from the manuscript by a scholar experienced in Deccani Urdu.

[3] Ibid., p. 144.

The manuscript of the " Ratan Kahan " contains a good illuminated *'unwān* and thirty-four miniatures, which with three exceptions (folios 177b, 178b and 184a) occupy the whole page. The whole page miniatures measure about $6\frac{9}{10}$ inches by $3\frac{9}{10}$ inches. One however (folio 80a) is larger and broader, measuring $7\frac{1}{10}$ inches by $5\frac{3}{10}$ inches, and another (folio 197b) is exceptionally tall and narrow, measuring $8\frac{1}{5}$ inches by $3\frac{9}{10}$ inches. Two main hands or manners may clearly be distinguished in the manuscript, and probably a third. Hand A is responsible for eighteen of the miniatures (folios 46a, 47a, 49b, 69a, 75b, 80a, 82b, 89b, 119a, 138a, 181b, 183a, 197b,

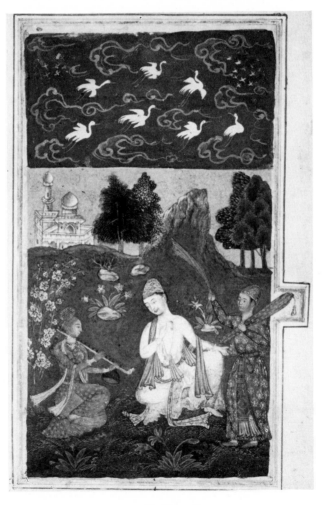

91. Folio 46a

210a, 213b, 215a, 219a, and 232a). (Figs. 91–99.) Seven of these minia-
tures are composed to fill the whole of the allotted field, but in eleven of
them a horizontal band of decoration is introduced at the top of the
picture, as if the tall, narrow format were an embarrassment to the artist.
This band is filled with gold "Chinese" cloud-scrolls on a solid blue
ground. Occasionally flights of white cranes are painted among the cloud-
scrolls. On a few miniatures, e.g. folios 181b and 210a, two bands of
decoration are employed at the top: the gold "Chinese" cloud-scrolls
on blue and below, a band of red "Chinese" cloud-scrolls on gold, or of

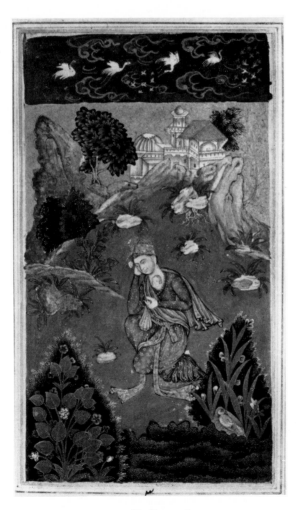

92. Folio 49b

regular scrolling, also red on gold. Below this again sometimes hangs a
textile *torana*. This use of bands of decoration employing two forms of
cloud and sky convention, is of course found on the British Museum
portrait of Muḥammad Qutb Shāh of Golconda. On the picture proper
the sky is usually solid gold, sometimes with long, ragged red clouds.
Occasionally dark and light blue with white are used to produce a stormy
sky: an effect found in the Hyderabad *Ni'mat-nāma* and in the Bikaner
portrait of Ibrāhīm 'Ādil Shāh II. Gold is very lavishly used throughout
for jewellery, designs on costume, costume itself, and sometimes for the

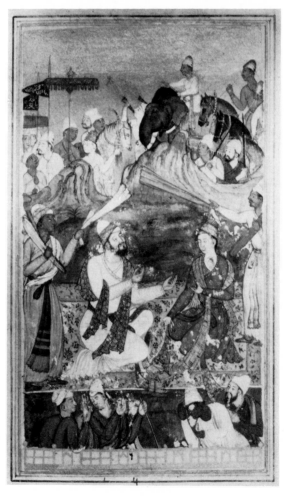

93. Folio 75b

entire ground of the scene. The general impression of the miniatures is consequently of a richness and brilliance rare even in Deccan painting, which delighted in such effects. In general the foliage of trees and bushes is depicted as a dark mass edged with flickering touches of pale green, yellow, purple and red. Such foliage is also used to provide a background to the strangely out of scale iris-like plants frequently found in Deccan painting. The trees, like the sky, are usually full of white cranes, as on the miniature in the Hyderabad *Ni'mat-nāma*. Certain trees, like the banyan, are individually portrayed. The ground itself, when not gold, is a warm

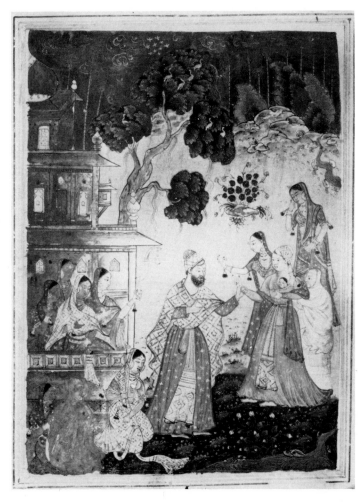

94. Folio 80a

brown, or a dark green lit with light green grass or small red and white glimmering flowers. White palaces and pavilions embowered in trees or perched on " Persian " crags are a frequent feature of the high sky line. The human face is already modelled with skill, and the artist has, with the princess of Ceylon in particular, achieved a delicate charm of expression in his women. The men wear the typical costume of Bijapur, the folds of shawl, coat or girdle often being treated with considerable plasticity. The coats have the long prominent straps on either side, often in a contrasting

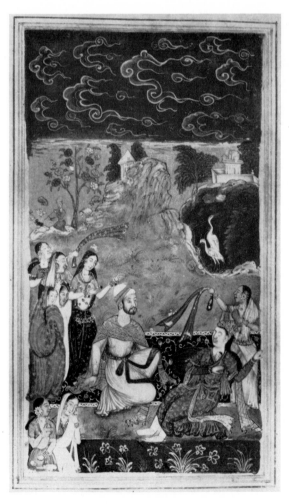

95. Folio 82b

colour: a fashion peculiar to the two southern kingdoms of Bijapur and Golconda. The finery of the women is as splendid as the men's. The saris are very long, drawn across the bosom and over the back of the head, like an *orhni*, to hang down in a long, narrow fold, which either caught at the girdle or elegantly held by the hand or over the lower arm, is allowed to splay outwards. Everywhere is found those daring colour clashes of dark green and pale purple, gold and black and chocolate and blue, to which Deccan painting owes so much of its distinctive quality.

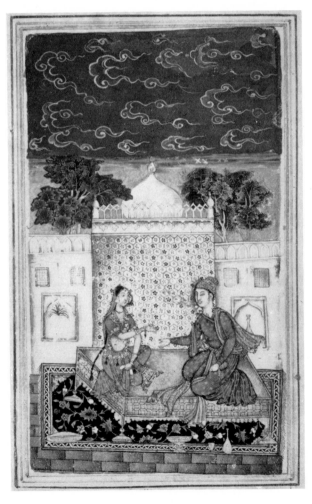

96. Folio 119a

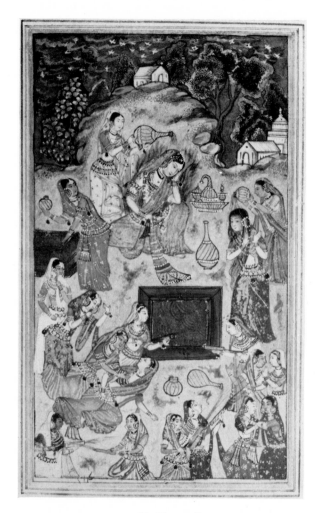

97. Folio 138a

98. Folio 197b

99. Folio 213b

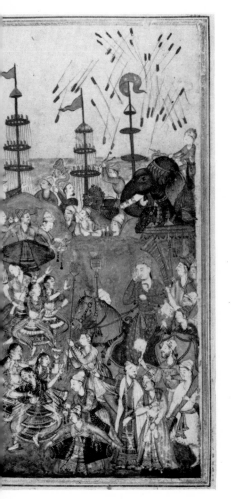

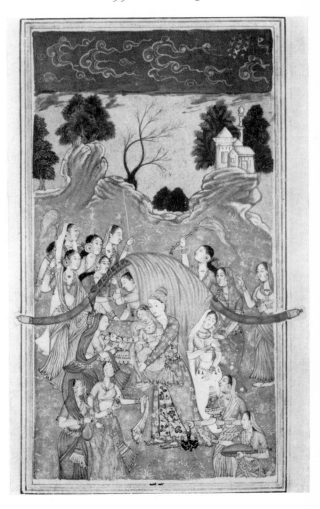

 Hand B is responsible for fourteen miniatures (folios 90b, 135a, 147a, 166a, 168a, 171a, 172a, 176a, 177b, 178b, 184a, 202a, 206a, and 224b). (Figs. 100, 101.) Though he commands most of the stylistic vocabulary of Hand A, this artist is altogether a smaller talent. He attempts little or no modelling of the face, and his efforts to realise the volumes of the human form or the plasticity of drapery folds are usually clumsy and unconvinc- ing. He has a particular fondness for purple grounds, on which large gold flowers and scrolls are heraldically placed with no concern for scale or " naturalism ". At his most pedestrian his line is coarse and colours harshly juxtaposed. But he often communicates a real, if naive charm, as two of

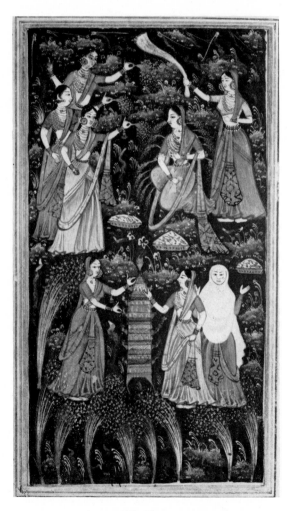

100. Folio 147a

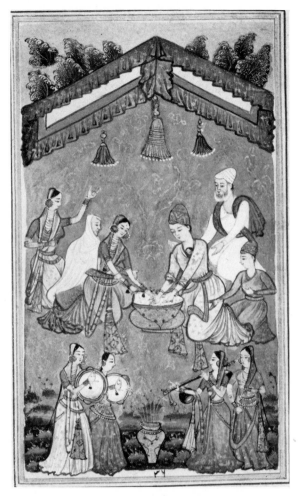

101. Folio 224b

his more successful pages (folios 147a, and 224b) illustrate.

Hand C, responsible for two miniatures (folios 70b and 87a) (fig. 102) should also perhaps be isolated. The general style of this artist is close to that of Hand A, but a little less finished. His two pictures have a quite distinctive tonality, in which pale and dark blue predominate. His best miniature (folio 87a) shows Ratan Sen, the image of his beloved in his bosom as in every appearance of the hero, listening to two musicians. The agony of separation causes the lover to emit flames of longing, a conceit applied to Ātish Khān in the *Kitāb-i Nauras*.

The evidence of the introduction to the " Ratan Kahan " is sufficient

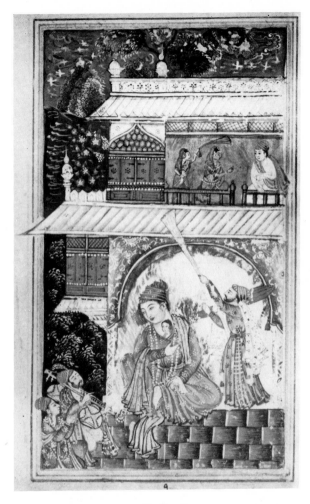

102. Folio 87a

support for the assertion that the manuscript was both written and illus-
trated at Bijapur. It reinforces the attribution to Bijapur of the Hyder-
abad *Niʿmat-nāma* and of the Bikaner portrait of Ibrāhīm II, both of which
are very close to the style of Hand A. As has already been said, there is
no colophon to the " Ratan Kahan ". If however the Hyderabad *Niʿmat-
nāma* can be accepted as about A.D. 1590 to 1600 and the Bikaner portrait
as about A.D. 1595, then it is fair to suggest that the date of composition
(A.D. 1590–1) of the " Ratan Kahan " is probably also the date of this,
perhaps unique, manuscript of it. In support of this it may be added that

the date of composition of the poem is curiously emphasised.[4] The date, given as a chronogram in black ink in the poem (folio 38b), is repeated below in *abjad* numerals in red ink. If the British Museum " Ratan Kahan " can plausibly be dated about A.D. 1590 to 1591 it will be the earliest, as it is certainly the finest, illustrated manuscript which can be attributed with near certainty to Bijapur. It will have been written and illustrated at the moment when Ibrāhīm II had reached the age to take over control of government, himself to begin poetic composition, and to exercise effective patronage of the arts.

The British Museum manuscript also underlines the early appearance in Deccan painting of shading of the face and plastic modelling of body and drapery. This " naturalistic " intention is clear in the Hyderabad *Ni'mat-nāma* and the Bikaner portrait of Ibrāhīm II, and also in the portrait of Burhān II of Ahmadnagar to be dated A.D. 1591 to 1595. It does not appear in the five miniatures which I have attributed to Golconda of about A.D. 1586 to 1590 which follow rather the Persian conception of picture making as a two-dimensional emotive pattern of line and colour, a conception which survives, though much modified, in the British Museum portrait of Muḥammad Quṭb Shāh of about A.D. 1612. The Bijapur style of Hand A however looks forward, perhaps with some influence from Mughal painting of the Jahāngīr period, to the small but exceptionally fine group of highly finished portraits of about A.D. 1615 in the British Museum, the Victoria and Albert Museum and the India Office Library, of which the " Ibrāhīm II " in the British Museum is the best known. The style of Hand A also suggests that another important Deccan picture of the early 17th century A.D., the Chester Beatty " Yogini " should be attributed to Bijapur, as earlier claimed by Basil Gray, Dr. Moti Chandra and other scholars, rather than to Golconda, as I had proposed.

Hand B in the British Museum manuscript, less competent than Hand A, is also more old fashioned. It has perhaps a bearing on the provenance and date of some of the most controversial groups of 16th century A.D. Deccan paintings, especially of the Chester Beatty *Nujūm al-'Ulūm* and of the more " southern " group of Rāga paintings and their copies.[5] Though most of the pages of the *Nujūm al-'Ulūm* show strong influence from the style of the Vijayanager Empire, certain elements, the small female figures on the frontispiece and the preference for grounds of

[4] I owe this interesting observation to my friend Muhammad Idris Siddiqi.

[5] Douglas Barrett, *Painting of the Deccan. XVI–XVII Century*, London 1958, Pl. **3** and note.

solid colour, especially purple, with heraldically placed floral designs in gold, do seem to be related to the style of Hand B of the British Museum manuscript. If the latter is accepted as about A.D. 1590 to 1591, the thrice repeated date of A.D. 1570 in the *Nujūm al-'Ulūm* and its attribution to Bijapur would receive some support. The same stylistic elements in the Rāga paintings, especially the women with their long, looped saris, would also suggest that the " southern " group at least was painted at Bijapur sometime between A.D. 1570 and 1590.

The manuscript of the " Ratan Kahan " has a certain relevance to the identity of the subject of the British Museum " portrait " of Ibrāhīm II. The miniatures by Hand A of the meeting of the King of Ceylon and Ratan do seem to establish that in Bijapur painting a heavily built man with a beard is not necessarily Ibrāhīm II. It would have been a doubtful if not dangerous compliment to employ the figure and features of the nineteen-year-old King to depict the middle-aged father of the heroine of the poem. The identity of the subject of the British Museum portrait remains an open question. In this context something may be said of the portrait of Ibrāhīm II in the Naprstek Museum, Prague.[6] The inscription at the top of the page on which the portrait is mounted, reads: " Allah is greatest. Portrait of Ibrāhīm 'Ādil Khān Dekkanī, governor of Bijapur, who in the knowledge of the music of the Deccan made himself the master of those who profess the art." The inscription continues at the bottom of the page: " and it is the work of Farrukh Beg in the 5th regnal year equivalent to the year 1019 (A.D. 1610–11). Written by Muḥammad Ḥusayn Zarīn Qalam Jahāngīr-Shāhī ". There is of course no suggestion that Ibrāhīm II, who like the other Deccan rulers, was regarded as a mere fief-holder by the Mughals and addressed as " Khān ", sat for Farrukh Beg. In the Prague portrait the King seems to be about the same age as in the Bikaner portrait, perhaps a little younger. I would suggest that the original Bijapur painting on which the Mughal copy by Farrukh Beg is based, was, in the light of the style of Hands A and C of the British Museum manuscript, not much later than A.D. 1595.

In the introduction to the " Ratan Kahan ", immediately after the long and grandiloquent eulogy of Ātish Khān, Chanchal is briefly mentioned as having gone over the salt sea. This is evidently an elephant, and the Chanchal which Ibrāhīm II reluctantly handed over to Akbar in A.D. 1604. Chanchal—the name means playful or coquettish—was, one may believe, a female. Perhaps her absence from Bijapur, whither I cannot

[6] Lubor Hajek, *Indian Miniatures of the Moghul School*, London 1960, pls. 10–14.

conceive, caused Ātish Khān, in the imagery of the *Kitāb-i Nauras*, to
burn with the fire of longing, if she was his favourite. It would be useful
if someone experienced in this field could sex the splendid elephant in the
famous Deccan or Mughal copy of a Deccan miniature in a private collec-
tion in Banaras.[7] If the elephant is female, Dr. Moti Chandra's suggestion
that it is Chanchal is very plausible. If it is male, as N. C. Mehta assumed,
then it may well be a portrait of Ātish Khān, the most prized and admired
of Ibrāhīm II's elephants, whose likeness the painters could not success-
fully capture. The date usually given to the miniature, about A.D. 1600,
would suit either alternative.

I wish to thank my friends Muhammad Idris Siddiqi and Ralph
Pinder Wilson for their help in preparing this paper.

[7] N. C. Mehta, *Studies in Indian Painting*, Bombay 1926, pl. 47.

AN ILLUSTRATED MUGHAL MANUSCRIPT
FROM AHMADABAD

by

R. Pinder-Wilson

The Mughal school of painting owed its origin and development to the enthusiastic patronage of the Emperor Akbar. The imperial library set the standards for the lesser establishments of the great Mughal officers. Since these could not command the resources of the emperor, their productions lack the inspiration and finish of the great imperial books. Nevertheless it was through these more modest works that the canons of Mughal taste and style came to be disseminated in the provinces where paintings were executed which have been characterised in recent years as " popular Mughal ".[1] These in their turn contributed to the creation and development of the independent schools of Rajasthan such as those of Bundi and Mewar.

It has yet to be shown whether " popular Mughal " paintings were produced earlier that the period of Jahāngīr. This is not the case, however, with Mughal paintings made for court circles. There is evidence that private establishments were already at work in the last years of Akbar. If little is known of the extent of Hindu patronage in this period, we have precise, albeit exiguous, information regarding Muslim patrons. There are two illustrated manuscripts which are expressly stated to have been made in Allahabad and their dates fall within those years during which Prince Salīm, the future Emperor Jahāngīr, had his official residence in that city.[2] They may well be, therefore, the products of his own establishment.

We are particularly well informed by contemporary writers about the

[1] See Karl Khandalawala, Moti Chandra and Pramod Chandra, *Miniature Painting, a catalogue of the Exhibition of the Sri Motichand Khajanchi Collection held by the Lalit Kala Akademi, 1960*, New Delhi 1960, pp. 14 ff: and Pramod Chandra, " Ustad Salivahana and the development of Popular Mughal Art ", *Lalit Kala*, 1960.

[2] These are (*a*) a manuscript of the *ghazals* of Amīr Najm al-Dīn Ḥasan Dihlavī completed in Allahabad on the 27th Muḥarram 1011 H. (A.D. 1602) by Mīr ʿAbd Allāh Kātib, now in the Walters Art Gallery, Baltimore, U.S.A., see R. Ettinghausen, *Paintings of the*

library establishment of 'Abd al-Raḥīm Khān-i Khānān (1556–1627), son of Akbar's tutor and guardian, Bayram Khān.[3] Apart from scribes and bookbinders, no less than three painters are mentioned as being in his service. Moreover, there still exists a manuscript of the Persian translation of the *Ramayana* made for him from Akbar's own copy between A.H. 996 (1587/88) and 1007 (1598/99).[4] At least fifteen artists contributed the one hundred and thirty surviving miniatures. We are not informed where this manuscript was made but since it was copied from the original made for Akbar the most likely city would be either Lahore or Agra.[5]

An illustrated manuscript now preserved in the British Museum,

Sultans and Emperors of India in American Collections, Bombay 1961, plate 8: and (*b*) a manuscript of the *Raj Kanvar*, a romance, copied at Allahabad in 1012 (A.D. 1603) by the scribe Burhān, now in the Chester Beatty Library, Dublin (no. 37).

[3] M. Mahfusul Haq, " The Khan Khanan and his painters ", *Islamic Culture*, 1931, pp. 621–30; S. A. Zafar Nadvi, " Libraries during Muslim Rule in India ", *Islamic Culture*, 1945, pp. 333 et seq.

[4] Now in the Freer Gallery of Art, Washington; see R. Ettinghausen, op. cit., plates 3 and 4.

[5] Apart from Allahabad, illustrated manuscripts in which the copyist has expressly named the city where the work was completed are listed hereunder:

Fathpur Sikri

Gulistān of Sa'dī copied by Muḥammad Ḥusayn al-Kashmīrī, now in Royal Asiatic Society of London (no. 258): see Leigh Ashton, *The Art of India and Pakistan, Commemorative Catalogue of the Exhibition held at the Royal Academy of Art, London, 1947–8* p. 143 and colour pl. 121, pl. 119: J. V. S. Wilkinson, *Mughal Painting*, London 1948, plate 4 (colour).

Agra

Nafaḥāt al-Uns of Jāmī, copied in A.D. 1603, now in British Museum (Or. 1362): H. Goetz, *Bilderatlas zur Kulturgeschichte Indiens in der Grossmoghulzeit*, Berlin 1930, Tafel 23, Abb. 64, Taf. 33, Abb. 87, Taf. 34, Abb. 90, Taf. 38, Abb. 112; E. Wellesz, *Akbar's Thought reflected in Mogul painting*, London 1952, p. 41, pl. 35: D. Barrett and B. Gray, *Painting of India*, Geneva 1963, pp. 96, 99 and illustr. p. 97.

Lahore

Dīwān of Anṣārī copied in 1588, now in Fogg Art Museum, Cambridge, U.S.A.; see S. C. Welch, *The art of Mughal India, Painting and precious objects*, New York 1964. *Bahāristān* of Jāmī copied by Muḥammad Ḥusayn Zarrīn Qalam in 1595, now in Bodleian Library (Elliot Collection, no. 254); see L. Ashton, op. cit., p. 146, no. 651, pl. 124 with bibliography to which add Barrett and Gray, op. cit. pp. 87–9, 96, 102 and plate on p. 88. *Anwār-i Suhaylī* copied by Mawlānā 'Abd al-Raḥīm al-Harawī in 1596–7, now in Bharat Kala Bhavan, Benares, India: see S. C. Welch, op. cit.; *Manuscripts from Indian Collections, descriptive catalogue of an exhibition of selected manuscript from Indian Collections in honour of the XXV International Congress of Orientalists*, New Delhi 1964, p. 102.

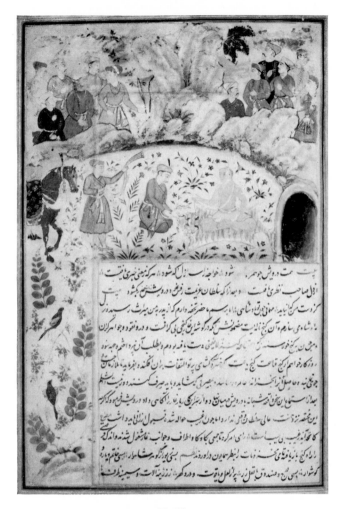

103. Folio 11a

provides evidence that at Ahmadabad, the capital city of the province of
Gujerat, there was a library studio producing Mughal paintings in the
closing years of Akbar's reign. This is a manuscript of the *Anwār-i
Suhaylī*, the Persian version of the *Kalīla wa-Dimna*, composed by Ḥusayn
Wā'iz-i Kāshifī at the end of the fifteenth century.[6] It has 207 folios
including 43 miniatures. The size of the page is $11\frac{5}{6}$ by $7\frac{3}{4}$ inches and
of the gold ruled text area $8\frac{3}{4}$ by 5 inches. There are 21 lines to the page.

[6] Or. 6317, acquired in 1902.

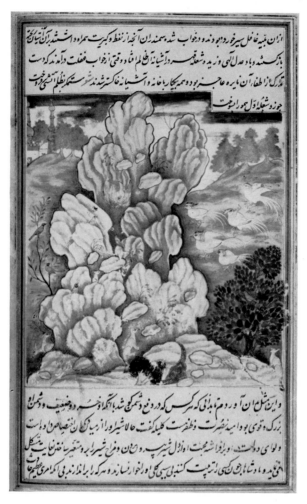

104. Folio 38b

There is an illuminated *sarlawḥ* on folio 1 verso and gold floral decoration surrounding the colophon on folio 207 recto. The manuscript copied in a fine *ta'līq*, was completed in A.H. 1009 (1600/1601) at Ahmadabad by Taymūr Ḥamus (? حموس). With the exception of the whole page miniature on folio 124 verso each miniature contains a portion of text. The most characteristic shape of the miniatures is one in which the principle part of the scene occupies about two thirds of the height of the text area while a narrow vertical area is added so that the complete miniature assumes the various positions of a L. (figs. 103, 105, 108). The miniatures are listed below.

No.	Folio	Subject
1	11r.	A hermit informs King Dabshalim of the treasure hidden in the cave (Eastwick, p. 33 ff.)[7] (fig. 103).
2	15v.	The eagle and the falcon contest for the pigeon (Eastwick, p. 47).
3	20r.	The hawk wins the quarry from the royal falcon and thus secures the king's favour (Eastwick, p. 62).
4	23r.	King Dabshalim visits the Brahman Bidpai in the mountain cave on Sarandīb (Eastwick, p. 70).
5	29r.	The monkey is injured while presuming to perform a carpenter's work (Eastwick, p. 86).
6	31v.	Ghānim carries the stone lion to the top of the mountain and is acclaimed sovereign by the citizens (Eastwick, p. 91).
7	38v.	The sparrows enlist the help of the salamanders in burning the falcon and his nest (Eastwick, p. 111 et seq.) (fig. 104).

This is the smallest of the miniatures. The trees on the horizon are " stippled "; the ground is washed with horizontal stripes. Green " stippling " on rocks is intended to indicate lichen. The white birds with long tails on the right have gold crests; other birds are vermilion and brown.

No.	Folio	Subject
8	41r.	The crab kills the old and treacherous heron (Eastwick, p. 117 et seq.).
9	43v.	The hare by a ruse causes the lion to be drowned in a well (Eastwick, p. 124 et seq.) (fig. 105). The miniature is rubbed in places. The hillocks are rendered in ranging from green to yellow with heavy contour lines. The brickwork of the well is mauve.
10	52v.	A leopard instead of a fox is caught in the hunter's snare (Eastwick, p. 151 et seq.).
11	54v.	The camel sacrifices itself to the lion and his subjects, the crow, the wolf and the fox (Eastwick, p. 153 et seq.).
12	56v.	The tortoise is borne by his companions, the geese, into the sky (Eastwick, p. 159 et seq.).
13	57v.	The Simurgh causes the genius of the sea to restore the fledglings of the sandpipers (Eastwick, p. 164).

[7] The *Anvar-i Suhaili; or the Lights of Canopus* . . . translated into prose and verse by Edward B. Eastwick, F.R.S. etc., Hertford (England) 1854.

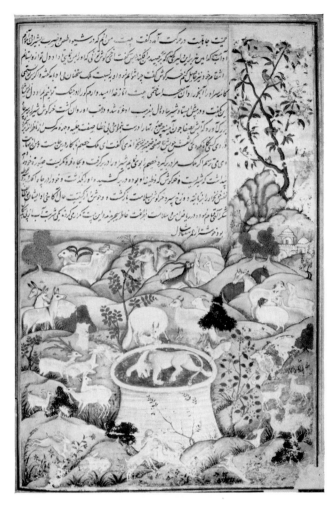

105. Folio 43b

No.	Folio	Subject
14	59v.	The monkeys rebuff the bird when it tries to convince them that the sugar cane is not really burning and so will not keep them warm (Eastwick, p. 170 f.).
15	61v.	The mongoose devours the frog which persuaded him to eat the snake (Eastwick, p. 174 f.).
16	64r.	The bear casts a stone onto the face of his friend the gardener in order to ward off the flies (Eastwick, p. 180 et seq.).

No.	Folio	Subject
17	68r.	The fox having lost the fowl and the skin having been carried off by the kite, dashes his head against the stones in his despair (Eastwick, p. 193 et seq.).
18	78v.	The blind man who mistook a snake for his whip (Eastwick, p. 209 et seq.).
19	86r.	A hawk tears out the eye of the falconer who had calumniated his master's wife (Eastwick, p. 241 et seq.).
20	89r.	The pigeons caught in the fowler's net (Eastwick, p. 250 et seq.).
21	93r.	The treacherous hawk after professing friendship, devours the partridge (Eastwick, p. 258 et seq.).
22	96r.	The fox by a ruse enables the camel driver to destroy the snake which he had saved from the fire (Eastwick, p. 264 et seq.).
23	99v.	The hunter having shot a deer is killed by the boar which he had slain. A wolf enjoying the prospect of three carcases is itself killed when, gnawing through the hunter's bow string, the arrow is released (Eastwick, p. 275 et seq.).
24	107r.	The crow, the mouse and the deer cause the tortoise to escape from the hunter's bag (Eastwick, p. 295).
25	114r.	The hare Bihrūz induces the elephants to refrain from drinking in the fountain of the moon (Eastwick, p. 315 et seq.) (fig. 106).
		One elephant is white, three are grey-black with buff coloured trunks. The pool is rendered by white washes on a grey ground. The rocks on the horizon are mauve. Tufts of grass grow on a yellow-green ground.
26	116r.	The partridge and the quail ask the pious cat to settle their dispute. The cat after offering some empty sentiments, devours them (Eastwick, p. 325 et seq.).
27	124v.	Maymūn the monkey entices the bears into the desert where they die of the heat thereby restoring their island to the monkeys (Eastwick, p. 345 et seq.) (fig. 107).
		The only whole page miniature in the book. The scorching desert is effectively depicted by the natural tone of the paper save for light washes of yellow-brown and by the absence of a defined horizon. The sun in the top right is golden. The bears are grey-black.

The grey and white heron stands on one of the feet of the throne. Sulaymān is clothed in a gold and pink

striped *jāma*. His golden crown with red *kulāh* is set
against a gold flame nimbus. On the throne is a blue
cushion. The angels have variously coloured wings and
golden crowns. The plumage of the birds is variegated:
the peacock's tail feathers being gold with " turquoise "
eyes.

The miniatures appear to be the work of a single artist who was more
familiar with the Mughal style of the two previous decades rather than
with the developments that were taking place in the imperial library at
the turn of the century. While his colours are typical of the Mughal palette,
he attempts neither tonal differentiation in his landscape nor the modelling
of faces. He adheres to the Mughal convention of the high horizon, strews
his ground with tufts of grass or flowering plants, or uses stippling for
ground and trees. Usually white clouds rendered naturalistically adorn
his skies. If his human figures are the stock-in-trade of Mughal painting,
his animals are well observed. If his style is somewhat attenuated, he has
achieved several striking compositions notably those of the bears in the
desert (fig. 107) and of Ghānim carrying the stone lion up the mountain.

[8] Illustrated manuscripts and detached miniatures known to me are:

The *Anwār-i Suhaylī* copied by Muḥibb Allāh b. Ḥasan in 1570, now in the School of
Oriental and African Studies, University of Lindon; see L. Ashton, op. cit., p. 142, no.
636, colour pl. F, and pl. 119; Goetz, op. cit., Taf. 26, Abb 72 (folio 172); H. Goetz,
Geschichte der indischen Miniaturmalerei, Berlin 1934, fig. 2; Wilkinson, op. cit., pl. 4
(colour); Barrett and Gray, op. cit., pp. 81, 2, 4 and plate (colour) on p. 80 (folio 183v.).
The *Anwār-i Suhaylī* copied in 1596–7 by Mawlānā 'Abd al-Raḥīm al-Harawī at Lahore,
now in Bharat Kala Bhavan, Benares; see note 5 above.
The *Anwār-i Suhaylī* copied in 1610, now in the British Museum (Add. 18,579). Two of
the miniatures bear the date 1013 H. (1605). See J. V. S. Wilkinson, *The Lights of Canopus*,
Anvar i Suhaili, London 1929; A. Coomaraswamy, " Notes on Mughal Painting ",
Artibus Asiae, 1927, no. 3; Goetz, *Bilderatlas*, Taf. 23, Abb. 65, Taf. 33, Abb. 89,
Taf. 36, Abb. 95, Taf. 44, Abb. 126; Sir T. Arnold, *Painting in Islam*, Oxford 1928, pl.
63b.
The *'Iyār-i Dānish*, an incomplete manuscript of which 52 leaves are in the Sir Cowasji
Collection, Bombay and 103 leaves with 96 miniatures in the Chester Beatty Library,
Dublin; see K. Khandalavala, " Five miniatures in the collection of Sir C. Jehangir
Bart., Bombay ", *Marg*, v, p. 30 f. and pl. C opp. p. 29; Ashton, op. cit., p. 144 f. and pl.
123; Sir T. W. Arnold and J. V. S. Wilkinson, *The Library of A. Chester Beatty, a catalogue
of the Indian Miniatures*, 1936, pp. 12–21, pls. 38–47; *Marg*, xi (1958), illustration of
the lion and the jackal opp. p. 21; K. Khandalavala and M. Chandra, *Miniatures and
sculptures from the collection of the late Sir Cowasji Jehangir, Bart.*, Bombay 1965, p. 17,
no. 7.

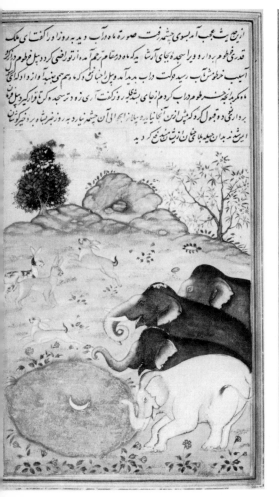

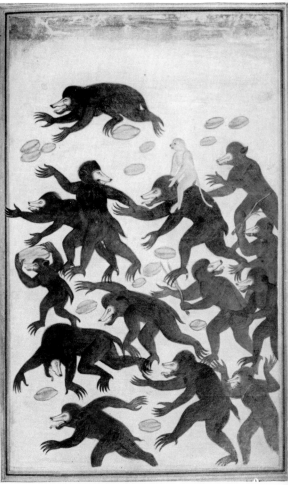

106. Folio 114a

107. Folio 124b

Moreover he does not seem to be a mere copyist since none of the subjects he has chosen to illustrate resemble the same subjects in other known manuscripts either of the *Anwār-i Suhaylī* or of the *ʿIyār-i Dānish*, the Persian translation of the *Kalīla wa-Dimna* made by Abu'l-Faẓl.[8]

108. Folio 187b

At the time our manuscript was made, Gujerat was under the governor-
ship of Akbar's foster brother, Mīrzā 'Azīz Koka who, however resided at
Agra leaving the actual government of the province to his sons. Neither
he nor his family are known to have patronised painting and we cannot
ascertain for whom our manuscript was made. 'Abd al-Raḥīm Khān-i
Khānān was twice governor of Gujerat, from 1575 to 1578 and from 1584
to 1589. It seems more than likely that during his years in Ahmadabad
he attracted artistic talent to that city thereby giving an impetus to the
subsequent creation of other establishments. But the principle interest

of our manuscript is in providing incontestable evidence that Mughal painting was already established in Ahmadabad late in Akbar's reign. Ahmadabad may well have had its share in contributing to the dissemination of the Mughal style in the courts of Rajasthan.

AN ILLUSTRATED MANUSCRIPT FROM SIND

by

M. Idris Siddiqi

A complete and illustrated version of the romance *Sayf al-Mulūk wa-Badī' al-Jamāl* was acquired by the British Museum in 1921. The manuscript (Or. 8758) is in a good state of preservation. It is written in *nasta'līq* and the text on each folio is framed by a border of two red and three black lines enclosing a thicker yellow line. The headings are in red in the running text and occasionally form separate lines. There are 109 folios each measuring $9\frac{3}{4} \times 4\frac{3}{4}$ ins. The 65 illustrations occupy the top, middle or bottom of the text area: and none covers the entire page. There is a double page illumination at the beginning of the manuscript. The colophon at the end reads:

تمت كتاب سيف الملوك وبديع الجمال بعون حضرت رب الوهاب از دست فقير سراسر تقصير الراجى الى رحمت رب الغنى عبد محمد وارث بتاريخ چهارم شهر شعبان المعظم سنه ١١٨٩ در دار الصفا بلدة تهتا فى يوم السبت بوقت نماز عصر بالخير والظفر صورت اختتام يافت.

The manuscript was completed by Muḥammad Wārith on 4th Sha'bān A.H. 1189 (1st October, A.D. 1775) in Thatta. To the best of my knowledge it is the earliest illustrated work known to have been executed in Sind; and its many miniatures may make an important contribution in the future study of painting in Sind. These miniatures are rather archaic but possess a peculiar charm and certain features not to be found in the contemporary schools of painting in the Indo-Pakistan Sub-continent. These features are the characteristic representation of the vernacular culture of Sind although it is premature to single out these miniatures as " Sindhi painting ". For one manuscript alone cannot serve to establish a new school of painting although this has been the

practice in recent years when new schools have been created with the discovery of every new manuscript, every new collection and sometimes even with the discovery of one or two miniatures.[1] More material will have to be brought to light before such a claim can be justified in the case of the manuscript under discussion.

Sind, once occupying an area from the port town of Daybul to Multan, was reduced in the latter half of the 18th century A.D. to a petty Muslim state. How is it that the states of Bundi, Mewar, Kishangarh and others in Rajasthan and of Guler, Bilaspur, Kangra, Basohli and Kulu in the northern Punjab—all much smaller by comparison—have produced an immense wealth of visual art while no such material is available from Sind? The answer may be sought in the historical and cultural background of Sind in general and of Thatta in particular.

Thatta is mentioned as a flourishing city before A.D. 1331, when Muḥammad Tughlaq, sultan of Delhi, died in its vicinity while pursuing the leader of a revolt in Gujerat who was given shelter by the rulers of Thatta. For four centuries it was the capital of lower Sind, under the Muslim dynasties of the Sammas (*c.* 1340–1520), the Arghūns (1520–55), the Ṭarkhāns (1555–92) and the Mughal emperors of Delhi (1592–1739). During these four centuries Thatta was one of the seats of Islamic learning, arts and crafts as well as a flourishing port of continental trade.

Sind had formed part of the Umayyad and ʻAbbāsid caliphate, and from the end of the ninth century was divided into the small principalities of Multan and Manṣūra. Subsequently it was ruled, under the suzerainty of the Ghaznawid, Ghūrid and Delhi sultans and also by princes of the Rajput tribe of Sumra, who embraced Islam. In about 1340 the Sammas, who were also Rajput converts to Islam, wrested power from the Sumras. We have no contemporary record of their cultural attainments but the surviving monuments of this period which stand on the northern extremity of the necropolis at Makli Hills, two miles south of Thatta, testify to the way in which their contact and matrimonial alliances with the states on their eastern border helped in the procuring of stone-cutters from Ahmadabad and Bijapur. The tomb of Jām Niẓām al-Dīn (1461–1509) is a stone structure in the Aḥmad Shāhī style with ornamental carving found in the 15th-century monuments of Gujerat with a local character.[2] A band of interlaced *thulth*—a verse from the Koran—characteristically Islamic—

[1] K. Khandalawala, M. Chandra and P. Chandra, *Miniature Painting, a catalogue of the Exhibition of the Sri Motichand Khajanchi Collection held by the Lalit Kala Akademi, 1960,* New Delhi 1960, p. 9.

[2] P. Brown, *Indian Architecture, Islamic period,* Bombay 1942, p. 119.

provides a striking contrast to its neighbour, a band decorated with carved geese, half and full lotuses, and arched panels set with sunflowers entirely Hindu in character.[3]

Shāh Beg Arghūn defeated the last Samma prince in 1521. The brief rule of the Arghūns was ended when Mīrzā 'Isā Khān Ṭarkhān I seized lower Sind with Thatta in 1555. During the rule of Mīrzā Jānī Beg Ṭarkhān Akbar decided to annex Sind. After a desperate resistence Jānī Beg sued for peace and was confirmed as governor of Thatta, in which charge he was succeeded by his son Mīrzā Ghāzī Beg Ṭarkhān. Upon his death in 1612 the Mughal officials were appointed as governors of Sind. In about 1733 Thatta was given to one Amīn Khān as a reward and henceforth was held on a sort of contract or lease. The last lessee was Miān Nūr Muḥammad, the real founder of the Kalhora dynasty, which ruled Sind when our manuscript was executed. From the seventeenth century we have various accounts by European travellers, who, impressed by its charm and prosperity, called Thatta an Eldorado and a Utopia of wealth beyond avarice. To the trader and traveller from the West, Thatta was practically synonymous with Sind. In 1607 the East India Company instructed its agents to sail to Laurie a good harbour within two miles of Nagor Tuttie, as great and as big as London. In 1613 Captain Paynton described Thatta as one of the most celebrated marts of India. Mandelslo praised the artisans of Thatta as the most industrious in the Mughal kingdom.[4] Alexander Hamilton in 1699 mentions Thatta as a large, densely populated and a very rich city about three miles long and one and a half miles broad.[5] According to him there were four hundred educational establishments in Thatta where students from all over Asia studied philosophy, politics and the different branches of the speculative sciences in addition to theology.[6] Tavernier classed it as one of the greatest cities of India.

This was the period when Mughal painting having reached maturity began to influence provincial centres. We are told that two palaces built by Ghāzī Beg Ṭarkhān in Thatta were decorated with wall paintings. In all probability these were executed in the style of the wall paintings at Agra and Lahore. Nothing of these palaces has survived. After the death of Mīrzā Ghāzī Beg, the Ṭarkhāns ceased to be associated with the govern-

 [3] Idris Siddiqi, *Thatta*, Karachi 1963, p. 16.

 [4] J. Albert de Mandelslo, *The Voyages and Travels of the Ambassadors, Travels into the Indies*, iii, 2nd ed. 1669, p. 14.

 [5] Capt. A. Hamilton, *A new account of the East Indies*, Edinburgh 1727, i, 115.

 [6] Ibid., p. 127.

ment of Thatta. Whatever painters they may have patronised were presumably engaged in laying the foundations of a school in which Mughal painting was adapted to Sindhi requirements; and they may have dispersed without having accomplished much. The influences which may have helped in the formation of this provincial school, if any, can be assumed from the relationship of the Ṭarkhāns with the Mughals and the Rajputs. Jānī Beg Ṭarkhān and Mīrzā Ghāzī Ṭarkhān were closely connected with the court of Akbar and Jahāngīr. Jānī Beg's daughter was married to prince Khusraw. They were also related to the Rajputs: Mīrzā Bāqī Beg Ṭarkhān and his son Mīrzā Muẓaffar were married to Rajput girls. Mīrzā Ṣāliḥ Ṭarkhān and Jān Bābā, both sons of Mīrzā 'Isā Khān Ṭarkhān, had strong supporters in Kutch. Mīrzā 'Īsā Khān Ṭarkhān II, grandson of the elder Mīrzā 'Īsā Khān Ṭarkhān, was related to Samejas on his mother's side. Unfortunately, as yet, there is no evidence of the impact on the paintings of Sind by these contacts with Kutch, Rajasthan, Agra, Delhi and Qandahar.

The decline and decay of Thatta began in 1739 when the province of Sind was ceded to Nādir Shāh by the emperor Muḥammad Shāh. Nādir Shāh entrusted its administration to Miān Nūr Muḥammad, chief of the powerful politico-religious Kalhora clan of Sind. Nūr Muḥammad abandoned Thatta to its fate preferring to rule Sind from the small township of Khudabad. Moreover Thatta lost its importance as a commercial centre owing to the silting up of the branch of the Indus Delta on which it was situated. Pottinger who visited Thatta in 1809 remarks that with the transfer of the capital " the population has decreased so rapidly that upwards of two thirds of the city is now uninhabited[7] and in lieu of the bustle of a trading city the streets are deserted.[8] Despite this the copyist Muḥammad Wārith has preferred to add the honorific " Dār al-Ṣafā' " to Thatta while working there in 1775. We need not follow in detail the history of the Kalhora dynasty: Nūr Muḥammad died in 1755, and was succeeded by Muḥammad Murād Yār Khān, who was dethroned in 1758. The government of Sind was contested by 'Aṭṭār Khān and Ghulām Shāh. The latter was ultimately confirmed in 1764 by the Afghan amir Aḥmad Shāh Durrānī (who had succeeded Nādir as suzerain of Sind). Although illiterate, Ghulām Shāh was an energetic ruler. In 1768 he founded the town of Hyderabad which he made his capital. In 1772 he was succeeded by Miān Muḥammad Sarfarāz Khān; but Kalhora rule was brought to an

[7] Sir H. Pottinger, *Travels in Baluchistan and Sind*, 1816, p. 351.
[8] Ibid., p. 353.

end in 1783 by the Talpurs, who were in their turn defeated by the British in 1843.

The Kalhoras were the first Sindi dynasty to wield power after the fall of the Sammas in 1521. This gave them some degree of popularity but the period was one of unrest and disorder punctuated by three civil wars—the invasion of Nādir Shāh and the constant threat of invasion due to their intransigence in paying tribute to their suzerains of Persia or Afghanistan. In spite, however, of their limited resources they patronised art and learning; and it was in this period that Sind produced the great mystical poet Shāh 'Abd al-Laṭīf of Bhit[9] who composed and sang for the people of Sind as Farīd had for the Punjab.

In the thousand chequered years of Muslim rule, Sind was brought into contact with Persia, Qandahar, Kabul, Multan, Agra and Delhi, Rajasthan, Bijapur, Ahmadabad and Kutch. These contacts made their impact on the cultural life of Sind—an impact however more apparent than real since owing to its geographical isolation, Sind has tended to develop its own indigenous traditions taking foreign influences and moulding them to its own pattern. This applies as much to its architecture as to its legends, folklore and painting.

The romances of Laylā and Majnūn, of Shīrīn and Farhād, of Wāmiq and 'Udhra and others did not attract the imagination of the bards and poets of Sind. It is not that Sind has failed to produce its share of Persian scholars who composed excellent poetry and prose. Works of considerable value were produced in the field of theology, philosophy, logic, medicine and other branches of knowledge. But such works were written for the learned few. What has most popular appeal in Sindi folklore and poetry are the romances of which most are connected with the Sumra and Samma periods. Umar, the hero of *Umar Marvi* was a Sumra prince as also was Chanesar, hero of *Chanesar Lailan*, the latter being the daughter of the Raja of Khangar; Tamachi of the *Noori-Jam Tamachi* was a Samma prince who lost his heart to Noori a fishermaid. The *Sasui Panhun, Rano and Mumal, Sohni and Mehar* and other stories are tales of simple people The story of Sayf al-Mulūk and Badī' al-Jamāl was equally popular in Sind although its hero and heroine are " foreigners ". For reasons unexplained their story is associated with the destruction of more than one town of Sind. According to *Tūḥfat al-Kirām* it was also in the reign of one of the Samma princes that Dalurai, a descendant of the Hindu king of the same name and the founder of Dalur or Alor, tried to seize Badī'

[9] H. T. Sorley, *Shah Abdul Latif of Bhit,* Oxford 1940, p. 9.

al-Jamāl, the wife of a princely merchant Sayf al-Mulūk, travelling through the city and for this brought down the wrath of God. As a consequence the ancient town of Alor was destroyed.[10] The *Ta'rīkh-i Ṭāhiri* also has same account of the destruction of the city.[11] The story continues that on returning from pilgrimage the couple settled in Dera where they had two sons and eventually died and were buried.[12]

The story of Sayf al-Mulūk and Badī' al-Jamāl in the version of our manuscript and that of many others differs from the version of *Tuḥfat al-Kirām* or of the *Ta'rīkh-i Ṭāhirī*. Sayf al-Mulūk son of the king of Egypt falls in love with Badī' al-Jamāl, a fairy, after seeing her picture. Many obstacles have to be overcome before he finally succeeds in marrying her. The story has been variously told and is derived from a tale of the Arabian Nights in a Persian adaptation. It has been translated into Turkish,[13] Pushto[14] and Urdu[15] both in prose and poetry; and there are a number of Persian manuscripts. The commonest version opens with a fanciful introduction in which Ḥasan Maymandī, vizier of Sultan Maḥmūd sets out from Ghazni in quest of amusing tales with which to entertain his sovereign. He discovers the story of Sayf al-Mulūk in a book called *Rūḥ-afzā* in the Treasury of the King of Damascus.[16] Our manuscript contains a slightly different introduction quite apart from verbal variants characteristic of such manuscripts. But the sequence of the story is unchanged.

To my knowledge there are only three illustrated versions of the story. There is a copy in the India Office Library dated Ramaḍān of the seventeenth year of Muḥammad Shāh's reign, that is A.H. 1148 (A.D. 1736) and containing 25 illustrations.[17] Another copy in the British Museum contains a transcription of the translation of the story into Deccani Urdu in verse by Gawasi which was composed for Sultan 'Abd Allāh Quṭb Shāh

[10] 'Ali Shēr Qanā'ī, *Tuḥfat al-Kirām*, Vol. III, Bombay, p. 94.

[11] Mīr Ṭāhir Muḥammad Nasyanī, *Ta'rīkh-i Ṭāhirī*, Hyderabad, 1964, p. 26.

[12] Qana'ī, *Tuḥfat al-Kirām*, p. 45.

[13] G. Fluegel, *Die Arabischen, Persischen und Türkischen Handschriften der Kaiserlich-Königlichen Hofbibliothek zu Wien*, 1865, ii, 28.

[14] E. Blochet, *Catalogue des Manuscrits Persans de la Bibliothèque Nationale*, Paris 1912, ii, 297, no. 1107, a Pushtu translation by Veli: a second version by Ghulām Muḥammad in Fluegel, op. cit., ii, 27 and a third version in prose in Raverty, *Grammar of Pushtu*, p. 31.

[15] E. G. Brown, *A Catalogue of Persian Mss. in the Library of the University of Cambridge*, 1896, p. 406, Add. 242; and British Museum, Or. 86.

[16] Rieu, *Catalogue of Persian Mss. in the British Museum*, ii, 764b.

[17] H. Ethe, *Catalogue of Persian Mss. in the Library of the India Office*, i, 521-2, no. 788.

by Gawasi in A.H. 1025 (A.D. 1616–17).[18] This poem is remarkable for the
large number of Hindi words and the comparatively small number of
Persian and Arabic words. The British Museum manuscript was copied
in A.H. 1159 (A.D. 1746) and has a large number of illustrations, in mid-
eighteenth century Deccani style.

The British Museum copy which is the subject of this essay is dated
A.D. 1775 and is therefore the latest of the three. It was executed at
Thatta at a time when that city had ceased to be the capital of Sind for
some forty years and when all the more important families had migrated
to Hyderabad and other towns. At this time Sind presents a picture of
factional rivalries, civil wars and the constant threat of invasion. Trade
and commerce were at their lowest ebb; the East India Company had
withdrawn its Factory from Thatta. It yet seems possible that the
scribe Muḥammad Wārith copied the manuscript for some Kalhora prince
or some influential patron.

The subjects illustrated are more or less those of the other two manu-
scripts already mentioned. The difference in style and execution is how-
ever marked. Anyone familiar with Sind and with the crowded bazaars
and narrow crooked lanes of Thatta, Hyderabad, Shikarpur or Sehwan
will meet the types he has seen in the illustrations of this manuscript
represented in all their simple charm and dignity.

In order to relieve the desolate and monotonous appearance of their
countryside the Sindis introduced colours into their buildings and em-
ployed bright polychrome effects in their handicrafts—textiles, pottery,
tiles, enamel and lacquer work. The palette of the miniatures in our
manuscript likewise includes green and yellow of various shades, dark blue
and red, dark and light brown, mauve, purple, grey, almond and orange.
These colours impart the warmth and brilliance which is characteristic of
the handicrafts of Sind. In certain cases the background is rendered in
rather dull and muddy colours in order to set off the figures which are
clothed in brilliant colours.

The miniatures are devoid of landscape. The background is mono-
chrome or painted with contrasting patches of colour (e.g. fig. 112). As a
result the figures stand out from the background. These features already
occur in the paintings of Malwa and Mewar at a much earlier date.

Compositions are simple; and forms somewhat crude leaving the
impression of a rustic rather than a metropolitan vision. There are no

[18] British Museum, Or. 86.

hanging clouds on the horizon which as in folios 13b, 14a, 48a, 68a, 90a and 94a, is shaded in grey or blue. In folio 68a where the background is yellow, the sky is rendered by light and dark grey shading with alternating streaks of glowing red and yelow indicating the clear Thatta dusk. In folio 90 a white line is fused with the blue which becomes darker towards the top.

Sind has been compared with Egypt inasmuch as it would be an arid desert but for the Indus.[19] Its network of irrigation canals is recent. It has none of the luxuriant vegetation of Gujerat and instead of the plantains of Gujerati paintings ours have the date palm which is ubiquitous in Sind. The date palms in folio 28a. (fig. 109) have five to eight long pointed leaves but are not rendered as naturalistically as those in Mewari paintings.[20]

The stylised foliage of other trees is derived from a Rajasthani proto-type, leaves placed schematically within an oval outline with sprays emerging on both or one side. The trunks are dark brown or mauve, some with dots of a darker tone. The knots are so strongly emphasised as to suggest that they are the stubs of branches that have been lopped off. In folio 29a two large trees have roots which spread over the ground like the tentacles of an octopus and knotted trunks surmounted by foliage within an oval outline which rests on a cluster of branches.

In the garden scenes the various planes are distinguished by the horizontal grass verges with trees, flowers or shrubs dividing the page into two or more compartments (e.g. fig. 109). The human figures are placed in the intervening spaces. Occasionally there are bands of flowers at top or bottom reminiscent of Mewari painting (e.g. fig. 112). Water is rendered in the " basket work " convention adopted by the schools of Rajasthan and the Deccan. Rivers and seas are filled with marine creatures and mermaids.

The architectural forms in the miniatures have little relation to the actual monuments such as those at Makli Hills, Thatta, which embody the architectural traditions of Sind from the Samma to the end of the Mughal periods or with those of Khudabad or Hyderabad, the capitals of the Kalhoras. In our miniatures the walls of some of the structures are rendered in dark brown and white. Other buildings appear to be of marble with *pietra dura* decoration. Arches are multicusped and in some cases side arches are trefoil—features unknown at Thatta. Some arches have a very wide span which supports a sloping eave surmounted by a railing

[19] H. Cousens, op. cit., p. 1.

[20] M. Chandra, *Mewar Paintings*, Lalit Kala Akademi, **1957**, pls. **3** and **7**.

of red sandstone. Pillars are cylindrical, some being surmounted by lotus form capitals. Such buildings are adaptations of the structures depicted in the paintings of Bikaner, Jaipur and Jodhpur in the 18th century;[21] but the resemblance must not be pressed too far since these buildings are lower, having small pillars, cusped arches and at the sides squat domes crowned by pinnacles. The upper storeys are more like wooden balconies of the type which is found in some residential houses of Thatta town.

The principal male figure represented is a Sindi landlord (*vaderah*) with regular features and muscular body draped in a distinctive attire (figs. 109, 110, 112, 113). Faces are roundish and are shown in three-quarter profile: features such as large eyes and delicate nose are precisely drawn and achieve some degree of expression. The colour and designs of textiles in the miniatures really seem to resemble those of Sind. Thatta has been famous for the spinning, dyeing and weaving of silk and cotton; and in its palmy days some five thousand looms were said to be employed in weaving shawls and *lungis*.[22] Dye stuffs were *rodung* or madder, saffron, sufflower and *musagh*—a dye prepared from walnuts.[23] The Sindi *ajrak* has beautiful geometrical and conventionalised flower patterns printed in light and dark red, brown, light and dark blue and white. The Thatta *lungis* used for turbans, scarves or waist bands were in great demand even as far as Agra; they had warps of silk and wefts of cotton and their ends were embroidered in gold or silver or decorated with fringes. Other stuffs were the *garbi* or *tasar* for the trousers of the well-to-do and *mashru* for cushion covers.[24] Trouser material known as *susi* had invariably striped warp.[25] Most of the patterns of these textiles are depicted in the miniatures in brilliant colours.

The turban does not consist of folds which sweep back along the head as is found in Rajasthani miniatures of the 17th and 18th centuries. It is the Sindi turban of *phentiyo* type,[23] loosely twisted round the head and divided into two parts by the cross band formed by one of the ends; the other end is pulled from the centre and arranged in the form of a fan known as a *turro* (fig. 109). These turbans are made either of *ajrak* or of

[21] Sir L. Ashton, *The Art of India and Pakistan, Commemorative Catalogue of the Exhibition held at the Royal Academy of Art*, London, 1947–8, pl. 86, no. 451; pl. 94, no. 457; pl. 97, no. 514.

[22] E. H. Aitken, *Gazeteer of the Province of Sind*, Karachi, 1907, p. 393.

[23] Ibid., p. 393.

[24] Ibid., p. 393.

[25] Ibid., p. 390.

[26] R. F. Burton, *Sindh and the races that inhabit the Valley of Indus*, London, 1851, p. 285.

109. Folio 28a 110. Folio 32b

lungi and are very handsome. With Sayf al-Mulūk and other important persons the *turro* is embellished with a black *sarpesh* (figs. 110, 113). In some cases a roundish *kulāh* sticks out from the turban (fig. 112).

The floating transparent draperies of contemporary and earlier Mughal, Rajasthani and Deccani paintings are here replaced by the *pehranu* or shirt with sleeves[27] sometimes of a flowered material called *phulio*. This is a shirt open at the sides and reaching to the calf; it is

[27] Ibid., p. 285.

brought in at the waist. The neck and chest are often decorated with *sauzankari*, that is embroidery. Sindi *sauzankari* is still popular today. Owing to the thickness of the material the figure is not revealed. In certain miniatures persons wear the *nimtano*, a long coat with arms reaching to the elbow and open in the front. It is always rendered in polychrome in contrast to the *pehranu*. The *bochanu* or sash is worn short with frills at the end and hangs in front, occasionally down the side and more rarely completely wrapped around the waist. The trousers are *salvars* (*suthnas*) of striped material known as *susi*.[28] The *chauri* bearers carry fly whisks made of peacock feathers as in the paintings of Rajasthan, the Deccan, Chamba and Kangra. Figures are shown either squatting on carpets, mounted on horses or standing in an attitude of composure and dignity. The effect of movement is rendered by the backward whirling *pehranu* (fig. 110).

With one exception the beard is worn short and well trimmed: this is the type known as *sunhari* or auspicious. Hair is concealed by the turban except for a curl which generally protrudes and encircles the ear lobe. This hair style does not appear elsewhere and is perhaps intended to represent the curling end of *pattas* erroneously considered as *sharai* hairstyle.

The female type is graceful and conforms to the Sindi girl described by Burton.[29] The face is sharply outlined; the mouth delicate and rather sensual and the nose straight with upturned nostrils. Faces are shown in three-quarter profile while those of the fairy maids are in full profile. According to Burton's description, " her long, fine and jetty hair, is plastered over a well arched forehead in broad, flat bands, by means of a mixture of gum and water ".[30] This peculiar feature is represented in the paintings by a grey line immediately beneath the thick hairline (cf. folios 8a, 8b, 39a, 43a, 44b, 61a, 71b, 95a). Burton continues " behind the *chevelure* is collected in one large tail, which frequently hangs down below the waist, and then the head, as frequently happens here, is well shaped, no coiffure can be prettier than this ".[31] This is well represented in the manuscript; and on folio 61b these beautiful braids instead of hanging at the back where they could not be seen, are twisted over the shoulder so as to hang down in front thus adding to the charm of the composition. Occasionally locks of hair have been shown hanging on the cheeks in cork-

[28] Aitkin, op. cit., p. 390.
[29] R. F. Burton, *Scinde or the Unhappy Valley*, London, 1851, i, 275–7.
[30] Ibid., p. 275.
[31] Ibid. p. 275.

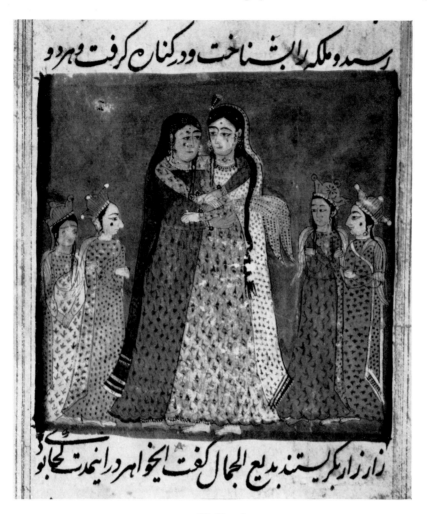

III. Folio 61a

screw fashion. " Her eyes," writes Burton, " are large and full of fire black and white as an onyx stone of almond shape with long drooping lashes, undeniably beautiful ":[32] the *kajal* (lamp black) " exaggerates eyes into becoming *the* feature of the face."[33] In folio 94a the eyes of the dancing girl are emphasised by the *kajal* which is not used for the other women. " Upon the brow and the cheek bones a little powdered talc is applied with a pledget of cotton to imitate perspiration ",[34] a feature faithfully portrayed

[32] Ibid., pp. 275–6. [33] Ibid., p. 276. [34] Ibid., p. 276.

in folio 61b depicting Badī' al-Jamāl and the daughter of the king of Ceylon embracing each other (fig. 111). Almost every detail corresponds to the description of the Sindi girl given above.

The female costume is typically Sindi. Over the head and extending down to the waist behind the back is a veil, *orhni* or *gaudhi* of Thatta silk with rich edgings. It is coloured in order to denote that the wearer is a happy wife, *subhagin*. Widows and old ladies, as in other regions, are generally dressed in white. The *orhni* except in folio 43b are not transparent.

The wide baggy skirt, the *cholo* is open in front reaching down to the ankles. Sleeves are loose and there is a richly worked border around the neck. The skirt envelopes the body very loosely and is quite unlike the transparent *choli* or flowing *jama* closely fitted above the waist and revealing rather than covering the form and contours of the body. In folio 45a the artist has tried although with little success, to depict the contours of the breast by shading in black lines over a yellow shirt. This device occurs in no other miniature. The striped *salvar* or *suthan* is generally concealed by the long skirt. On the whole the costume is picturesque but imparts a slightly grotesque impression to the wearer.[35]

Ornaments are shown by white dots. Over the head are white circular discs connected by a string of pearls. Occasionally a white dot, *bindi*, decorates the centre of the forehead. Disc-shaped ear studs, necklaces studded with semi-precious stones, armlets etc. are rendered in a similar way to those of Rajasthani paintings of the 17th and 18th centuries. Black pompoms and tassels are worn on the arms and wrists. The fairies wear a typical three pointed crown (figs. 111–113), a slightly modified form of that worn by Krishna in paintings of Gujerat, Rajasthan and Kangra.

The musicians and dancers are portrayed with great warmth of feeling (folios 54a and 94a). The dancing girl with slim body and beautiful appearance in folio 94a has her left hand on her waist and her right hand raised above her head. The *tabla* player with his two *tablas* attached to his waist is shown standing as also the castanet player. In scenes of dancing and singing the musicians are normally shown seated with their instruments but it seems that the artist of our manuscript was perhaps inspired by the performance of a street dancer—a common scene in the bazars of the Sub-continent where dancer, musicians and audience remain standing. In folio 62a (fig. 112), however, the three musicians depicted in the upper

[35] Ibid., p. 277.

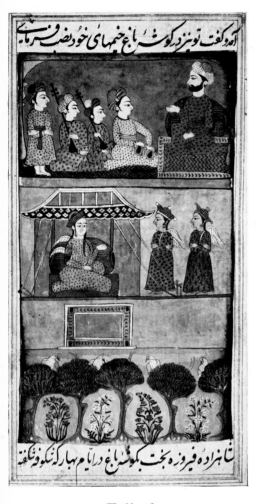

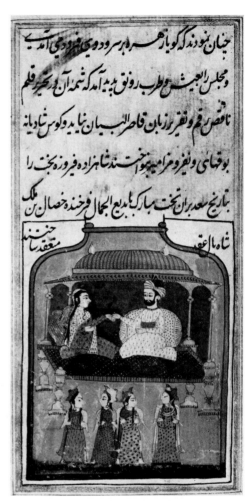

112. Folio 62a 113. Folio 95a

register are seated; two hold the *ektara* and the third plays the *tabla*. The *ektara* is still a popular instrument in Sind.

The carpets have chevron, floral or striped patterns and are presumably of local origin since carpets, *farshi*, used to be manufactured in Sind. The Bubak carpets of Sind[36] although well known were not as fine as those of Persia, Lahore and Delhi. This may account for the slight crudeness of those in our miniatures. The short legged settees with high

[36] Aitkin, op. cit., p. 391.

backs are common to Sind and Rajasthan. The artist however has not always found it convenient to place it at the proper angle and to render it in its true perspective. In folio 39a the lady is seated almost outside the rear limit of the settee so that only her legs find a place on the seat. The bed on fig. 113 has long legs of lacquer work from Hala near Hyderabad. It also has a finely painted canopy. The scene depicts the first meeting of Badī' al-Jamāl and Sayf al-Mulūk after their marriage.

Swords with or without sheath are shown in thick black lines. They are suspended from the waist on the left side. Instead of pointing behind the blade is placed in front across the legs—a position which would obstruct movement. In folio 101b a person is shown moving with an axe resting on his shoulder. The practice of carrying axes is commoner in Sind than in Kutch and Gujerat.

Animals are naturalistic. Horses are sturdy, their manes unplaited but well arranged and falling on one side as in the Rajasthani type of the 18th century (fig. 110). The camel in folio 3a is naturalistic but smaller than the man leading it. There are also the bear, fox and magra rendered naturalistically. The tiger is yellow with black stripes as in Mewari paintings of the 17th century.[37] The birds including the parrot, mina and pigeon are well executed but the peacock is treated conventionally.

Although the miniatures are the work of several hands and of varying quality, the style is uniform. It is a style possessing a simple charm and dignity with certain features unknown in contemporary schools of painting. Many other features however are borrowed but are assimilated so that the overall impression is one of local colour. This makes a quite definite impact and possesses something of the life of the people of Sind who rightly claim a culture older and more varied than that of any other region of the Indo-Pakistan Subcontinent.

The miniatures are the creation of a period when the Mughal order had been replaced by the vigorous Kalhora rule. They possess a rough country vigour, a simplicity and fresh charm characteristic of folk art. They also establish the fact that Sind had its own contribution to make to the history of late 18th-century painting in the Indo-Pakistan Subcontinent.

[37] M. Chandra, op. cit., pl. 4.

Mr. Siddiqi, a promising young scholar, died in June, 1967.

QĀJĀR PAINTED ENAMELS

by

B. W. Robinson

Visitors to the Persian Crown Jewels in the basement of the Central Bank of Iran on Firdawsi Avenue, Tehran, may be excused for catching their breath as they enter this Arabian Nights grotto. The whole collection has been superbly arranged and lit, and the eye wanders incredulously from rows of dishes heaped with unset diamonds, rubies, emeralds, and turquoises, to great candlesticks encrusted and dripping with gems, and from tassels and ropes of huge pearls, and swords entirely covered with diamonds, to the golden " Throne of Nādir " and the towering crown of Fatḥ 'Alī Shāh.

But amidst all this overpowering richness and splendour one comes across a considerable number of objects less obtrusive and spectacular, but of far greater interest to the lover of Persian art: the vases, dishes, boxes, and *qaliān* (water-pipe) fittings of enamelled gold or silver. These provided the Persian miniature painter of the Qājār period with his most exquisite field of activity, and, as many of the pieces are signed and dated, it seemed worth while to collect this material and, by collating it with examples elsewhere, to give a general idea of this little-known branch of Persian painting in its period of finest achievement, between about 1790 and 1880.

That most enlightened and observant traveller the Comte de Roche-chouart has left us a detailed account of Persian enamelling in the 1860s, including an exhaustive description of the technical processes involved and the composition of the various enamels used, an aspect of the subject which need not concern us here. He estimated that in Tehran alone more than two hundred craftsmen in enamel were at work, but that not more than half-a-dozen of them could be regarded as serious artists. The Count's attitude to Persian painting as such is by no means favourable (" C'est à faire grincer les dents "), but the painted enamels excited his enthusiastic admiration: " Pendant quelque temps, il a été de mode en Perse d'avoir les têtes de kalioun [sc. *qaliān*] émaillées à Genève ou à Paris,

mais je dois avouer que la comparaison était si peu à notre avantage, que ces objets ont vite disparu; certainement les personnages étaient plus régulièrement dessinés, et les paysages plus conformes aux règles de la géométrie; mais quelle différence dans l'éclat des couleurs et dans le goût des détails! Les uns étaient ternes et ressemblaient à une peinture sur porcelaine, tandis que les autres étaient d'une vigueur de tons qui les faisaient ressembler à une gouache." Some of the European imitation pieces to which he refers stand side by side with Persian originals in the Crown Jewels display, and they certainly make a poor show beside the glowing exuberance of the native product. Twenty years later the American Minister, S. G. W. Benjamin, was equally appreciative, remarking of a gold enamelled tea-service he saw in the Palace that it was " one of the most brilliant works in this art ever produced, whether in Persia or Europe ".

Enamelling has certainly been known in Persia for a very long time, but the type of work with which we are here concerned—more or less elaborate pictorial representations of figures, flowers, and birds—is not known, or at least has not survived, from a period earlier than the eighteenth century. In the contemporary portrait of Nādir Shāh (1736–1747) in the Victoria and Albert Museum, the hilts of his sword and dagger are accurately represented as of enamelled gold with designs of birds and flowers on a plain background of polished metal, but no surviving examples can be confidently dated earlier than the reign of Fatḥ ʿAlī Shāh (1797–1834).

This monarch was a lavish patron of any art that served to flatter and celebrate his magnificent person, and he was not slow to note the possibilities of painted enamel in this direction; his portrait appears on no less than nine of the enamels shown with the Crown Jewels, the first dating from the actual year of his accession. Among the enamel painters under his patronage three stand out for their superior ability and for the comparative size and importance of the objects they adorned. The first two, ʿAlī and Bāqir, worked in a similar style, meticulous and highly accomplished, and both used the title *ghulām-khānazād*, which means literally " slave born in the household ", but its actual significance is most likely " artist in the Royal service " or " member of the Royal workshops ". *Ghulām* and *khānazād* are often used separately as titles by artists and craftsmen of the Qājār period, but ʿAlī and Bāqir seem to have been the only ones authorized to use both together. The third leading enamel painter was Muḥammad Jaʿfar, whose works have survived in greater numbers than those of any of his colleagues; no title is ever found attached to his name. His style is distinctive, the drawing inclined to be stiff and the shading a

little hard, but his large pieces, such as the massive gold dishes presented to George III's ambassador Sir Gore Ouseley and to the East India Company, are well designed and impressive. Mīrzā Bābā, the *naqqāsh-bāshī*, or painter-in-chief, in the early years of Fath 'Alī Shāh, was an artist of remarkable versatility, producing oil-paintings, miniatures, illuminations, lacquer-work, and enamels of very high quality. But with him enamel painting seems to have been no more than a sideline.

No conspicuous distinction is to be found in the enamels produced during the reign of Muhammad Shāh (1834–48) and the early years of his successor Nāsir al-Dīn, but soon after 1860 the work of Kāzim ibn Najaf 'Alī began to equal and even to surpass that of his predecessors in fineness of execution and richness of effect. He was equally proficient in painted lacquer as in painted enamel (as was his brother Ahmad), but his designs, especially the human figures, are largely of European inspiration—and from rather mediocre models—and much of the boldness and strength of the earlier work is lost.

Kāzim seems to have been the last enamel painter of any stature: his latest recorded work (a lacquered pen-box or *qalamdān*) is dated 1299/ 1882. The art continued to be practised into the present century, and a snuff-box enamelled with a very poor portrait of Muzaffar al-Dīn Shāh (1896–1907) can be seen in Case XXI of the Crown Jewels. But its best period had passed with the death of Fath 'Alī Shāh, and though Kāzim's work in the '60s and '70s was undoubtedly brilliant, there was no general renaissance.

The charm of these Persian enamels, like that of ordinary Persian miniature painting, proceeds from a combination of meticulous technique, glowing colour, and a certain endearing naiveté. There is a constant striving to portray the ultimate in youthful beauty. He would be a hard man indeed who could resist the languishing glances of these sloe-eyed houris, so sophisticated, and yet so childlike (figs. 114, 115). But the enamels have the additional attraction of the warm glow of gold in the background, and this is used to great effect by the leading artists in setting off and enhancing their brilliant range of colours. Monochrome reproductions, alas, rob us of half the effect.

To fill in some details of this necessarily brief account, there follows an alphabetical list of Persian enamel painters with notes of their works. It makes no claim to be anything like complete, and there are no doubt many stray pieces still lurking unknown in public and private collections. Unless otherwise stated, all the pieces noted are signed with the form of the artist's name appearing at the head of the entry in question.

114.

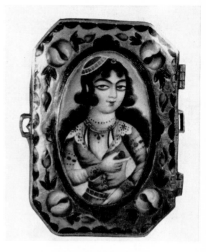

115.

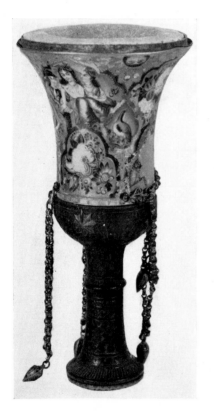

116.

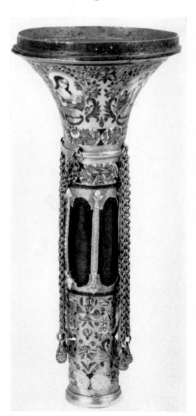

117.

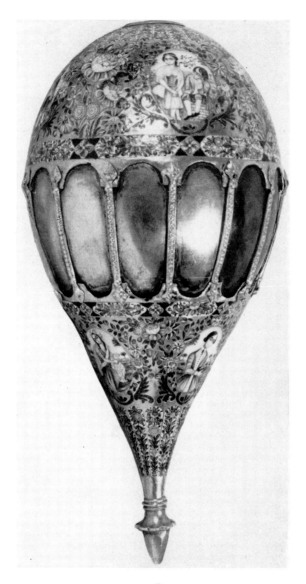

118.

'ABBĀS 'ALĪ. Early 19th century.

 Qaliān (water-pipe) bowl of fine quality, with designs of flowers surrounding medallions of human figures and birds; four human-faced suns round the upper rim. Paris, Hôtel Drouot, 25 May 1964, lot 33 (illustrated). *Fig. 116.*

'ABD AL-GHAFFĀR. *c.* 1800.
> Globular bottle of very good quality, with designs of flowers, birds, and animals, and busts in medallions; dated 1214/1799. Tehran, Crown Jewels, Case XXI, top shelf.

(*KHĀNAZĀD*) 'ABDALLĀH. 2nd ¼ 19th century.
> *Qaliān* base with designs of flowers, birds, busts, and reclining ladies. Tehran, Crown Jewels, Case IV, No. 11.
> Oval pocket mirror finely enamelled with the Madonna and Child with angels. Paris, Hôtel Drouot, 25 May 1964, lot 21.
> Oval portrait of Muḥammad Shāh set with diamonds. Tehran, Crown Jewels, Case XX, No. 19.

ABŪ'L-QĀSIM IBN MĪRZĀ MUḤAMMAD. 3rd ¼ 19th century.
> *Qaliān* with European figures (including one of Queen Victoria) in medallions amid flowers. Paris, Hôtel, Drouot, 25 May 1964, lot 32 (illustrated). *Figs. 117, 118.*

AḤMAD IBN NAJAF 'ALĪ. *c.* 1875.
> He and his brother Kāẓim (q.v.) did excellent work in both enamel and lacquer. A lacquer *qalamdān* by him is dated 1295/1878.
> *Qaliān* decorated with landscapes and portraits, made for General Muḥammad Ṣādiq Khān. Wiet, *Exposition d'Art persan*, Cairo, 1935, No. M.115.

(*GHULĀM-KHĀNAZĀD*) 'ALĪ. Early 19th century.
> One of the three foremost artists in enamel at the court of Fatḥ 'Alī Shāh, the others being Bāqir and Muḥammad Ja'far.
> Jewelled nephrite dish, the central gold plaque enamelled with a full-length portrait of Fatḥ 'Alī Shāh, presented on his behalf to the Austrian Emperor Franz I by the Persian ambassador Abū'l-Ḥasan Khān; dated 1233/1818. Vienna, Kunsthistorisches Museum, Plastik-sammlung No. 3223. *Fig. 119.* *Note:* This portrait was almost certainly inspired by the splendid life-size oil painting by Mihr 'Alī, dated 1220/1805, in the Amery Collection, London (*Fig. 120*). Mihr 'Alī painted another version in 1808 which is now in the Hermitage, Leningrad.
> Set of decanter, stem-cup with saucer, and domed cover (the cup signed " *Ḥusayn* 'Alī ") enamelled with figures of dancing-girls, musicians, and portraits of Fatḥ 'Alī Shāh and his sons, on plain gold ground. Tehran, Crown Jewels, Case II, No. 36, and Case XXXI, Nos. 11 and 26.

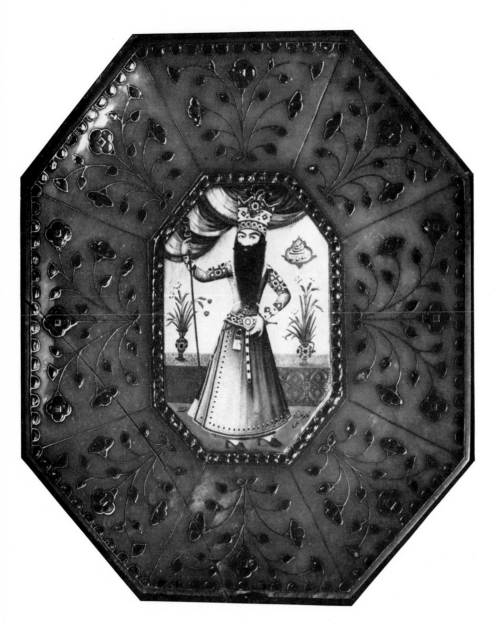

119.

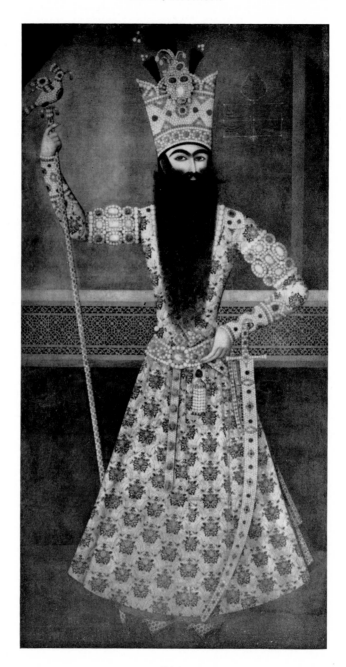

120.

Oval hand-mirror with jewelled border and carved jade handle, enamelled with a very fine portrait of Fatḥ 'Alī Shāh seated. Tehran, Crown Jewels, Case XXXIII, No. 38.

(GHULĀM) 'ALĪ. Mid 19th century.
Qaliān bowl of fair quantity with Bahrām Gūr in the various coloured pavilions. Paris, Hôtel Drouot, 25 May 1964, lot 15.

'ALĪ AKBAR. Mid 19th century.
Pendant with lovers embracing; fair quality. Paris, Jambon Collection.

MĪRZĀ BĀBĀ. Fl. *c.* 1785–1830.
The first painter-laureate (*naqqāsh-bāshī*) of Fatḥ 'Alī Shāh, and an accomplished artist in oils, miniature, lacquer, and enamel.
Octagonal snuff-box, the lid finely decorated with an old man and two girls in a landscape; dated 1224/1809. Tehran, Crown Jewels, Case XXI, top shelf.
Circular tray enamelled with flowers, scrolls, and a poetical dedication to Fatḥ 'Alī Shāh, and with an engraved sun in the centre. Attributed to Mīrzā Bābā by Mr. Yahya Zoka, Director, Ethnographical Museum, Tehran. Dated 1242/1826–7. Tehran, Crown Jewels, Case XXXI, No. 31.

(GHULĀM-KHĀNAZĀD) BĀQIR. Early 19th century.
One of Fatḥ 'Alī Shāh's ablest court artists in enamel; perhaps identifiable with Muḥammad Bāqir the lacquer artist who signed one of the covers of Or. 2265 in the British Museum, London.
Covered bowl, saucer, and spoon of excellent quality, enamelled with astrological figures and a poetical dedication to Fatḥ 'Alī Shāh. London, Messrs. Christies, 13 June 1956, lot 97. *Fig. 121.*
Tea-pot with busts of Fatḥ 'Alī Shāh and floral swags, and a dedication to the King. Tehran, Crown Jewels, Case IV, No. 21. *Fig. 122.*
Oval snuff-box with portrait of Fatḥ 'Alī Shāh seated. Tehran, Crown Jewels, Case IV, No. 33.

(USTĀD) ḤASAN SHĪRĀZĪ. 3rd $\frac{1}{4}$ 19th century.
According to the Comte de Rochechouart (*Souvenirs d'un Voyage en Perse*, Paris 1867, p. 255) he was responsible for a technical innovation, about 1860, whereby a full range of coloured enamels could be applied on silver by using a foundation of translucent green. Formerly only blue, green, and violet could be directly applied to the metal. This

artist may perhaps be identifiable with " Aga Mehmet Hassan " whose magnificent tea-service of enamelled gold so impressed the American Minister Benjamin (*Persia and the Persians*, London 1887, p. 310).

(*GHULĀM*) ḤUSAYN.　2nd ¼ 19th century.

Vase of fair quality, with dissipated groups in medallions and figures of dancing-girls between.　Tehran, Crown Jewels, Case II, No. 25.

ḤUSAYN 'ALĪ, see (*GHULĀM-KHĀNAZĀD*) 'ALĪ.

IBRĀHĪM.　Mid 19th century.

Qaliān bowl of excellent quality, with medallions of European ladies.　Paris, Jambon Collection.

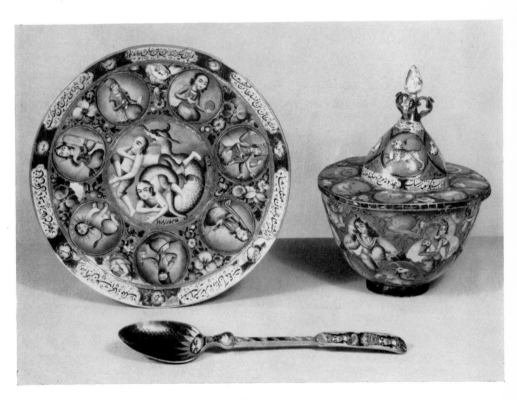

121.

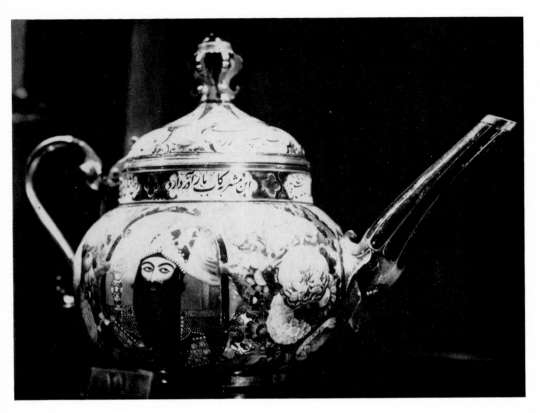

122.

KĀẒIM IBN NAJAF 'ALĪ. Fl. *c.* 1860–85.

Like his brother Aḥmad (q.v.) he was an accomplished artist in both enamel and lacquer. His earliest recorded work is a *qalamdān* dated 1278/1862, which is signed "*Muḥammad* Kāẓim ibn Najaf 'Alī ". For particulars of this artist's family, see B. W. Robinson, *A Lacquer Mirror-Case of 1854* in *Iran*, Vol. V (1967), pp. 1–6.

Qaliān bowl with medallions of the Holy Family amid flowers, dated 1280/1864. Tehran, Crown Jewels, Case II, No. 1. (*Note:* A *qaliān* bowl and base in Case IV, Nos. 2 and 3, though apparently unsigned, are also very probably the work of Kāẓim).

Qaliān bowl with portraits and flowers, dated 1287/1870. Wiet, *Exposition d'Art persan*, Cairo 1935, No. M. 114.

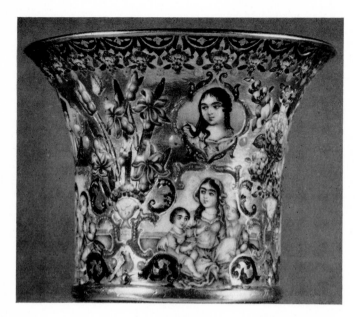

123.

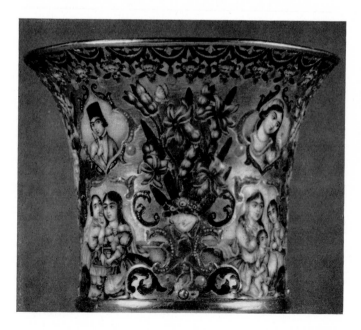

124.

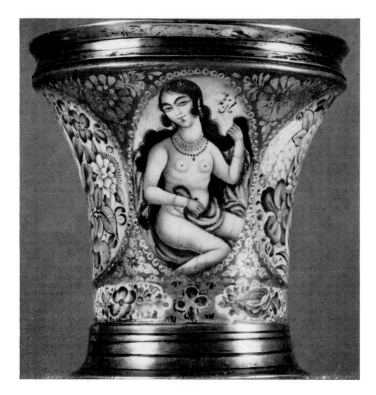

125.

Qaliān bowl with portraits and groups in medallions amid flowers. Made for Muḥammad Karīm Khān " Khāqān-i Maghrib ". London, private collection. *Figs. 123, 124.*

MUḤAMMAD. Early 19th century.

Qaliān bowl with flowers and medallions of an Indian youth and an unclothed lady. London, private collection. *Figs. 125, 126.*

Qaliān bowl with European couples and flowers. Paris, Hôtel Drouot, 25 May 1964, lot 10 (illustrated).

Qaliān bowl. Wiet, *Exposition d'Art persan*, Cairo 1935, No. M. 116.

(*ĀQĀ*) MUḤAMMAD 'ALĪ.

Mentioned by Benjamin (op. cit., p. 310) as a notable artist in enamel.

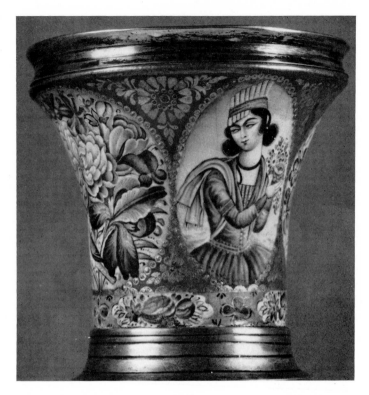

126.

(*GHULĀM-I DARGĀH*) MUḤAMMAD AMĪN. Early 19th century.
Mentioned by Benjamin (op. cit., p. 310) as a notable artist in enamel.

His style somewhat resembles that of Muḥammad Jaʿfar.
Circular tray made for the Crown Prince ʿAbbās Mīrzā, with
animals, birds, flowers, and three busts in medallions. Tehran,
Crown Jewels, Case IV, No. 8.

MUḤAMMAD BĀQIR, see (*GHULĀM-KHĀNAZĀD*) BĀQIR.

(*ĀQĀ*) MUḤAMMAD ḤASAN, see (*USTĀD*) ḤASAN SHĪRĀZĪ.

MUḤAMMAD IBRĀHĪM. Early 19th century.
Enamelled double candlestick, dated 1222/1807. Mashhad,
Shrine Museum No. 125.

MUḤAMMAD ISMĀʿĪL. Early 19th century.
Two small domed covers of good quality, enamelled with busts
and flowers; dated 1227/1812. Tehran, Crown Jewels, Case
XXXI, No. 36.

MUHAMMAD JA'FAR. Fl. *c.* 1800–30.

One of Fath 'Alī Shāh's three chief artists in enamel (the others being 'Alī and Bāqir) whom he seems to have employed especially in decorating official gifts and orders.

Ink-pot for a *qalamdān* with busts of a young man and a girl; dated 1220/1805. Paris, Hôtel Drouot, 25 May 1964, lot 2 (illustrated).

Qaliān base and bowl with busts in medallions, flowers, and birds; dated 1227/1812. Paris, Hôtel Drouot, 25 May 1964, lots 29 and 54 (illustrated). *Figs. 127, 128.*

Circular dish, presented by Fath 'Alī Shāh to Sir Gore Ouseley, Bart., the English ambassador. The Lion and Sun in the central panel is surrounded by alternating birds and floral swags within scrolled compartments on a plain gold background; the outer band of decoration is similar, omitting the scrollwork. Dated, 1228/1813. London, Messrs. Sotheby, Egyptian Royal Collection, March 1954, lot 867 (illustrated); Wiet, op. cit., No. M. 110 (when it was in the Kazrouni Collection).

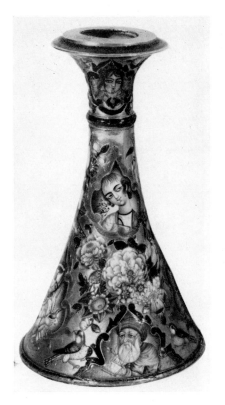

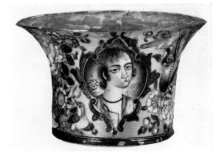

127. 128.

Jewelled snuff-box made for the Crown Prince 'Abbās Mīrzā, the lid enamelled with a European " classical " group of a lady, a child, and an angel, and the interior and base with birds and flowers; dated 1229/1814. Paris, Hôtel Drouot, 25 May 1964, lot. 17 (illustrated). *Fig. 129.*

Circular dish, almost exactly similar to the Ouseley dish above, presented on behalf of Fath 'Alī Shāh to the East India Company by his ambassador Abū'l-Hasan Khān; dated 1233/1818. London, Victoria and Albert Museum, No. I.S. 09406. *Figs. 130, 131.*

Qaliān bowl and base with busts in medallions, flowers, etc. dated 1234/1819. Tehran, Crown Jewels, Case I, No. 22, and Case II, No. 2.

Insignia of the Order of the Lion and Sun, dated 1240/1824, London, Messrs. Spink and Son.

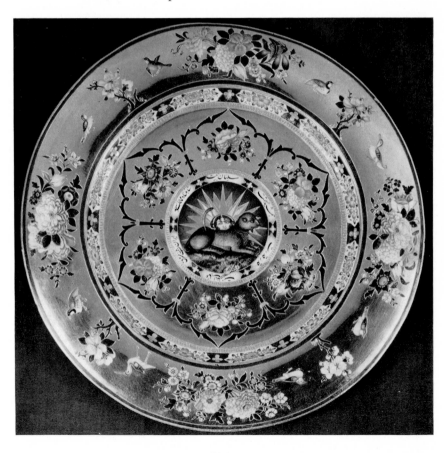

130.

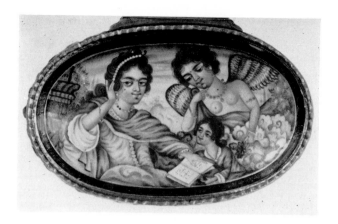

129.

131.

MUHAMMAD KĀZIM, see KĀZIM IBN NAJAF ʿALĪ.

MUHAMMAD MUHSIN " HALMĪ ". c. 1800.

 Rectangular mirror with fine portrait of Fath ʿAlī Shāh seated, on the inner face of the cover, within a floral border; dated 1212/1797–8 (the year of Fath ʿAlī Shāh's accession). Tehran, Crown Jewels, Case XXIX, No. 8.

 Circular box, the lid enamelled with a dissipated group of a greybeard, two ladies, and a child (signed, " Muhsin "). Tehran, Crown Jewels, Case XXI, bottom shelf.

MUHSIN, see MUHAMMAD MUHSIN " HALMĪ ".

(*GHULĀMZĀDA*) TAQĪ IBN MUHSIN. Early 19th century.

 Presumably the son of the preceding.

 Oval casket, the central panel of the lid enamelled with a group of the Holy Family, surrounded by four heads in medallions with birds and flowers between; similar designs, together with inscriptions, round the sides. Dated 1225/1810. Paris, Hôtel Drouot, 25 May 1964, lot 7 (illustrated in colour on the cover of the catalogue).

In conclusion I should like to express my gratitude to Mr. Yahya Zoka of the Ethnographical Museum, Tehran, the leading authority on the arts of the Qājār period, who kindly supplied me with several signatures and dates which I should otherwise have missed, as they were invisible from the front of the cases in the Crown Jewels display.

ACKNOWLEDGMENTS

The editor wishes to express his gratitude to the authorities of the following institutions for permission to reproduce paintings under their care: Bibliothèque Nationale; Bodleian Library; British Museum; Cleveland Museum of Art; Crown Jewels Teheran; Freer Gallery of Art; India Office Library; Institute of Arts, Detroit; John Rylands Library; Kunsthistorisches Museum, Vienna; Metropolitan Museum of Art, New York; Museum of Fine Arts, Boston; Museum of Turkish and Islamic Arts, Istanbul; Topkapu Saray; University Library, Leiden; Victoria and Albert Museum; Worcester Art Museum, U.S.A.; and to Mr. Julian Amery.

Al

M